POP-UP PIANOS

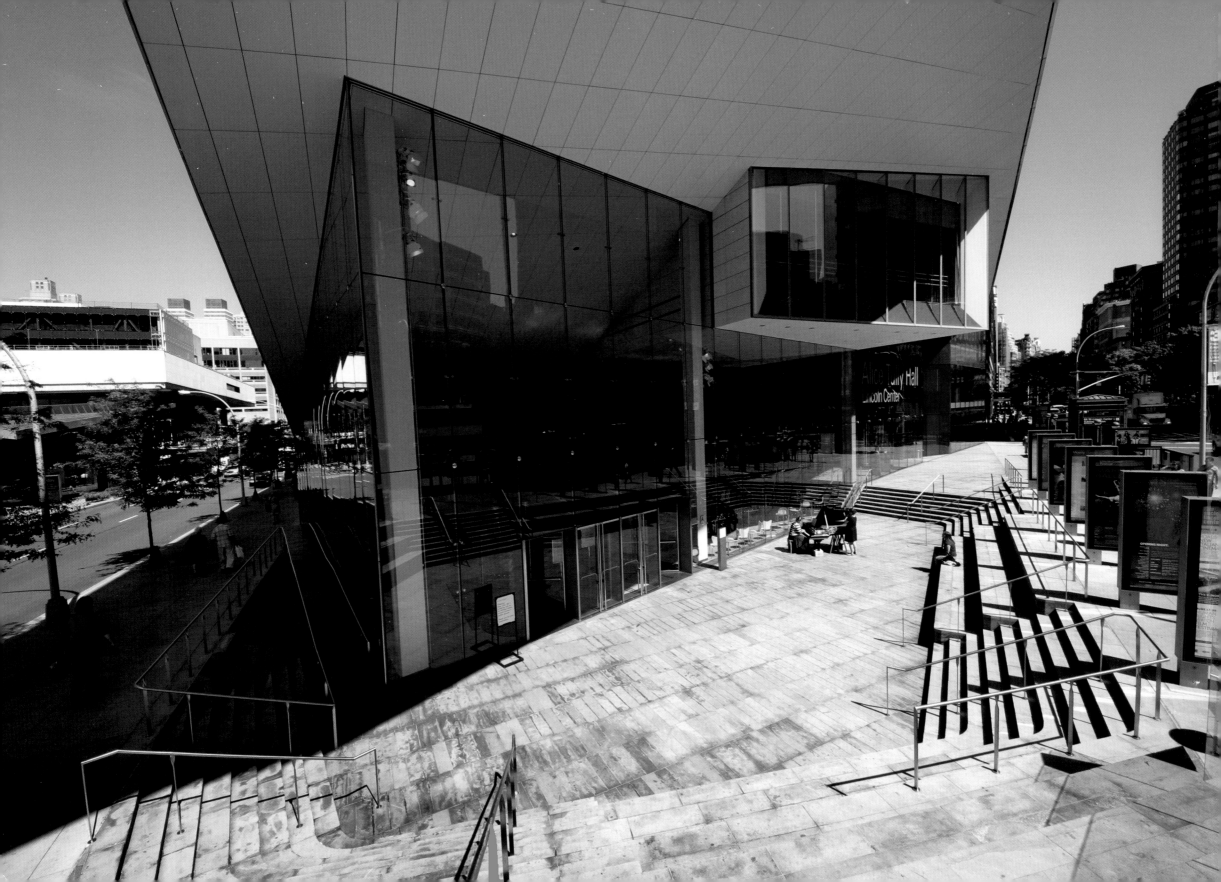

POP-UP PIANOS

ESSAYS BY MONICA YUNUS AND CAMILLE ZAMORA

Photographs by Lekha Singh

DAMIANI

For music lovers and artists everywhere.

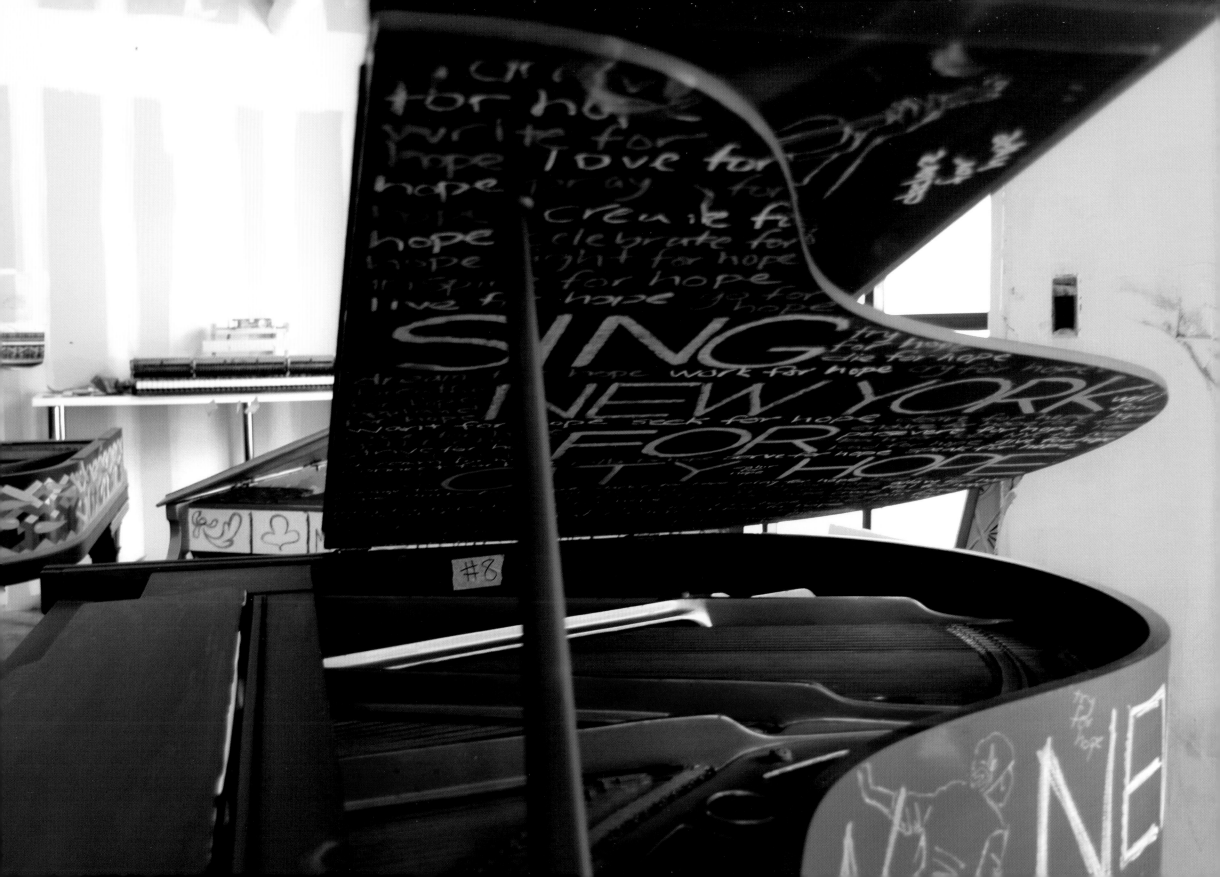

Jackie Robinson Recreation Center

Prospect Park Carousel

Dumbo Archway, Brooklyn

FORDHAM PLAZA,

ASTORIA PARK, Queens

Clay Pits Ponds St

Arthur Avenue. BRONX

Shore Road Park,

BROOKLYN BRIDGE PARK

Blue Heron Nature Center,

Carl Schurz Park, Manhattan

Little Red Square, man

Central Park Visitors Center

West 111th Street People's Garden, Manhattan

Astor Place, Manhattan

BATTERY PARK, MANHATTAN

ROOSEVELT ISLAND

Washington Avenue, Clinton Hill

La Maria Center for Ar

Coney Island Boardwalk at W 15th St

ROBERTO CLEMENTE

Faber Park & Pool

Joyce Kilmer Park, B

FORT GREENE PARK, Brooklyn

COLU

Williamsburg Oval.

14th street and 9th avenue

Armstrong House, Queens

Greeley Square

Brower Park, BROOKLYN

STATEN ISLAND FERRY TERMINAL

Central Park Bandshell

SAL

Gantry Plaza State Park

City Hall Par

Central Park, Dana Discovery Center

Highbridge Park, Ma

JFK AirTrain Terminal

TOWN HALL QUEENS

George Washington Bridge Bus Station

Tribeca Park, Manhat

Historic Richmond Town

Greenbelt Nature Center, S

Columbus Park, BROOKLYN

Saint Mary's Playground, BRONX

George Walker Jr. Brooklyn

Harlem Art Park

East River State Park

Washington Market

Brooklyn

SNUG HARBOR

TAPPEN PARK

RONX

Jackson Heights Post Office

Cultural Center

Prospect Park Grand Army Plaza

e Park

ntemore Park, manhattan

Brooklyn

Lincoln Center Alice Tully

taten Island

Van Cortland. Bronx

attan

Wilson Avenue

MacCarren Park, Williamsburg

Fort Greene / Myrtle Ave.

NYPL BRYANT PARK

Court Square Park

wen Dolen Golden Age Center, Bronx

Grand Army Plaza

Totten Park, QUEENS

Riverside Park, Manhattan

STA Rockaway Park

JOHN PAUL JONES PARK, Brooklyn

fus King Park, queens

BUS PARK, MANHATTAN

South Beach Boardwalk

Crotona Park, Bronx

. James Recreation Center, Bronx

Newtown Creek. Brooklyn

Lincoln Center Rubenstein

RED HOOK PARK

. Nicholas Park, Harlem

MARSH, Brooklyn

Staten Island Yankee Stadium

Sunset Park

Fort Tyron, manhattan

CLOVE LAKES PARK

hattan

Stone Street

TIMES SQUARE 42nd ST.

an

Wolfe's Pond, Staten Islan

Herbert Von King Park

ter Island

Tompkins Square Park

Inwood Hill Park, Manhattan

Unisphere in Flushing Meadows

MES SQUARE 45th STREET, MANHATTAN

RIVERBANK STATE PARK

Lincoln Center - Hearst Plaza

Pop-Up Pianos New York

It started with a piano that couldn't make it up the stairs.

In 2003, in Sheffield, England, student Doug Pearman found himself unable to get his beloved secondhand piano up the stairs to his new flat on Sharrow Vale Road. Doug's cousin, Hugh Jones, a Cambridge-educated mathematician working as a cabinetmaker, suggested that they just leave the piano where it was. They tracked down a stool for it, stapled on a tarp for protection from the sudden South Yorkshire showers, and attached a sign inviting passersby to sit down and play, right there in the middle of the sidewalk.

The world's first Street Piano was born.

The accidental debut of the Sheffield Street Piano was embraced by virtuosi and novices alike, and the instrument quickly became a local, then national, celebrity. Like any celeb, it had a period of thrilling ascendance, a splashy dedicated website, the occasional tussle with authorities (in the form of the Sheffield Council and its pavement obstruction laws), an impassioned crew of rally-round supporters, and a few newsworthy scandals, including being stolen in the dead of night, only to be replaced with a newer model by a group of committed volunteers.

The Sheffield Street Piano survived for five years, and when it was finally removed due to irreparable weather damage, its model for urban harmony had gone viral. Sixty miles to the south in Birmingham, an enterprising artist launched his version of Street Pianos —15 instruments emblazoned with "Play Me I'm Yours," which then traveled to other cities as an "internationally touring artwork." Off the coast of Southern China on Gulangyu Island, Street Pianos enlivened a biennial piano festival. In the United States, towns from Jacksonville to Orange County have produced their own Street Piano installations, each one bringing its own flavor to the mix: surfing themes in Southern California's "OC Can You Play," an adventurer spirit in Denver's "Keys to the City," a Sarah Palin/George Bush impersonator duo heralding the Street Piano launch ceremony in central Florida (admittedly, we weren't sure what to make of that one). And in the summer of 2011, New York City played home to a quintessentially Big Apple flavored Street Piano installation.

Sing for Hope's 2011 Pop-Up Piano installation was the world's largest Street Piano project to date. It was the first installation in which every instrument was an individually credited artwork by a dedicated artist or artists' group, each one chosen through an open application process. As an "artists' peace corps" powered by hundreds of professional artists who volunteer their time, Sing for Hope was uniquely positioned to produce the Pop-Up Pianos with a diversity and scope worthy of the city that never sleeps.

The organization collected donated pianos from the tri-state area and purchased abandoned instruments from wholesalers to be rehabbed by a generous piano technician and his team of young tuners. A sunlit warehouse space in Tribeca was loaned by a civic-minded real estate family, and an iconic New York power broker and his musically gifted wife stepped up to cover the lion's share of the project's costs, a respected arts foundation covering the rest. Sing for Hope's roster of artists worked alone, in groups, and in collaboration with students from under-resourced schools. One by one, 88 instruments (one for each key on the piano keyboard) were brought to vivid new life.

Isaac Mizrahi's hot pink glitter piano, "Hello Miss Piano," channeled, in his words, "the 12-year-old girl deeply rooted in my soul." The crochet artist Olek entitled her piano "Imagine the Clouds Dripping," explaining that it was a meditation on NYC's diversity via the expressive medium of 100% Red Heart Acrylic Yarn. BD Wong's piano, which he dubbed "Sings Eternal," glowed in silver and purple hues and gave voice, he said, to his inner child who had been forbidden to touch the pristine parlor piano of his youth. "Play On," the piano by high school students from The Center for Arts Education, invoked the wisdom of

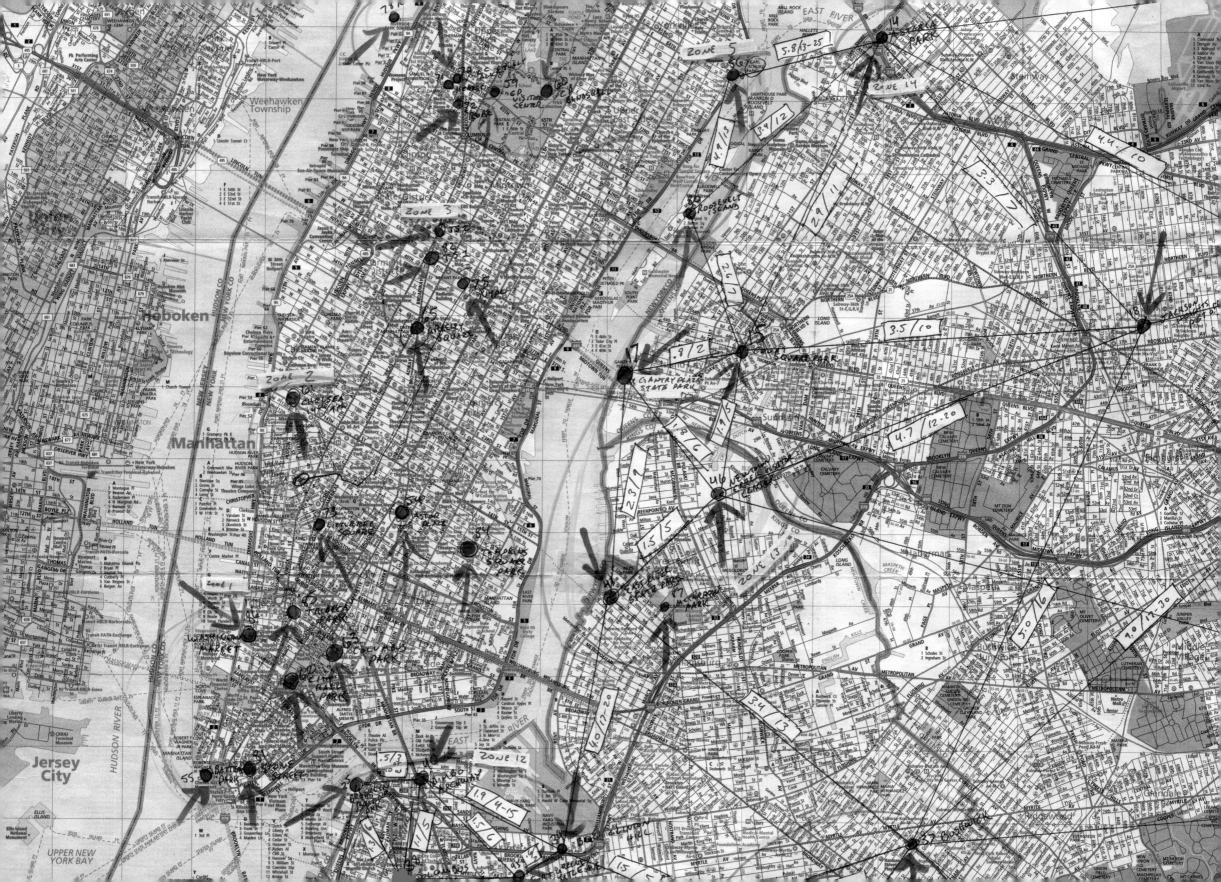

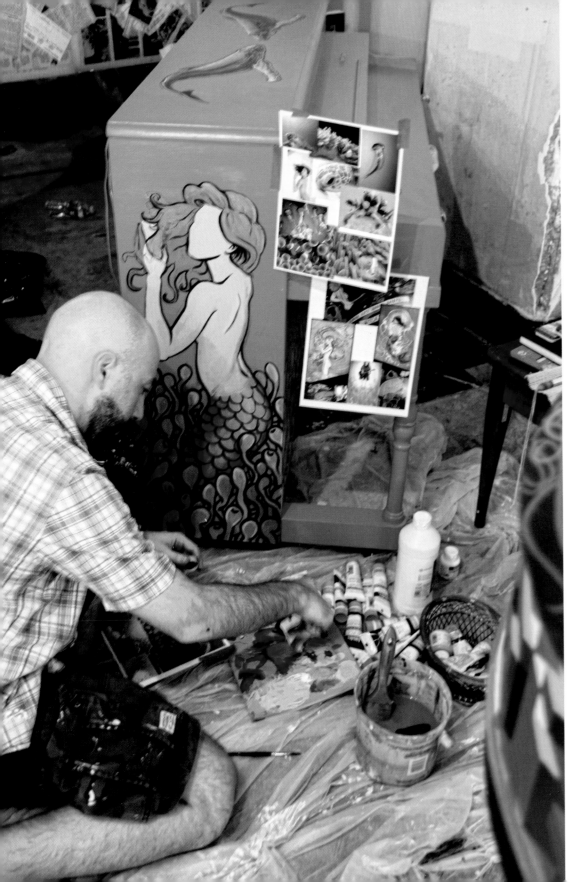

artists who came before, reminding us in bold white-on-black letters that "Creativity takes courage" (Henri Matisse) and "To be an artist is to believe in life" (Henry Moore).

As the artists worked their magic, the Sing for Hope team took countless meetings with city agencies and park managers to wrangle permits and placements, and made multiple visits to 88 chosen sites throughout the five boroughs. They enlisted "piano buddies" from local community organizations whose job it would be to cover the pianos with tarps in case of rain and to report on missing keys and other occupational hazards. And in keeping with Sing for Hope's year-round mission of arts outreach, they laid the groundwork to donate the pianos to underserved schools, hospitals, and community organizations upon completion of the project.

For two warm summer weeks, from the Bronx's Grand Course to Battery Park and from the Coney Island boardwalk to Far Rockaway, Sing for Hope's Pop-Up Pianos were enjoyed by an estimated 2 million people.

The Pop-Up Pianos are tangible, playable symbols of arts outreach—a whimsical but undeniable way of saying that art belongs to everyone. They inspired our city, they inspired the brilliant photographer whose book you hold in your hands, and we hope they will continue to inspire imitators in cities around the world for years to come. To quote Hugh Jones, who started it all on Sharrow Vale Road a decade ago, "Perhaps one day, Street Pianos will be a familiar sight everywhere. Now wouldn't that just rock your world?"

Frontispiece and following pages: Chris Soria's Pop-Up Piano, *Polychromatic Scales,* at Lincoln Center; Detail of Adam Suerte's Pop-Up Piano, *Brooklyn Love*; Zahir Babvani's Pop-Up Piano, *Chalk For Hope*. This page: Artist Marc Evan works on his Pop-Up Piano, *Whale Song,* at the Tribeca piano warehouse. Opposite page: Michael Kale's Pop-Up Piano, *Drips,* awaits its move from the warehouse to Times Square.

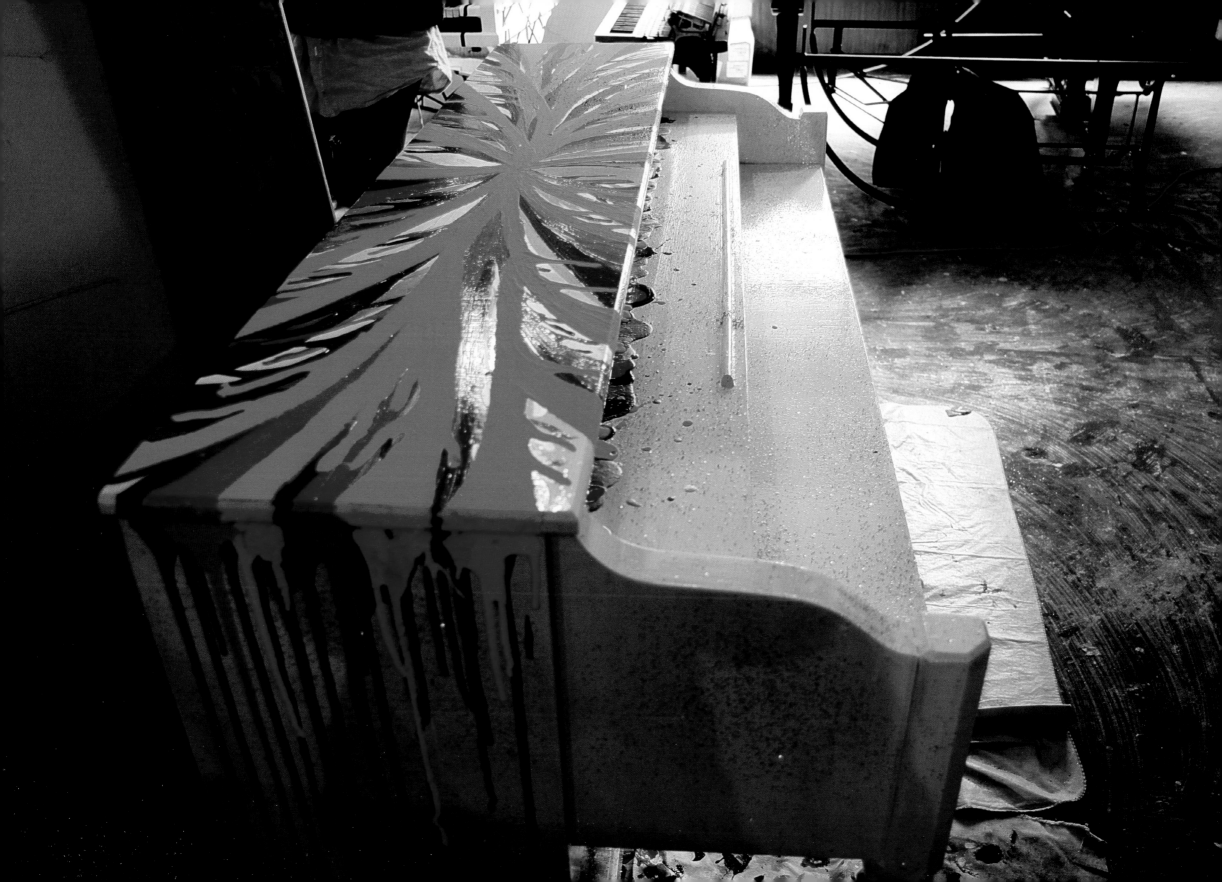

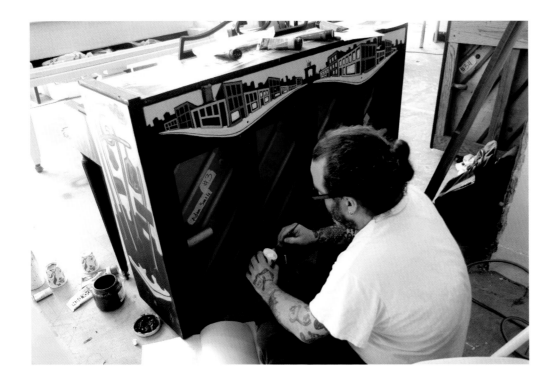

Opposite page: Alice Mizrachi's Pop-Up Piano, *Lady Drip*, before heading to Washington Market Park. Above, left: Tattoo artist Adam Suerte works on his Pop-Up Piano, *Brooklyn Love*.
Above: Piano awaiting the careful attention of technician Fred Patella. Bottom, left: Sing for Hope team piano, mid-découpage.

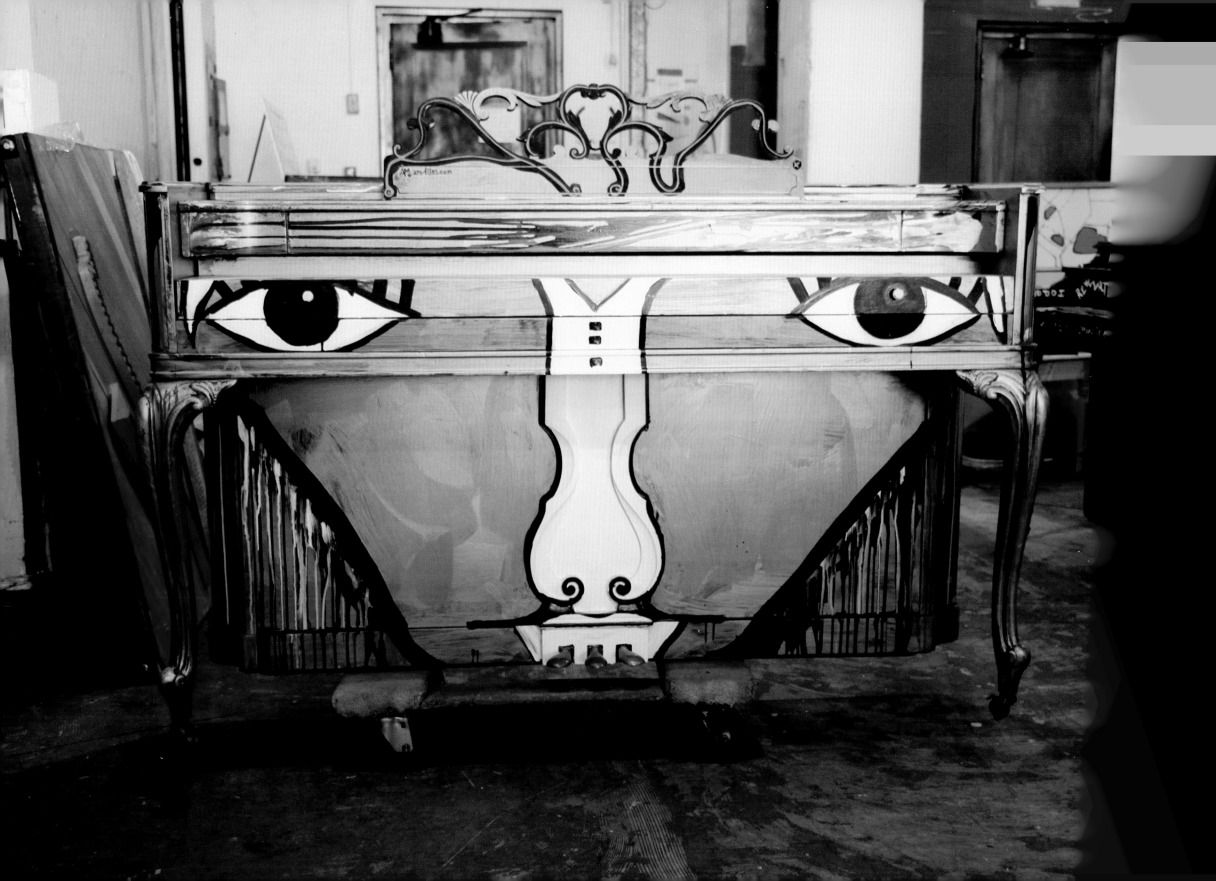

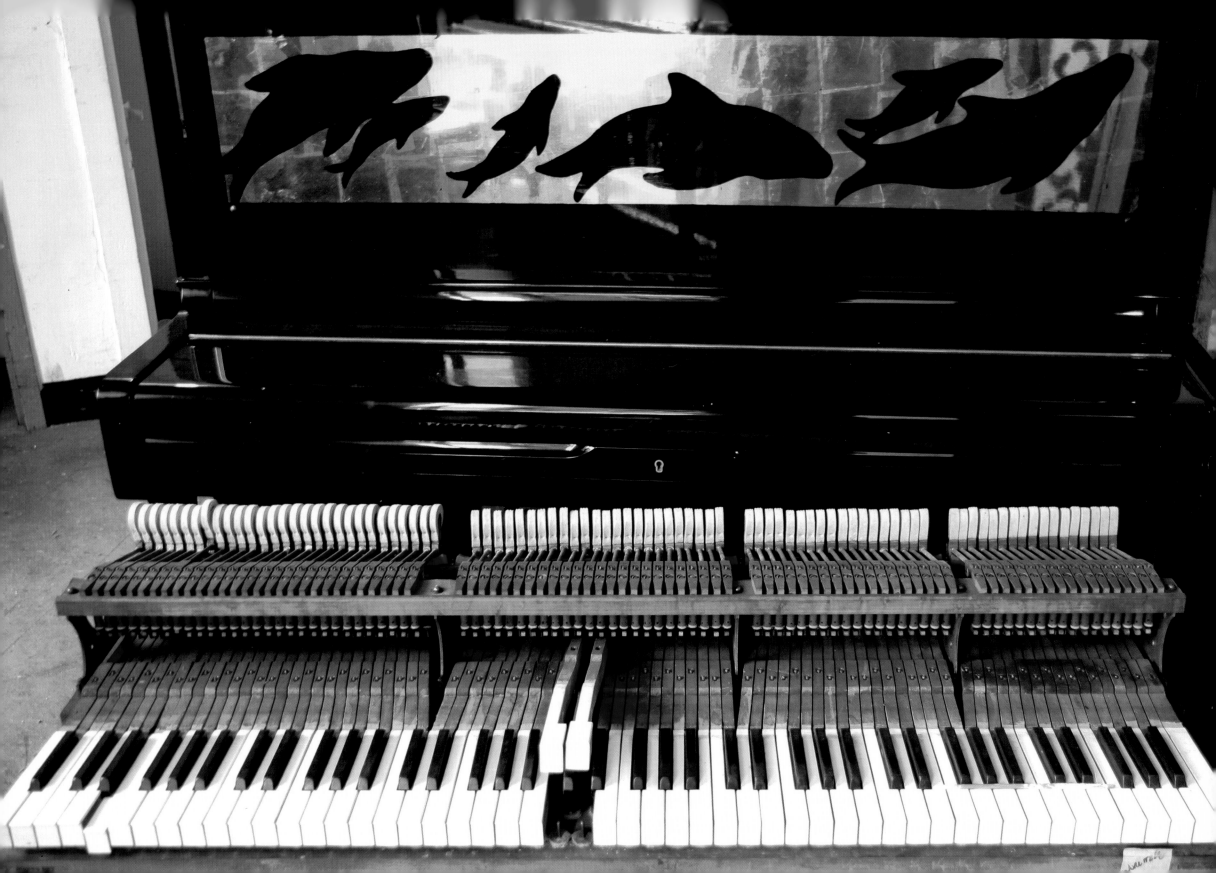

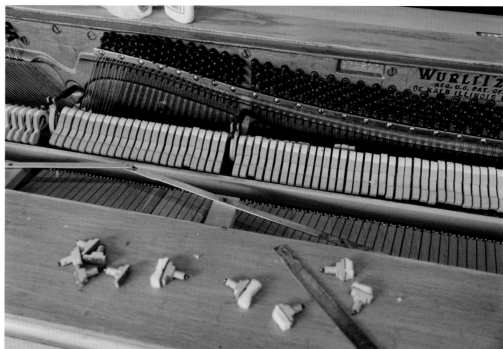

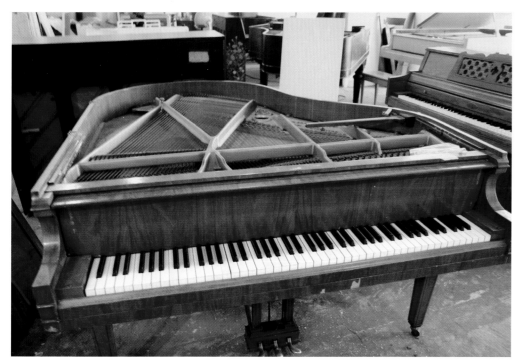

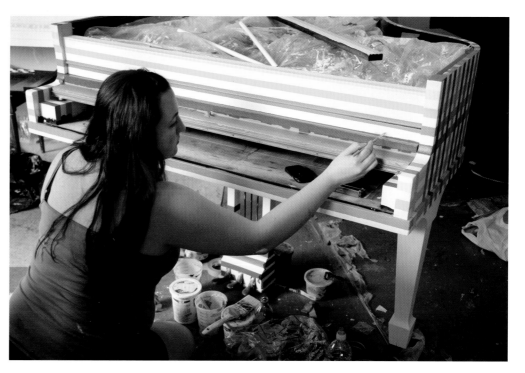

Opposite page: Sophie Mattisse's Pop-Up Piano, *Vox Balanae*, stands behind salvaged keys and hammers. Above, left: Detail of Tim Farley's Pop-Up Piano, *Intergalactic Melodies*. Above, right and below, left: Greater than the sum of their parts, pieces are collected, honed and redistributed to bring old pianos to new life. Bottom, right: Artist Emily Lynch-fries's Pop-Up Piano, *The Plaid Piano*, is based on Scottish tartans reimagined in a rainbow of colors for all New Yorkers.

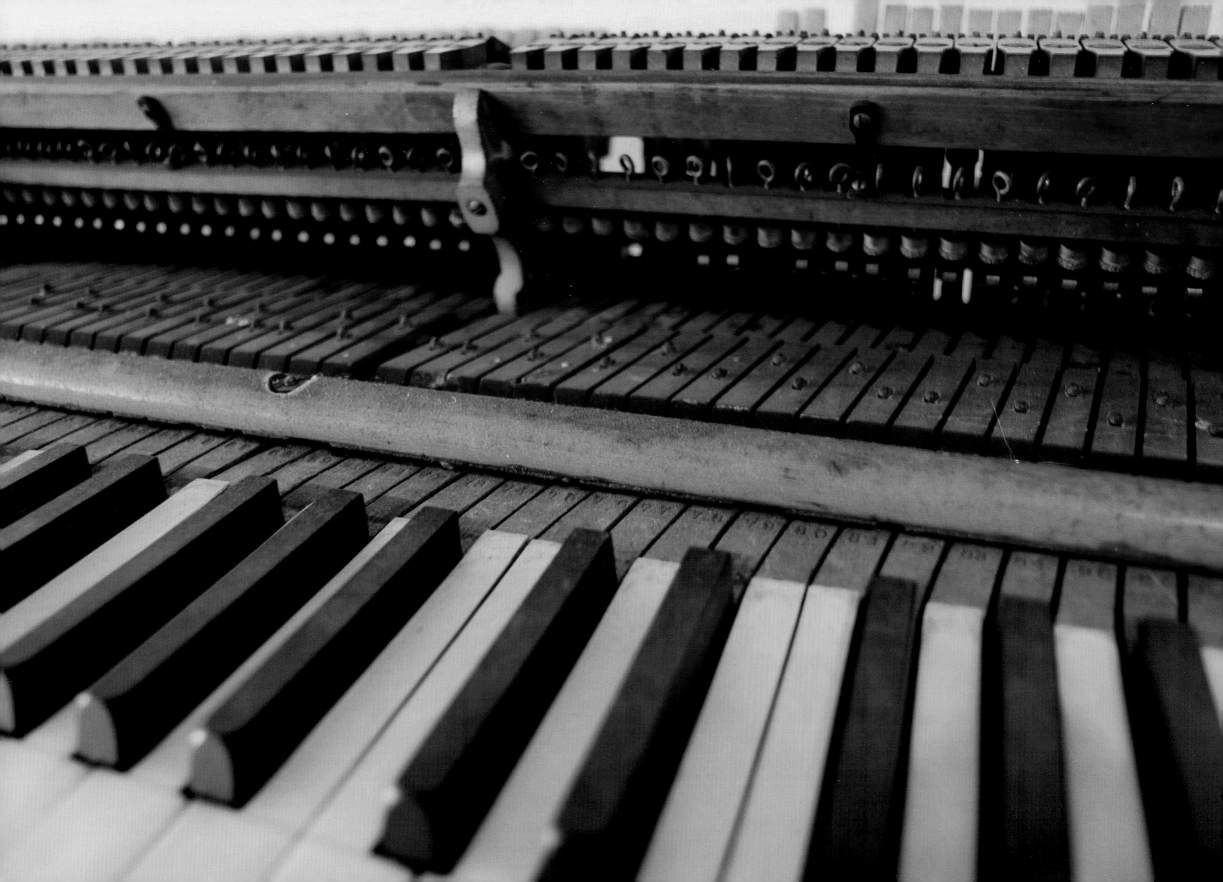

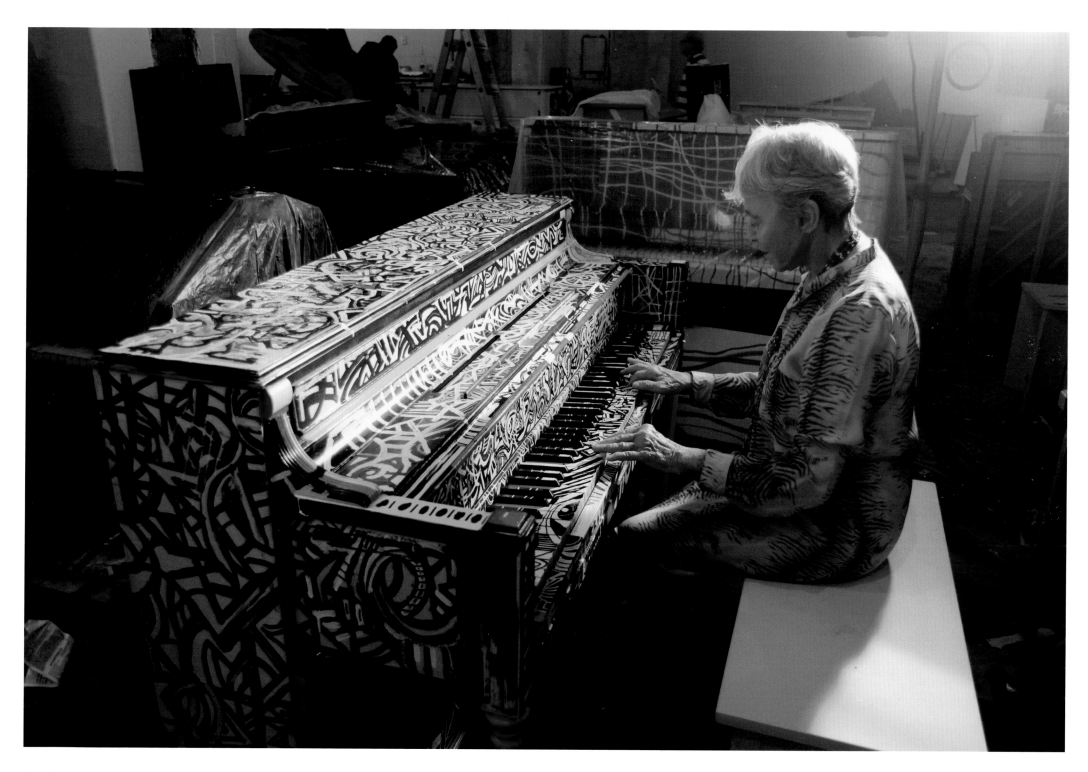

Opposite page: Detail of a vintage piano before renewal.
This page: Sing for Hope Board Chair Eva Haller coaxes a tune from Zeke Decker's piano.

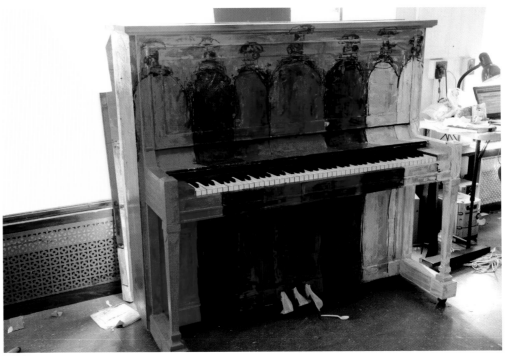

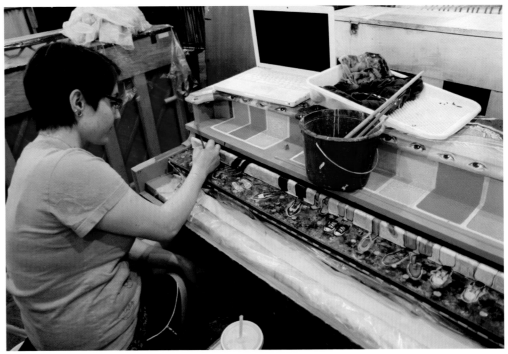

Left and opposite: Details from Sophie Matisse's *Sophia Musiki*. Above, right: Edyta Halon's Pop-Up Piano, *The Tanks*, in the warehouse.
Bottom, right: Jillian Logue and her Pop-Up Piano, *Subway Quilt*.

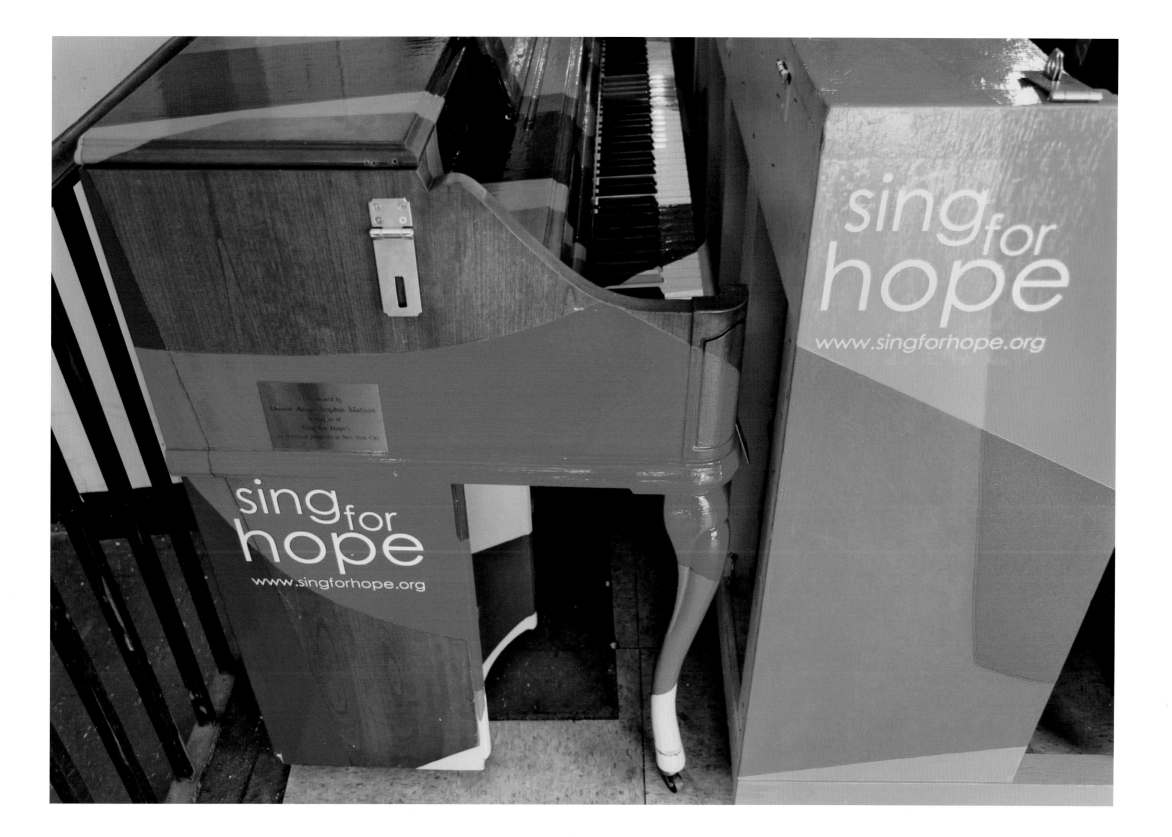

88 pianos

5 boroughs

100s of artists

countless performances

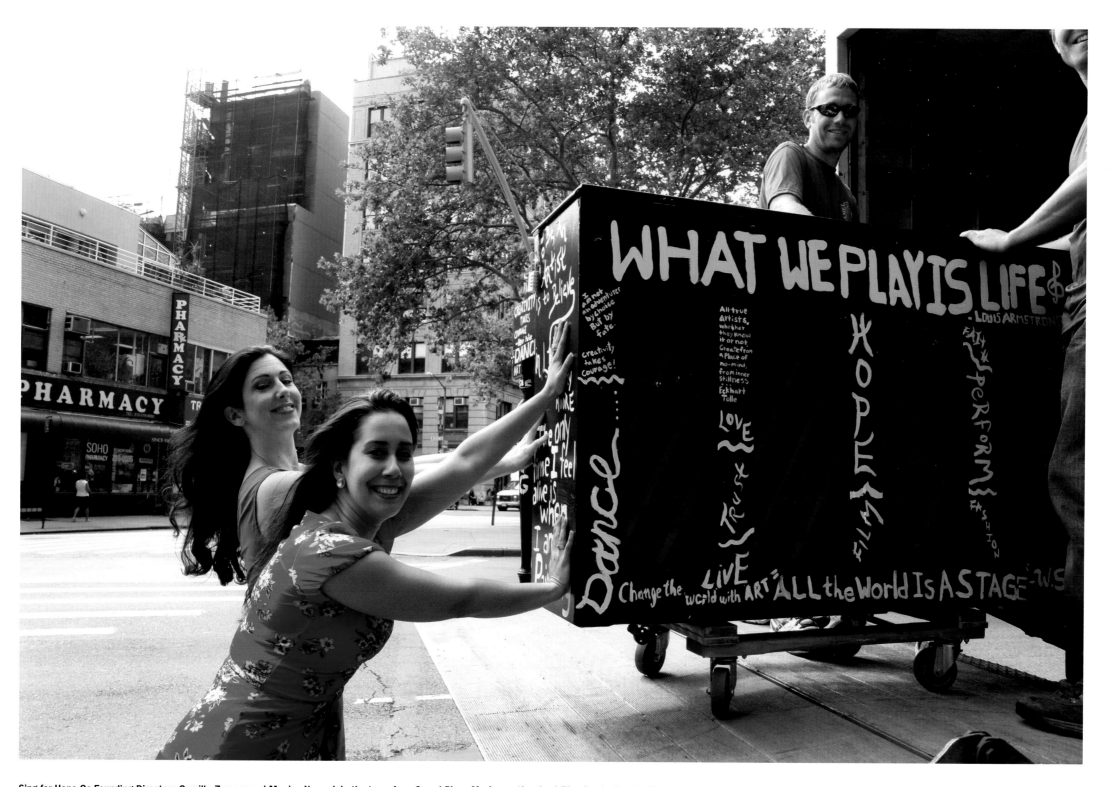

Sing for Hope Co-Founding Directors Camille Zamora and Monica Yunus join the team from Camel Piano Moving as they load *Play On*, the Pop-Up Piano by high school students from The Center for Arts Education.

 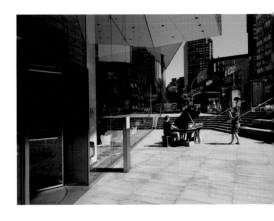

I LOVE A PIANO, I LOVE A PIANO, I LOVE

A GRAND PIANO, 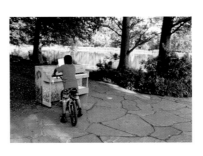 IT SIMPLY CARRIES ME AWAY.

I LOVE TO RUN MY FINGERS O'ER 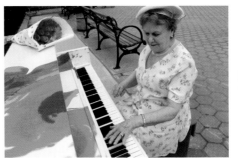 THE KEYS,

 TO MEDDLE . . . SO YOU CAN KEEP YOUR FIDDLE AND

I LOVE TO STOP 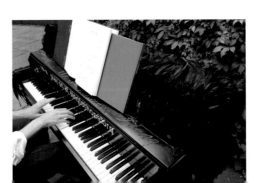 RIGHT BESIDE AN UPRIGHT,

TO HEAR SOMEBODY PLAY, UPON A PIANO,

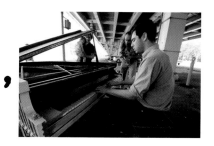

I KNOW A FINE WAY TO TREAT A STEINWAY,

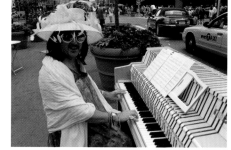

THE IVORIES. AND WITH THE PEDAL I LOVE

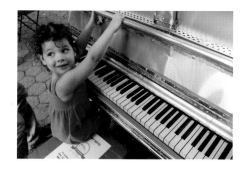

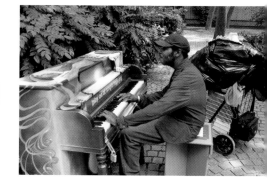

YOUR BOW, GIVE ME A P-I-A-N-O, OH, OH!

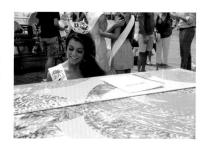

OR A HIGH-TONED BABY GRAND! I LOVE A PIANO

—Irving Berlin, 1915

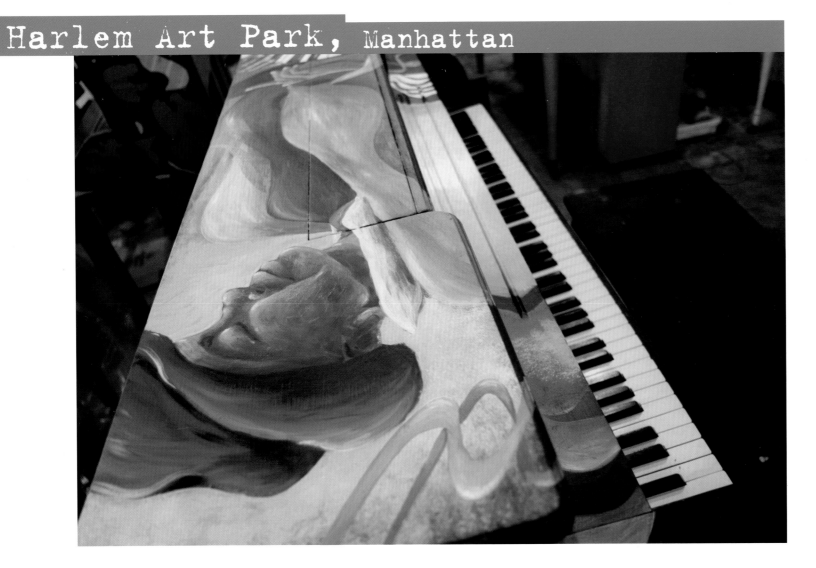

My artist is: Lauryn Pepe

My keys were at:
East 120th Sreet and Sylvan Place

My name is: Today We Play

This is what my artist says about me:
Color on top of color creates a harmonious
mood. Designed lines and imagery express
movement. When the magic combinations of
keys are played, the melody captures our attention.
Perfect partnership, bringing a unique vision
to the body that holds the keys!

You can find my artist at: www.laurynpepe.com

My community buddy is: NYC Parks

My new home is: Lt. Joseph P. Kennedy Center,
Harlem Arts Alliance

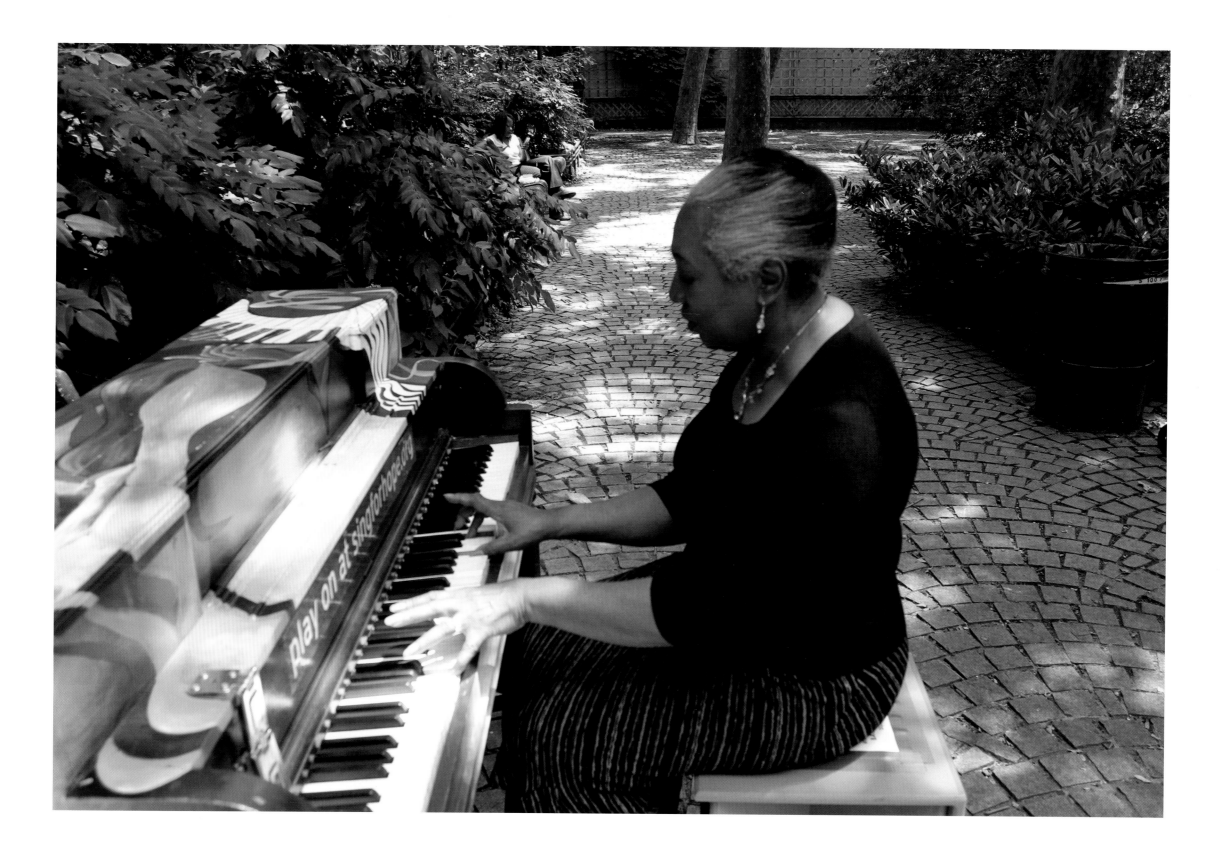

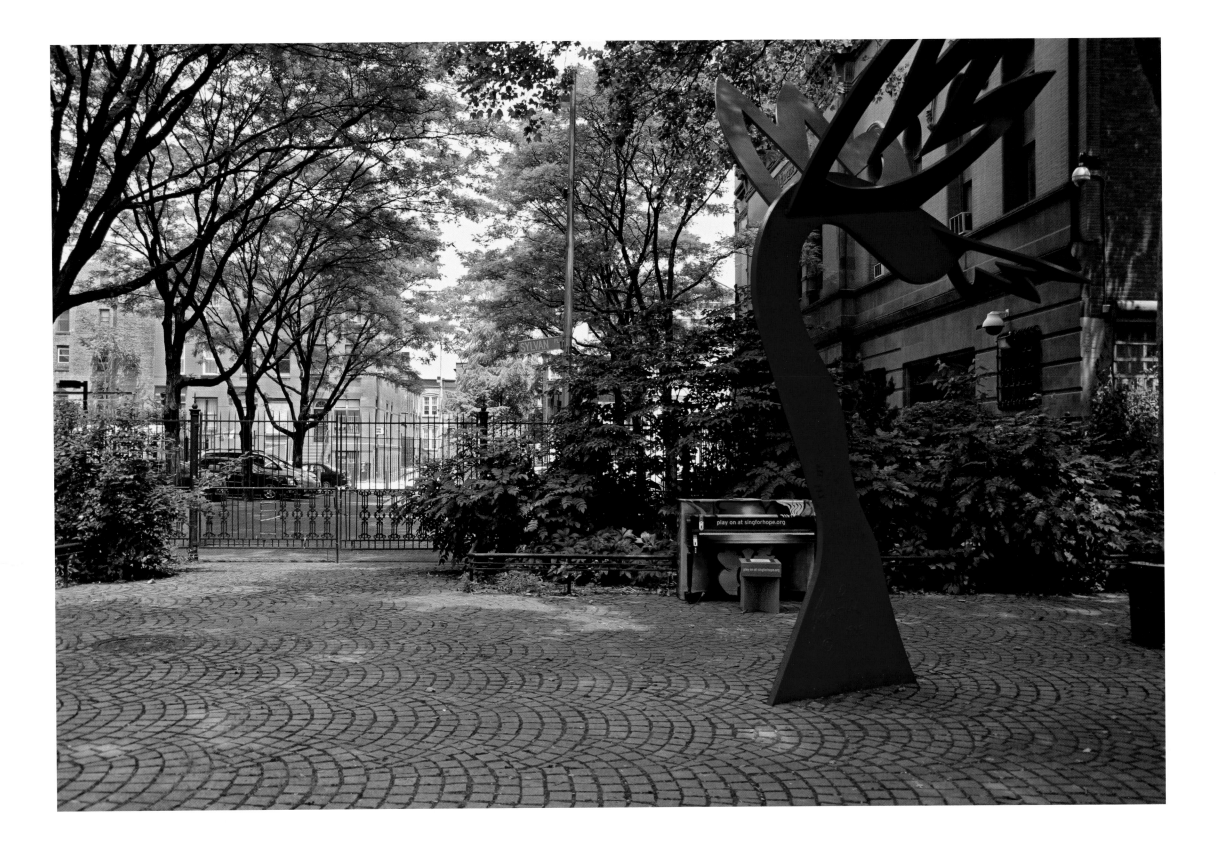

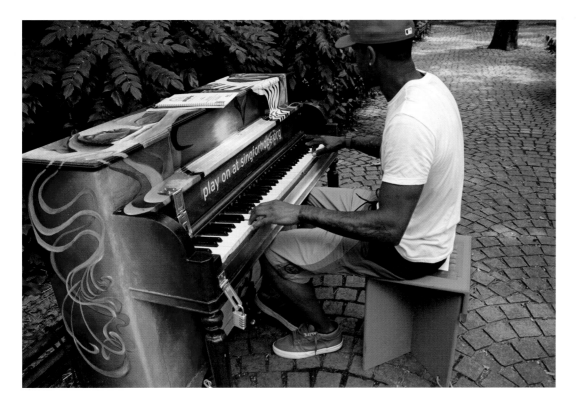

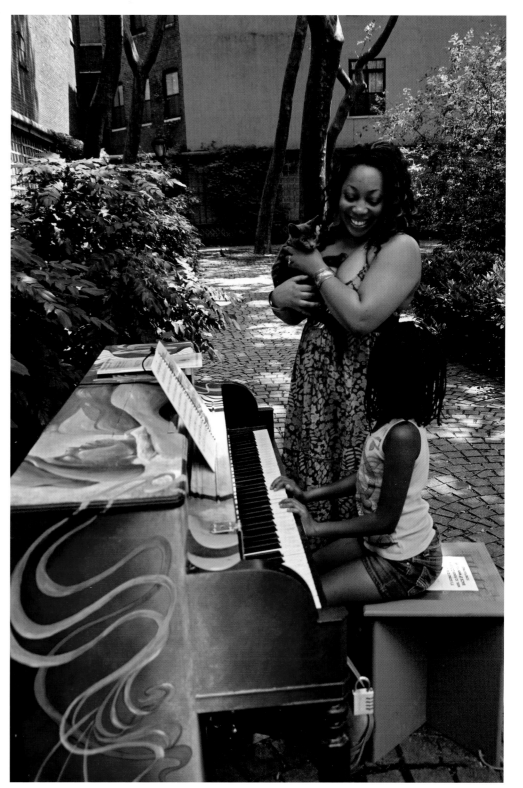

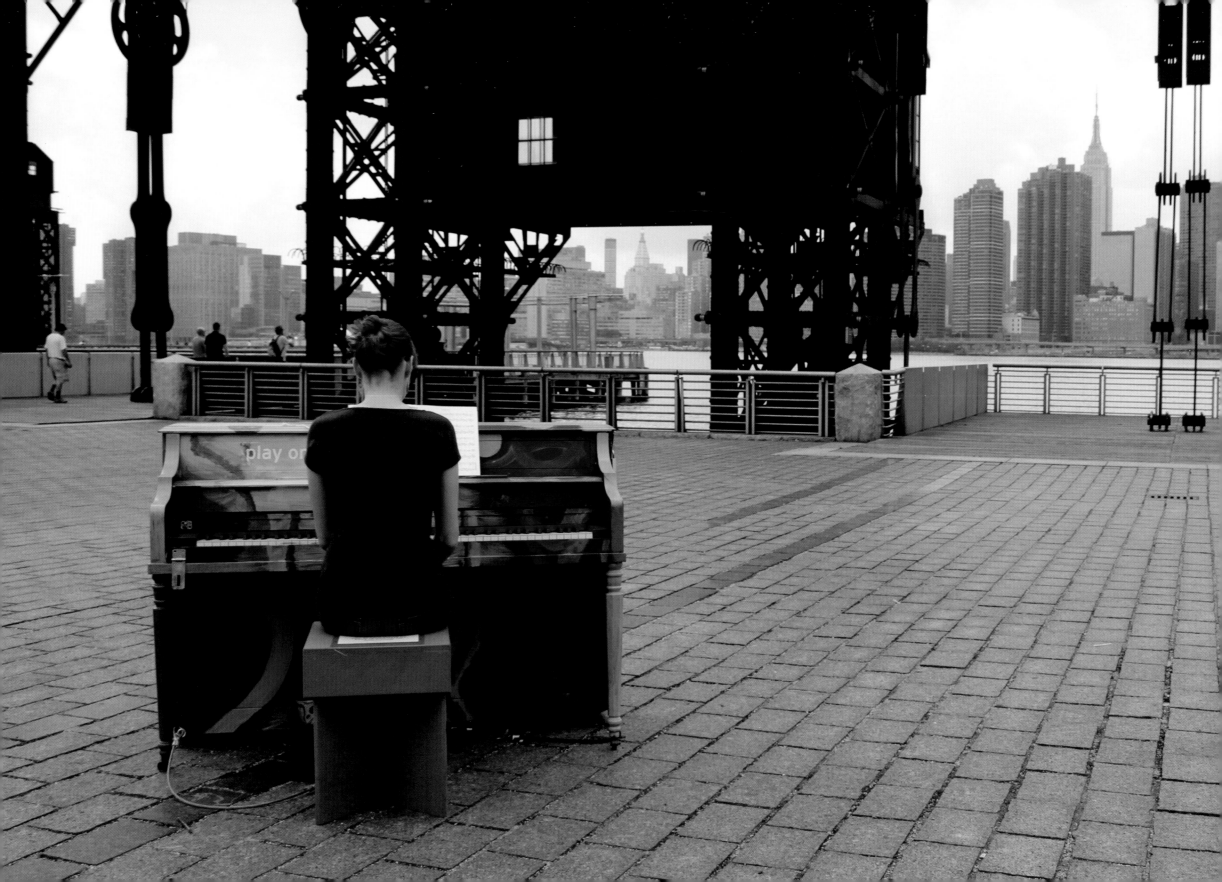

My artist is:
Sing for Hope Teaching Artist Team

My keys were at:
48th Avenue and Center Boulevard

My name is:
Second Time Around

This is what my artist says about me:
Reduce, Reuse, Recycle

You can find my artist at:
www.singforhope.org

My community buddy is:
NYC Parks

My new home is:
P.S. 78Q

Gantry Plaza State Park, Queens

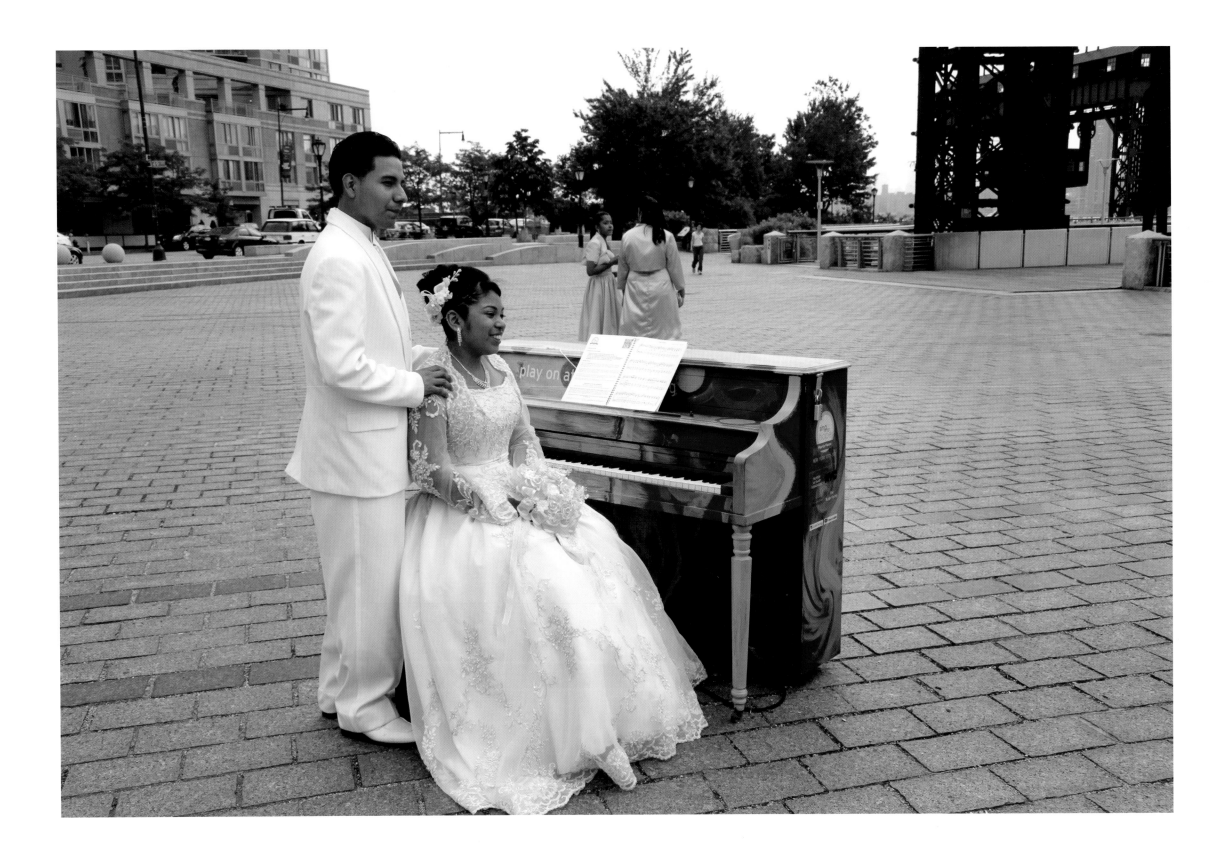

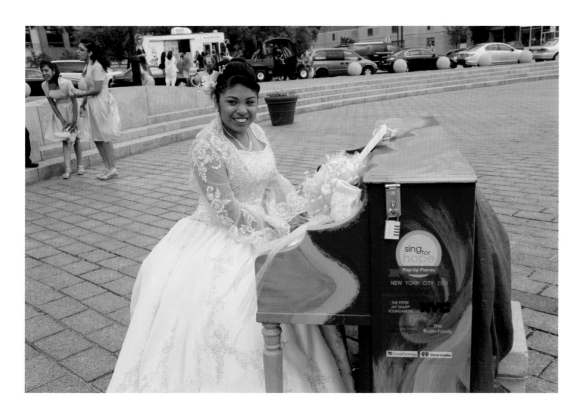

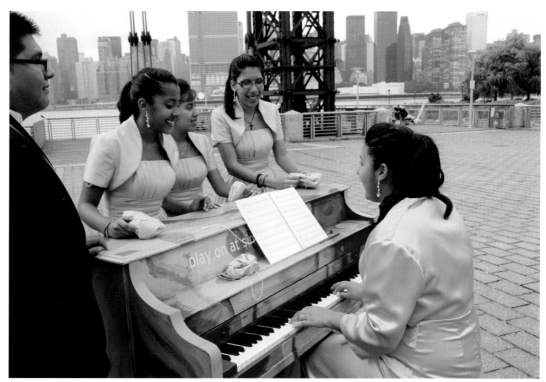

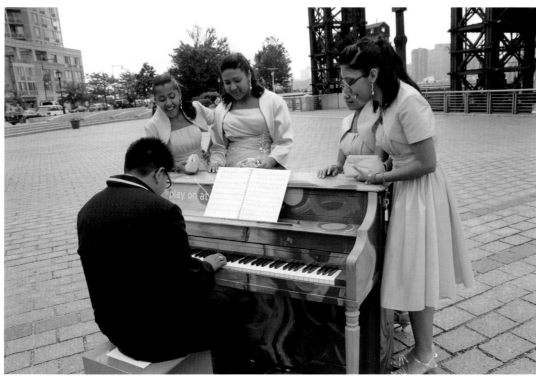

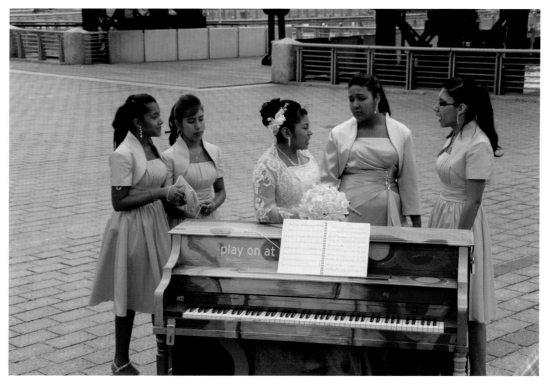

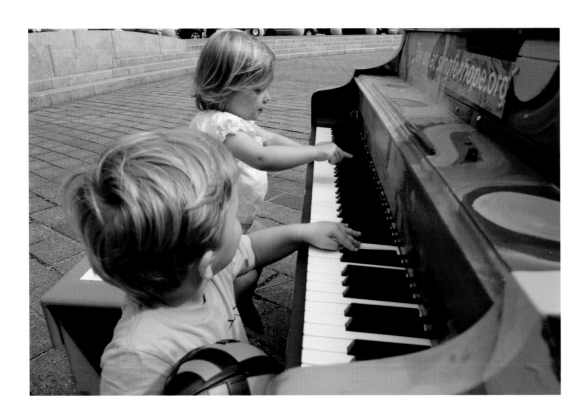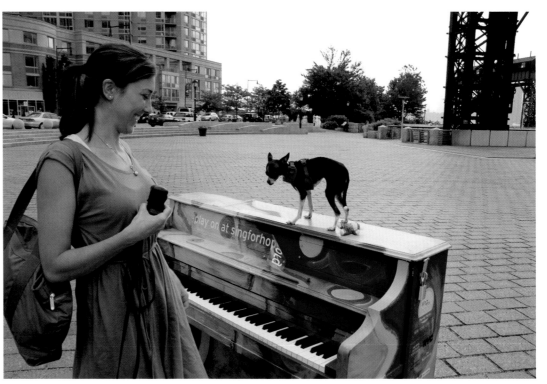
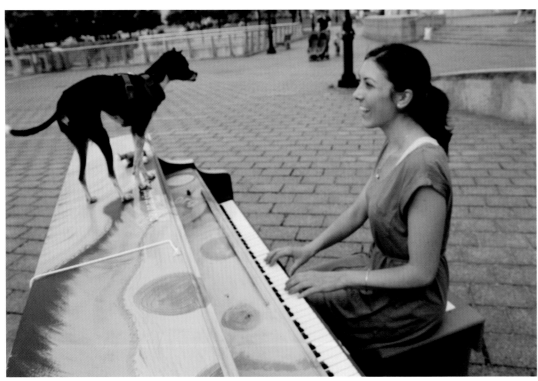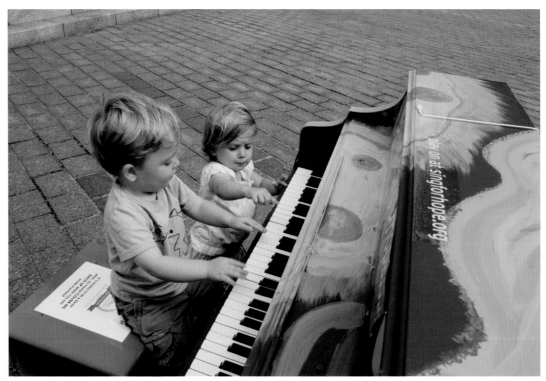

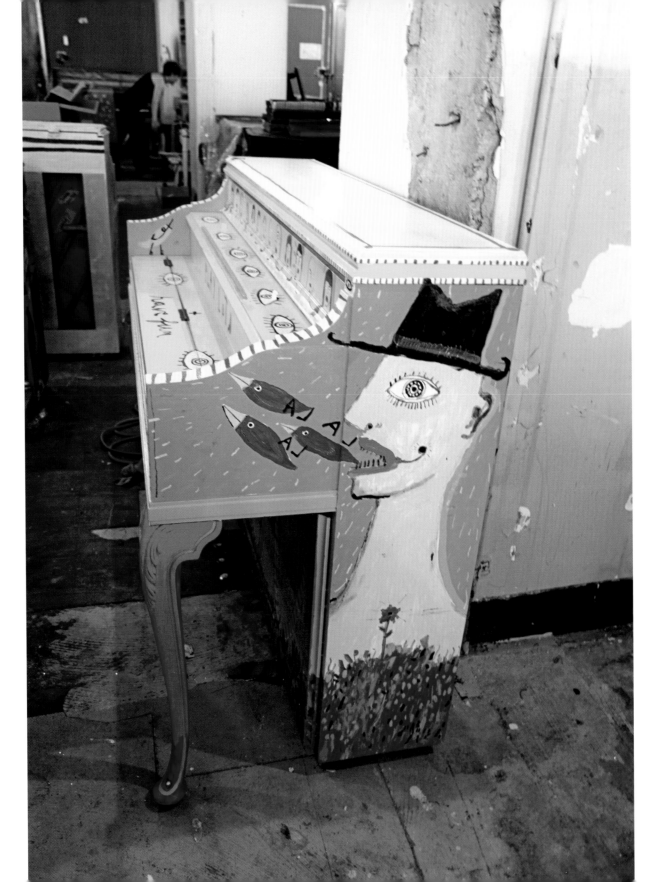

My artist is:
Scott Ackerman

My keys were at:
Washington Park and
Willoughby Avenue

My name is:
Play Lots

This is what my
artist says about me:
Like my paintings, my
piano is a step into my
idea of this hectic, busy,
fun life we live, and how
colors and words can trigger
different emotions in all
kinds of different people.
Have lots of fun, and
love what you do.

My community buddy is:
David Paarlberg, NYC Parks

My new home is:
Ridgewood Bushwick
Senior Center

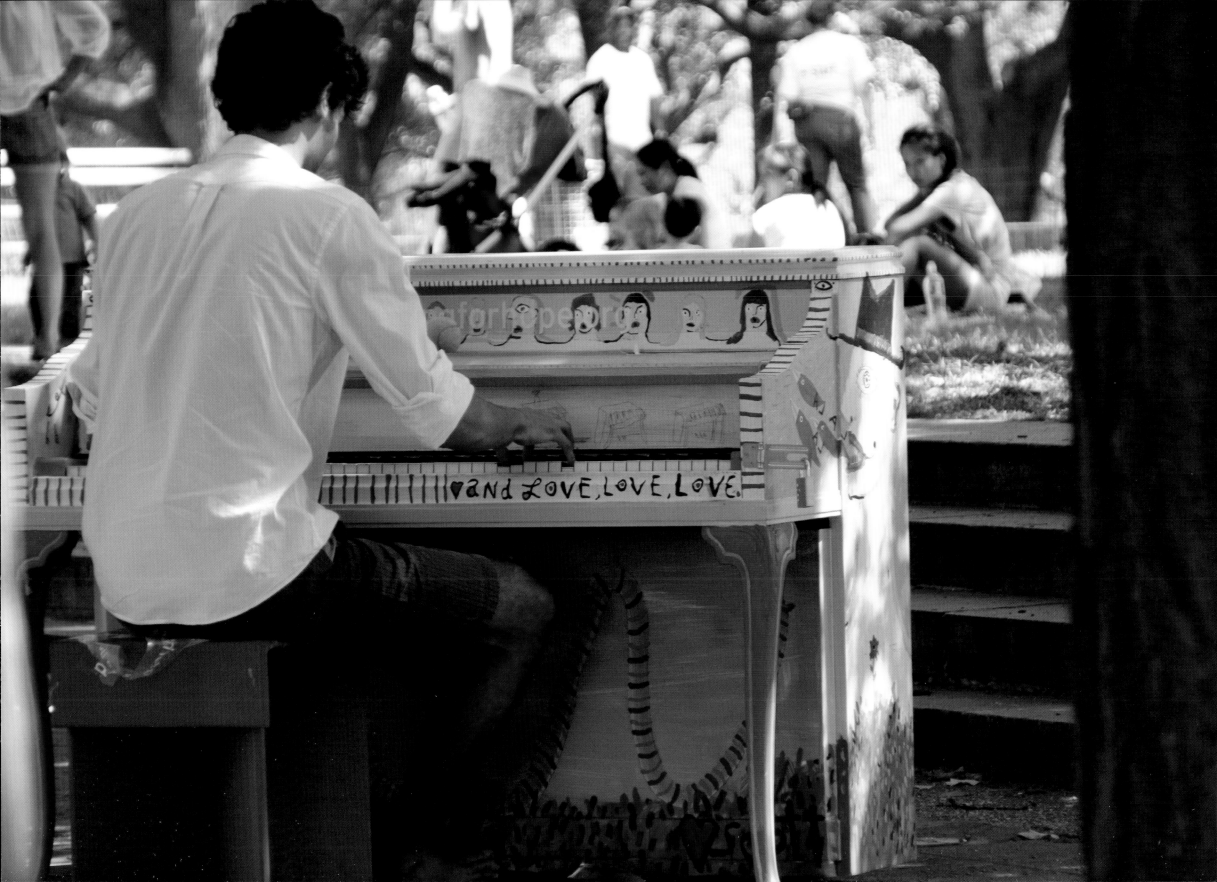

My artist is: Jenny Hung

My keys were at: West 14th Street and 9th Avenue

My name is: Left And Right

This is what my artist says about me:
Cool on one side. Fire on the other. Left and Right.
Black and White. The keys voice all shades in between.

You can find my artist at: www.jchiwan.com

My community buddy is: Fedcap Vocational Rehabilitation

My new home is: Fedcap Vocational Rehabilitation

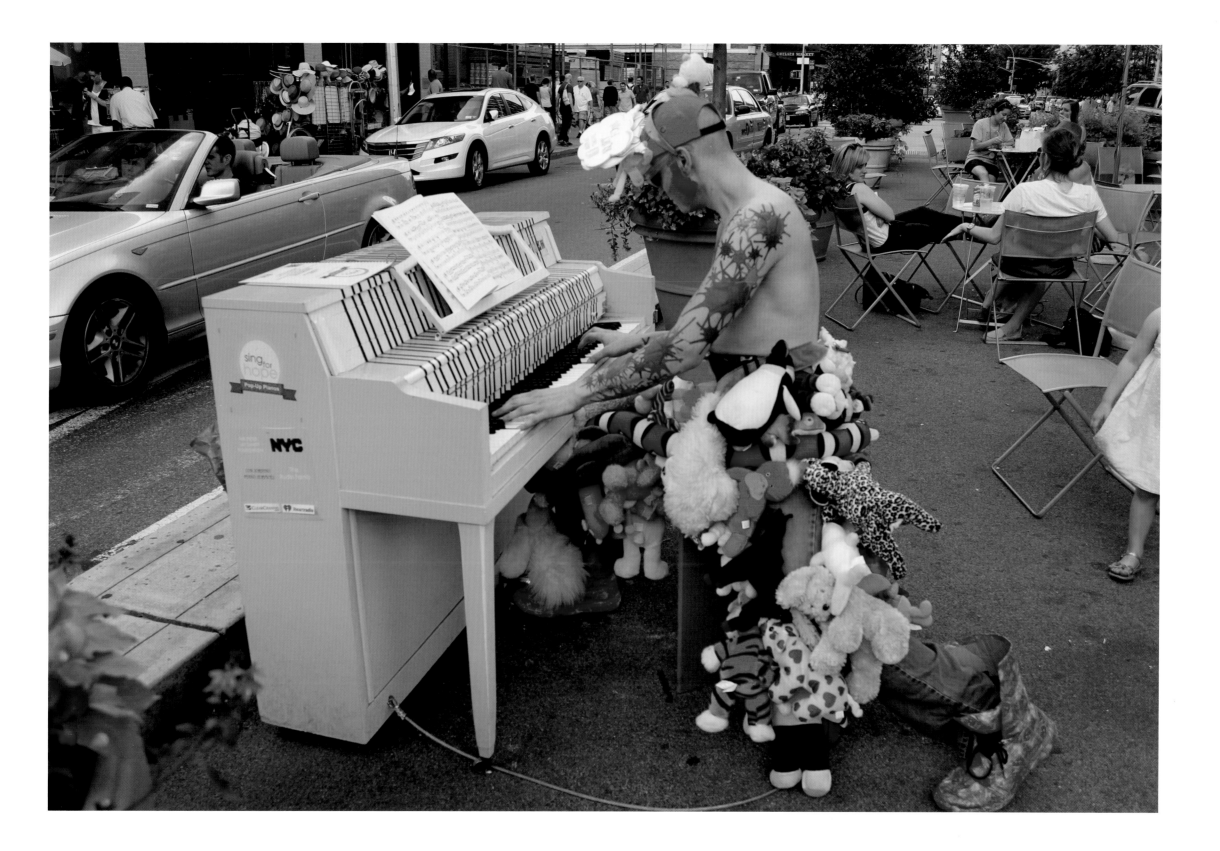

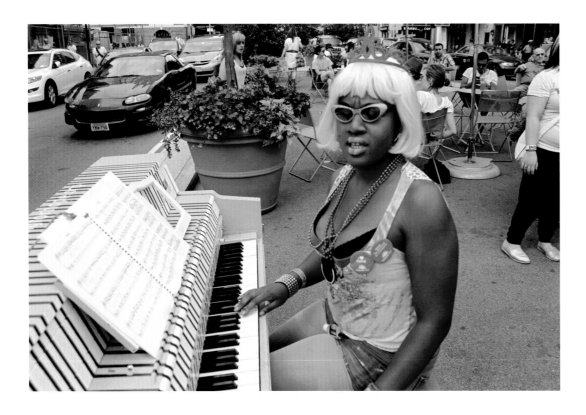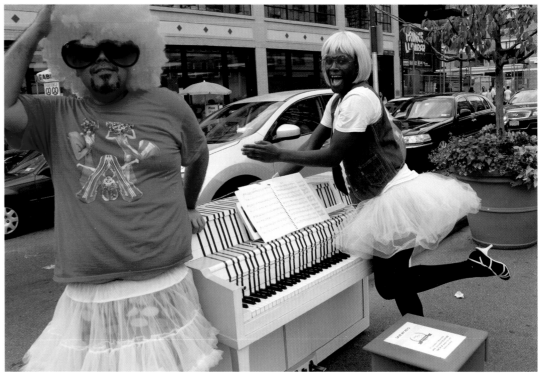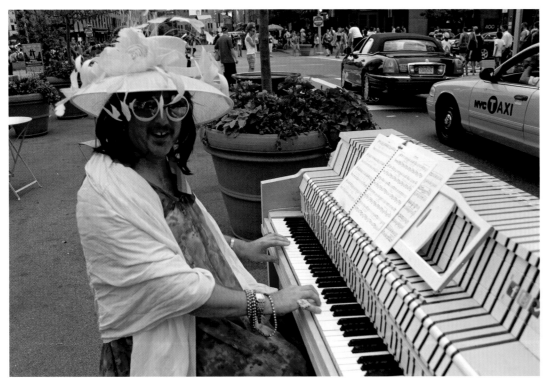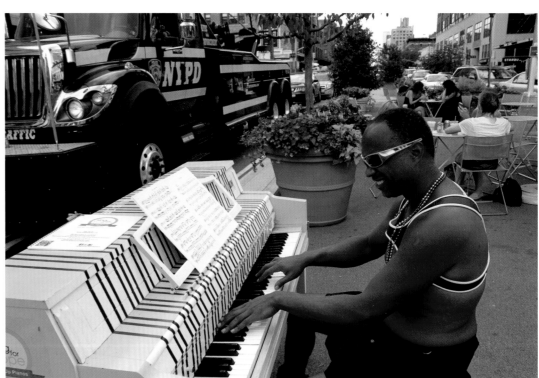

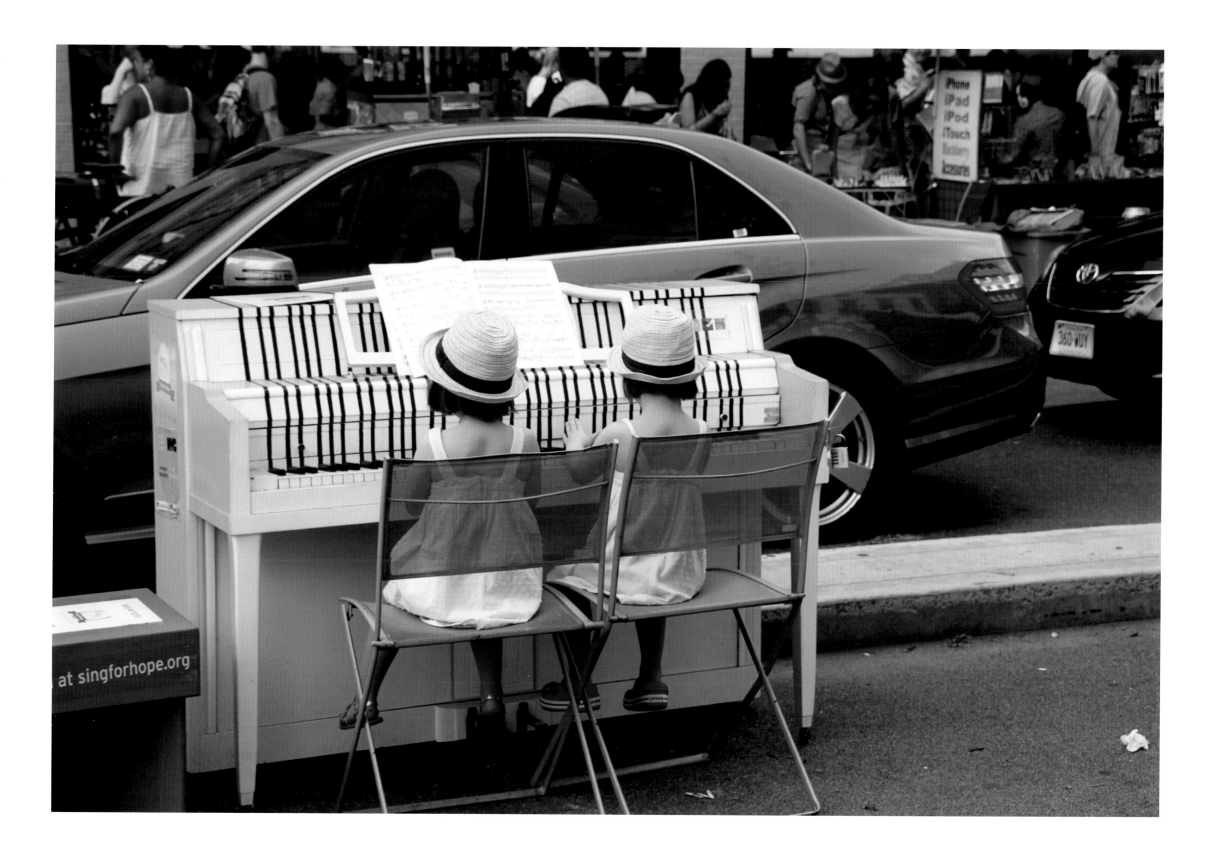

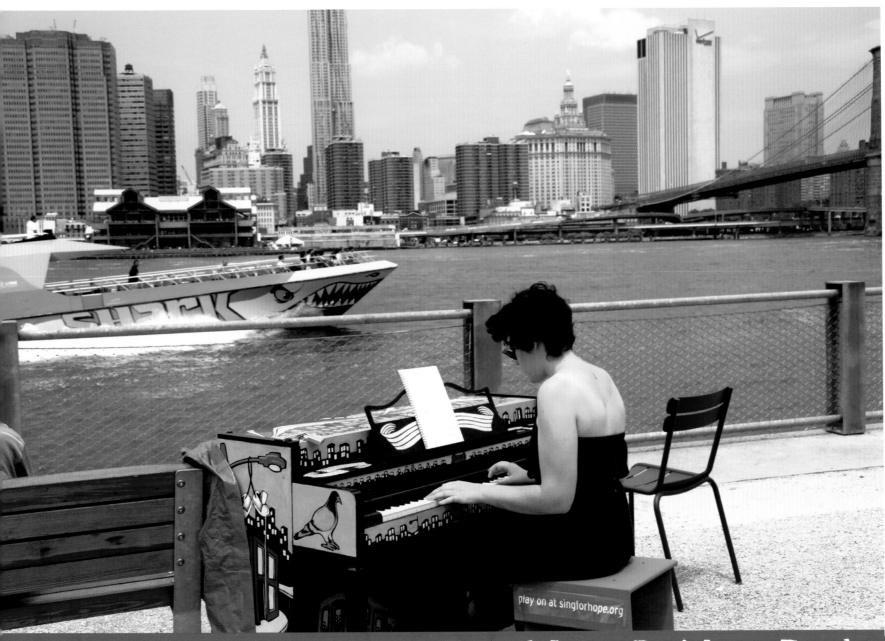

My artist is: Adam Suerte

My keys were at:
Brooklyn Bridge Park,
along riverfront

My name is: Brooklyn Love

This is what my
artist says about me:
Brooklyn and music are
great sources of inspiration
for me. I have created a melding
of the two. An homage to
the creative spirit that lives
in the County of Kings.

You can find my artist at:
www.adamsuerte.com

My community buddy is:
Brooklyn Bridge Park

My new home is:
This piano was auctioned to
fund Sing for Hope's Art U!
program that brings arts
education to under-resourced
youth in New York City.

Brooklyn Bridge Park, Brooklyn

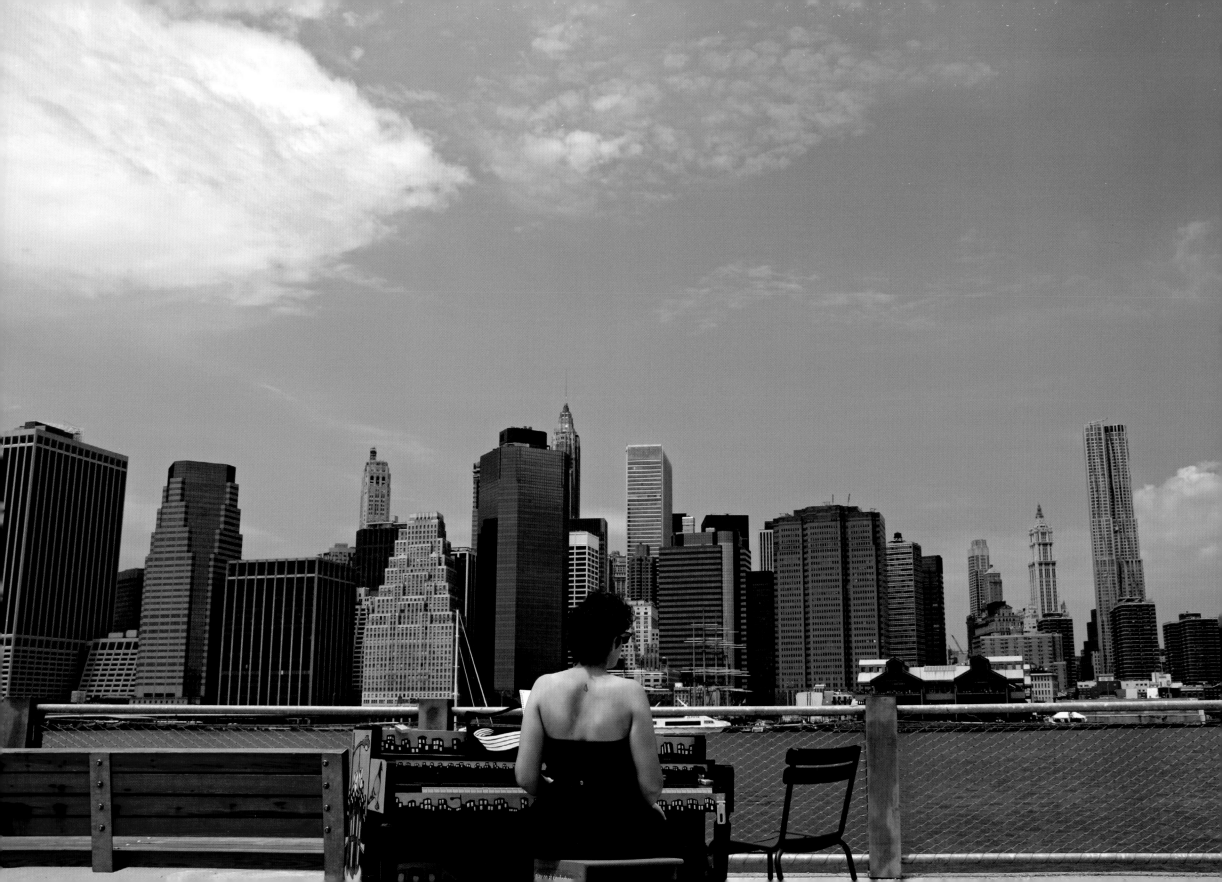

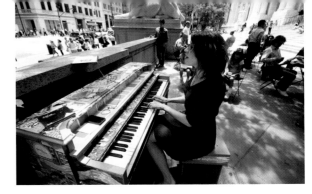

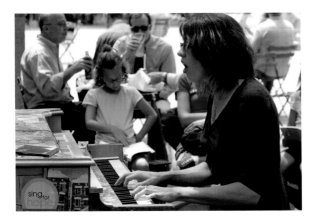

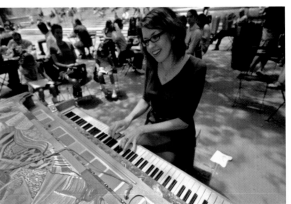

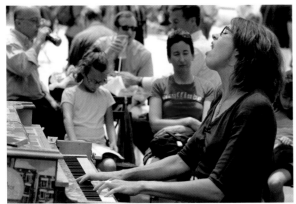

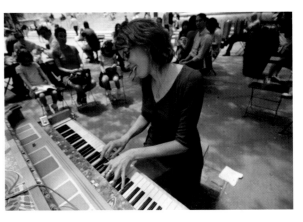

My artist is: Jillian Logue

My keys were at: 42nd Street and 5th Avenue

My name is: Subway Quilt

This is what my artist says about me:
My piano is inspired by the way people glance around
on the NYC subway cars, avoiding staring at anyone
for too long, and taking in a dizzying amount of tiny
bits of diverse people, objects, and activities.

You can find my artist at:
www.jillianlogue.carbonmade.com

My community buddy is:
New York Public Library, International Arts Movement

My new home is:
Betances Community Center in the Bronx

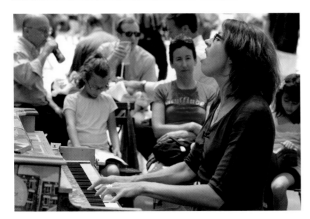

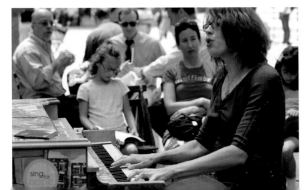

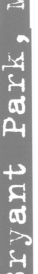

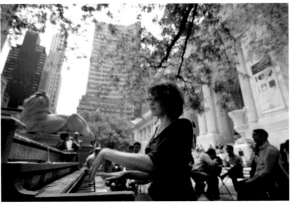

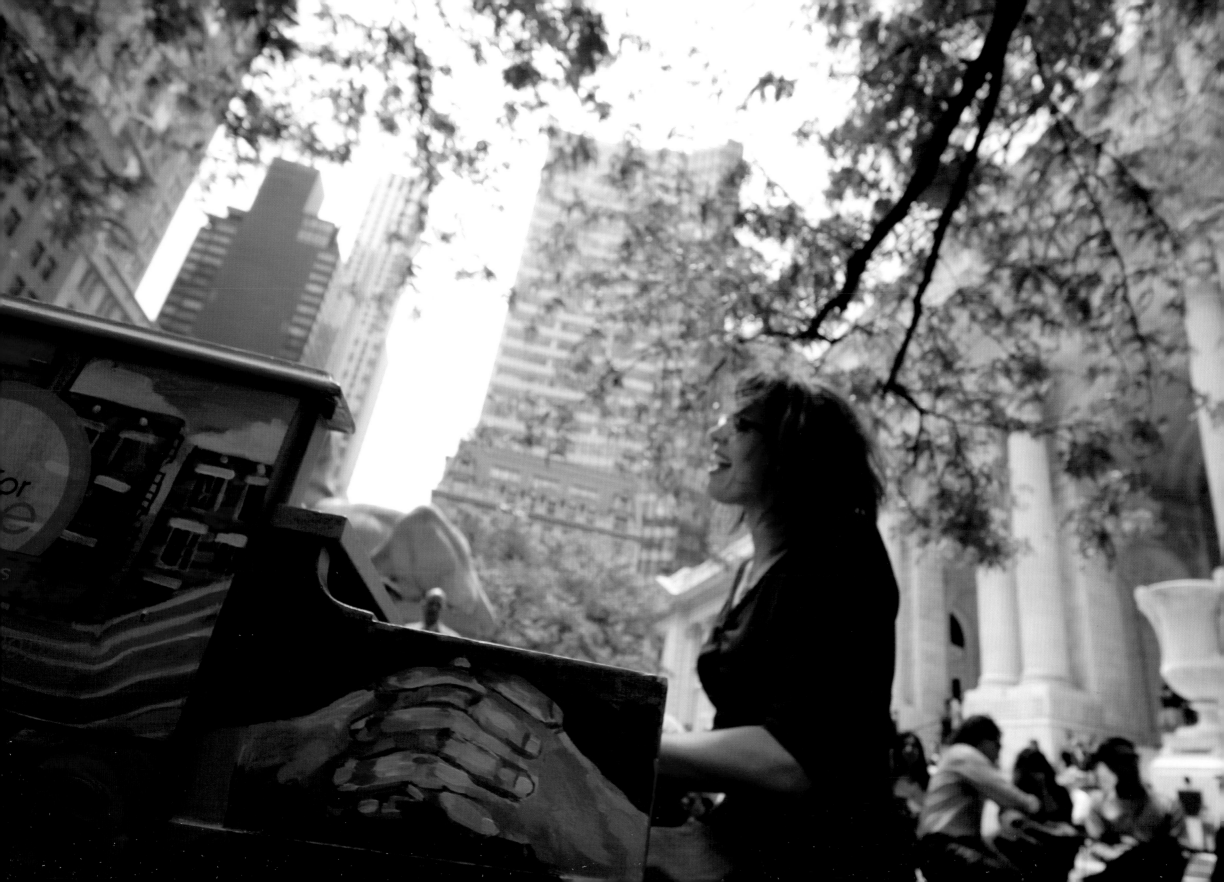

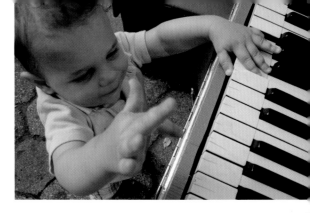

My artist is:
Moira Fain

My keys were at:
West 67th Street and Central Park West

My name is:
Pedal To The Metal

This is what my
artist says about me:
My piano represents
"the metals I have loved:"
Airstreams and Subway Cars!

You can find my artist at:
www.moirafain.com

My community buddy is:
NYC Parks, Central Park Conservancy

My new home is:
This piano was auctioned to fund
Sing for Hope's Art U! program that
brings arts education to under-resourced
youth in New York City.

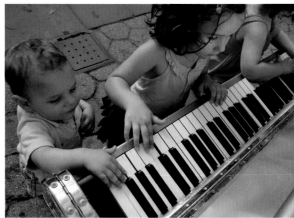

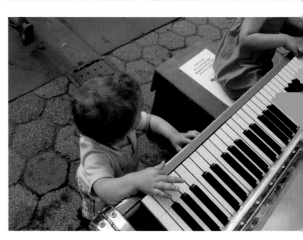

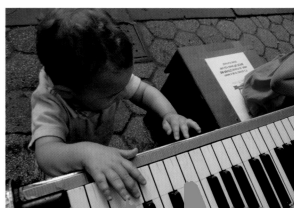

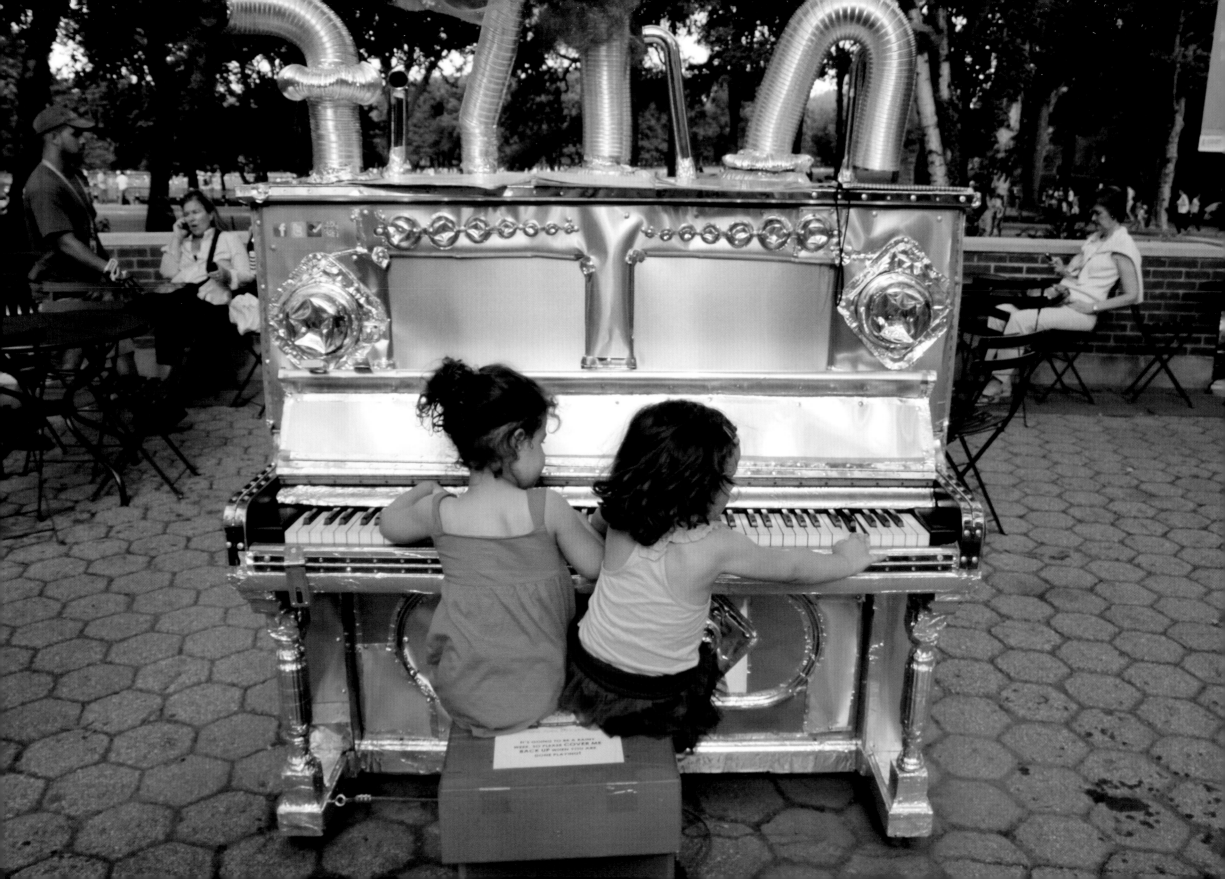

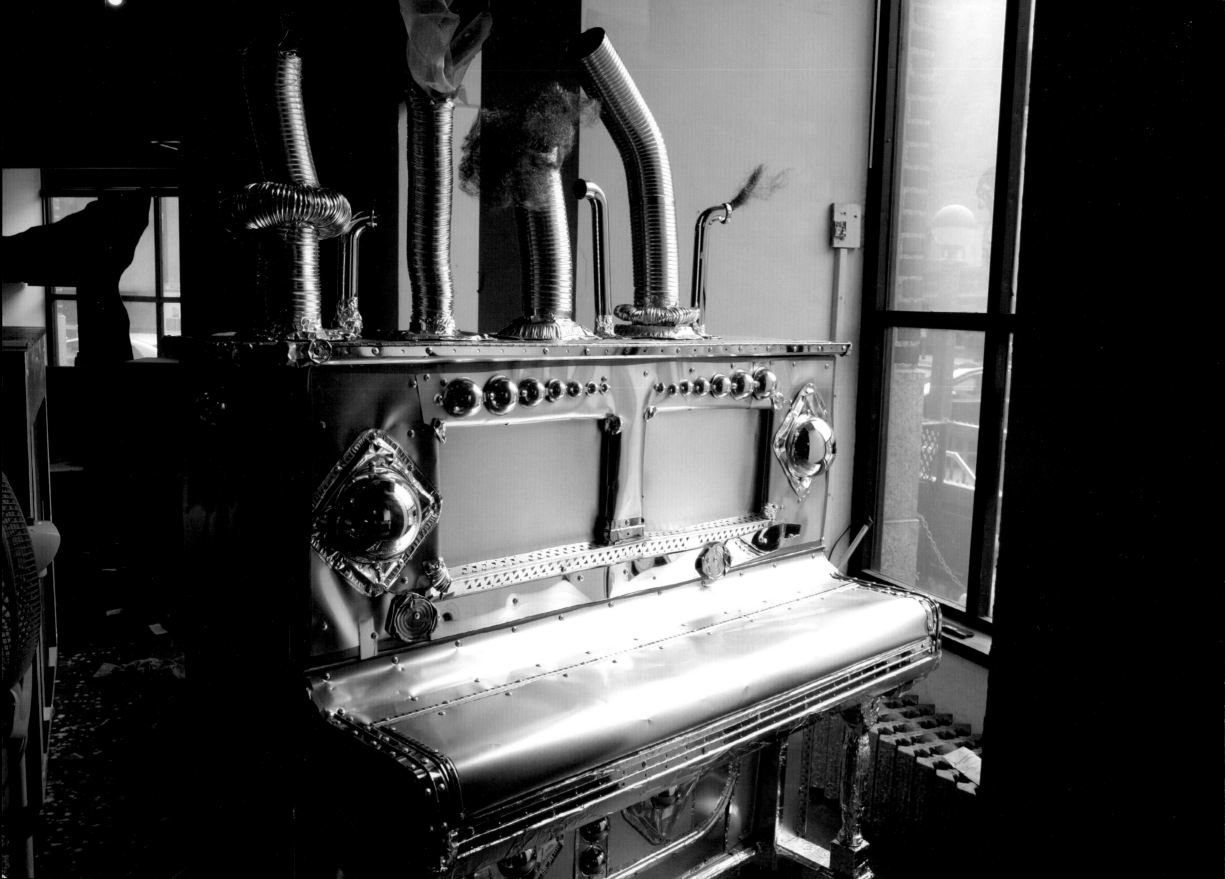

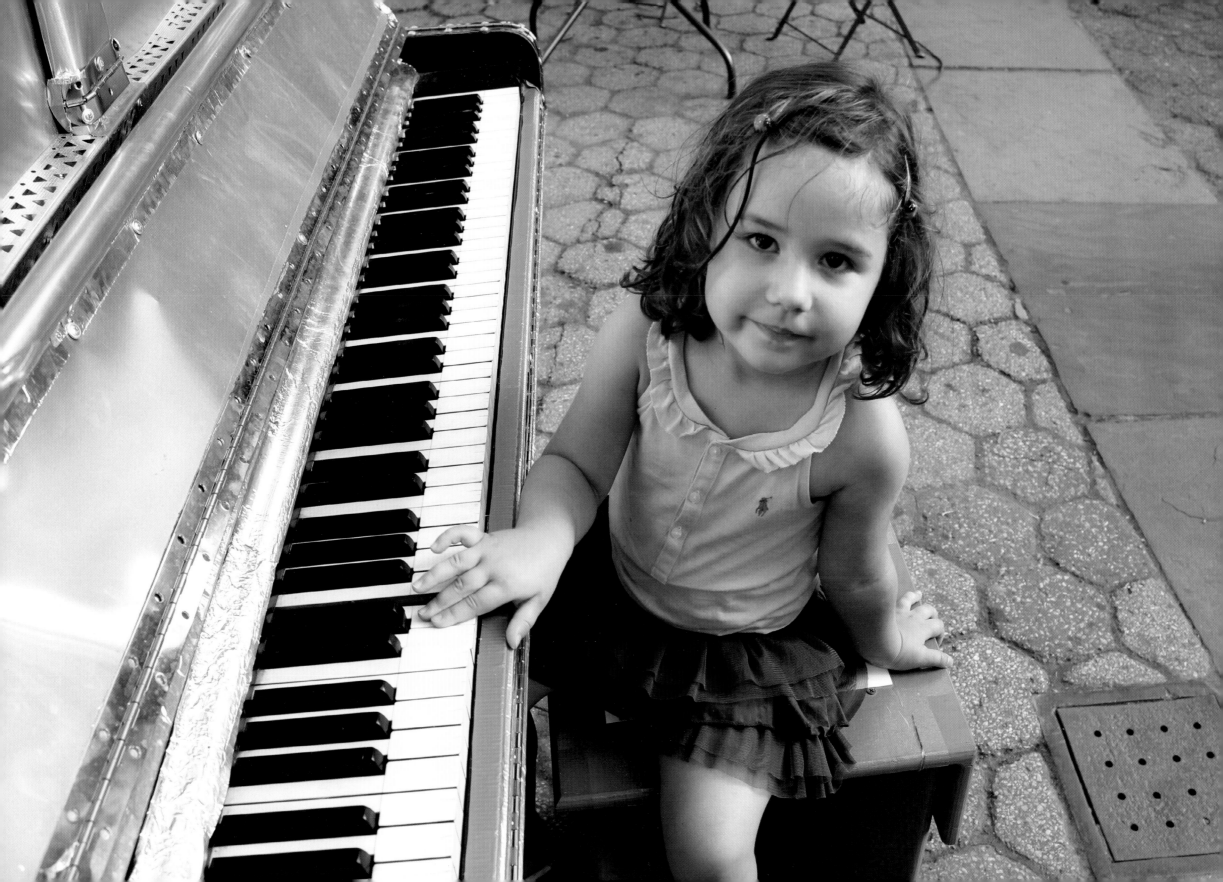

My artist is: Isaac Mizrahi

My keys were at:
Broadway and 33rd Street

My name is: Hello Miss Piano

This is what my artist says about me:
A shocking shade of pink, showered
in glitter and adorned with a larger-
than-life bow. They're my favorite three
things. I don't know what inspires them
except the 12-year-old girl who is
deeply rooted in my soul.

You can find my artist at:
www.isaacmizrahiny.com

My community buddy is:
Manhattan New Music Project

My new home is:
This piano was auctioned to
fund Sing for Hope's Art U!
program that brings arts
education to under-resourced
youth in New York City.

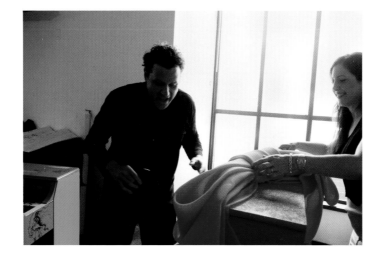
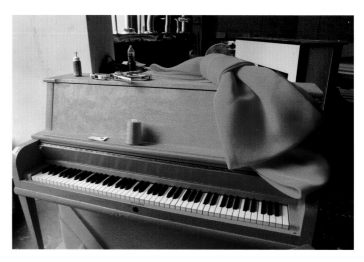

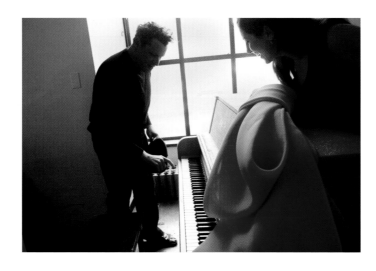
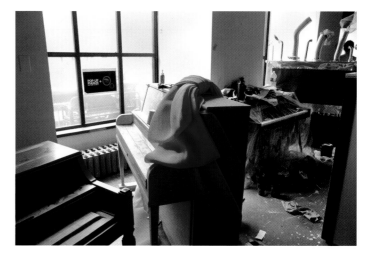

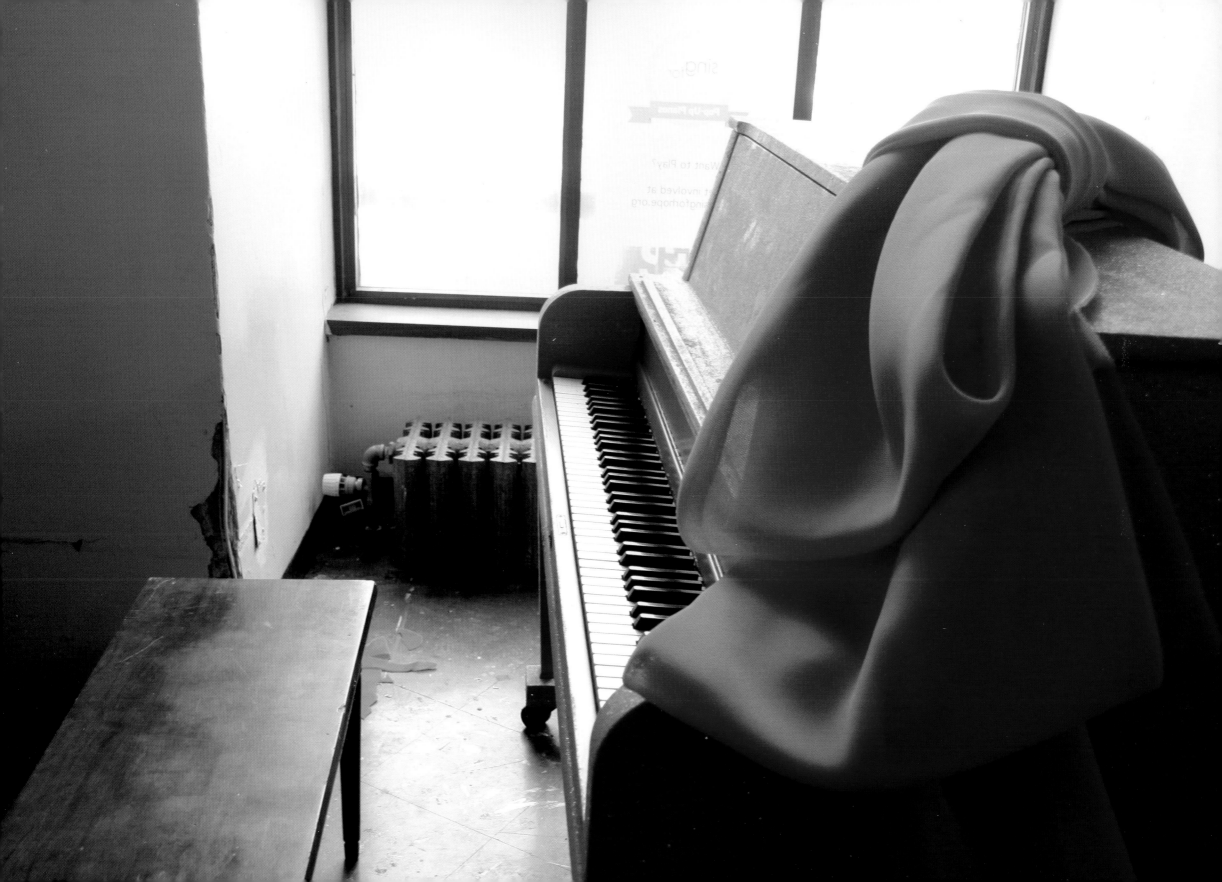

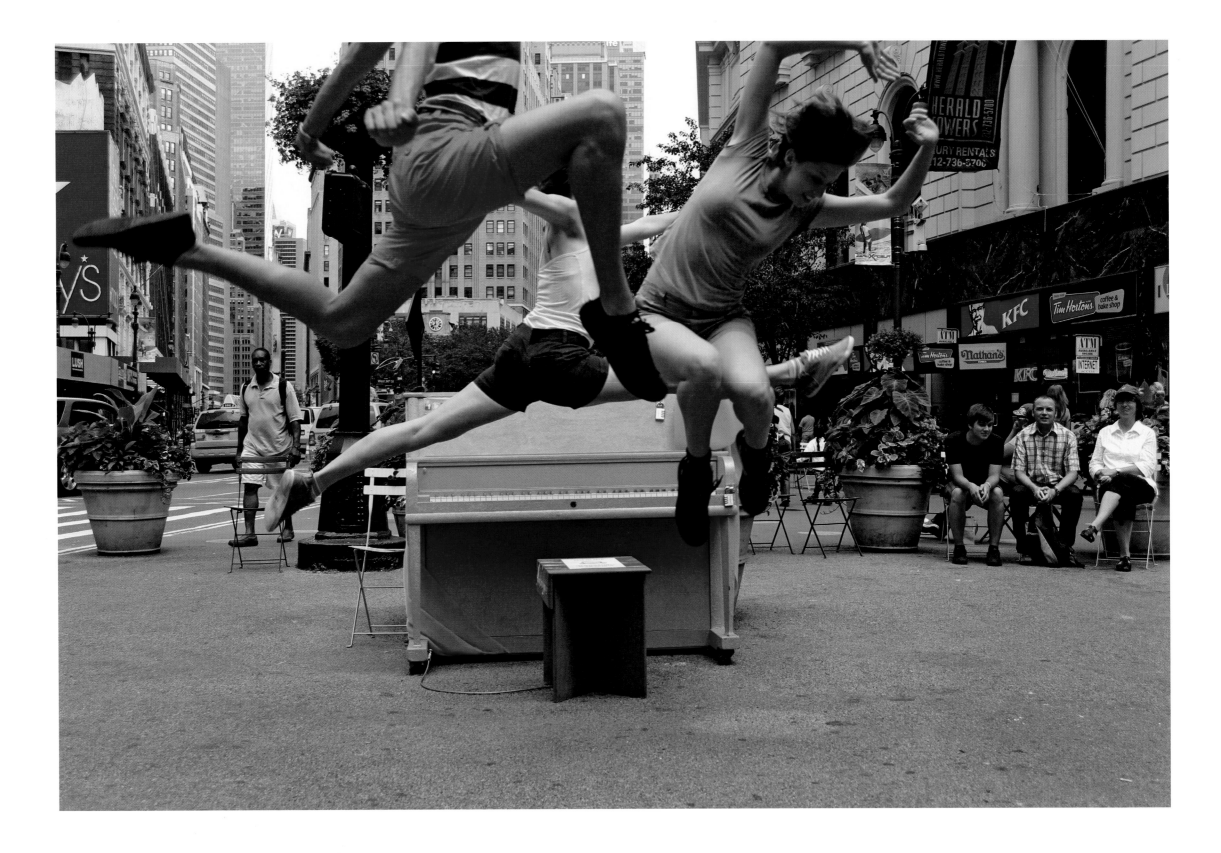

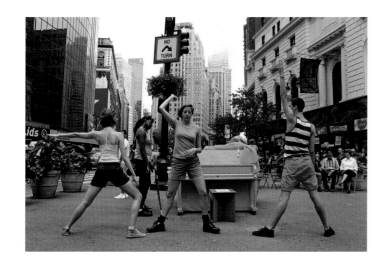
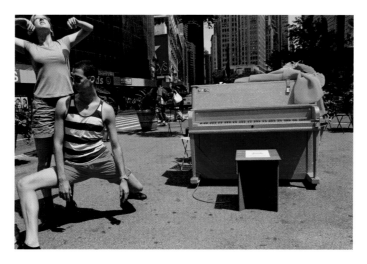
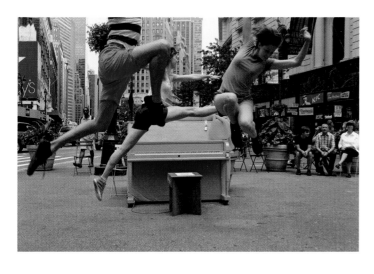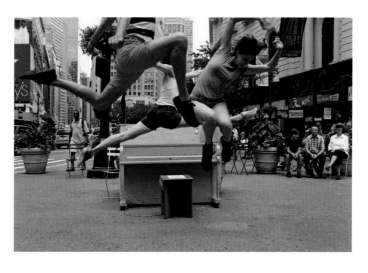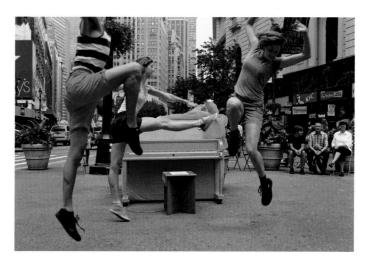

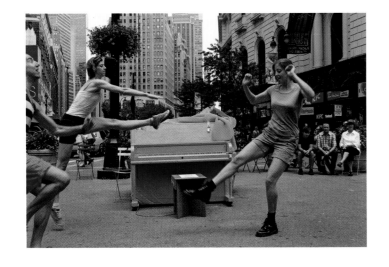 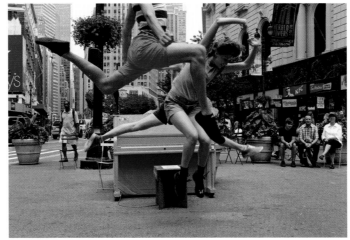 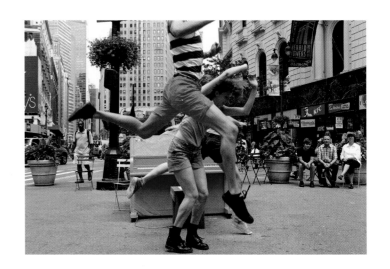
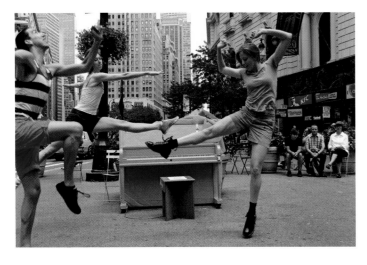 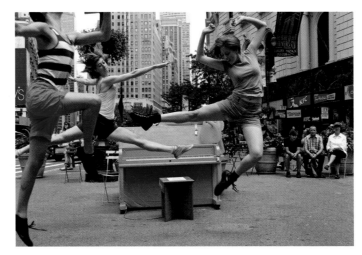 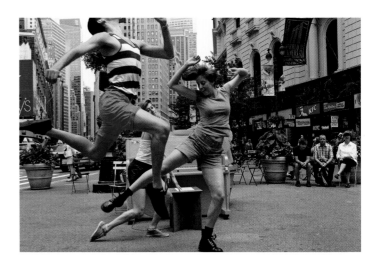
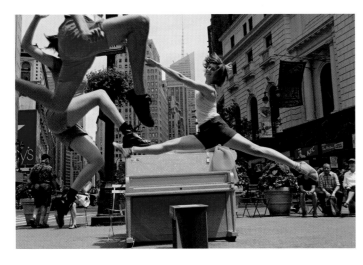 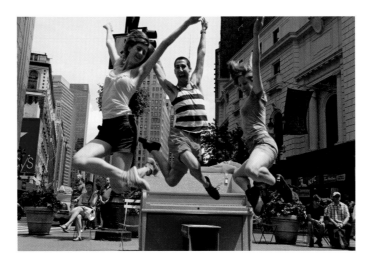 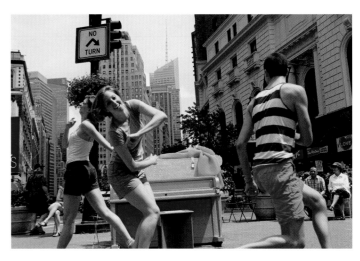

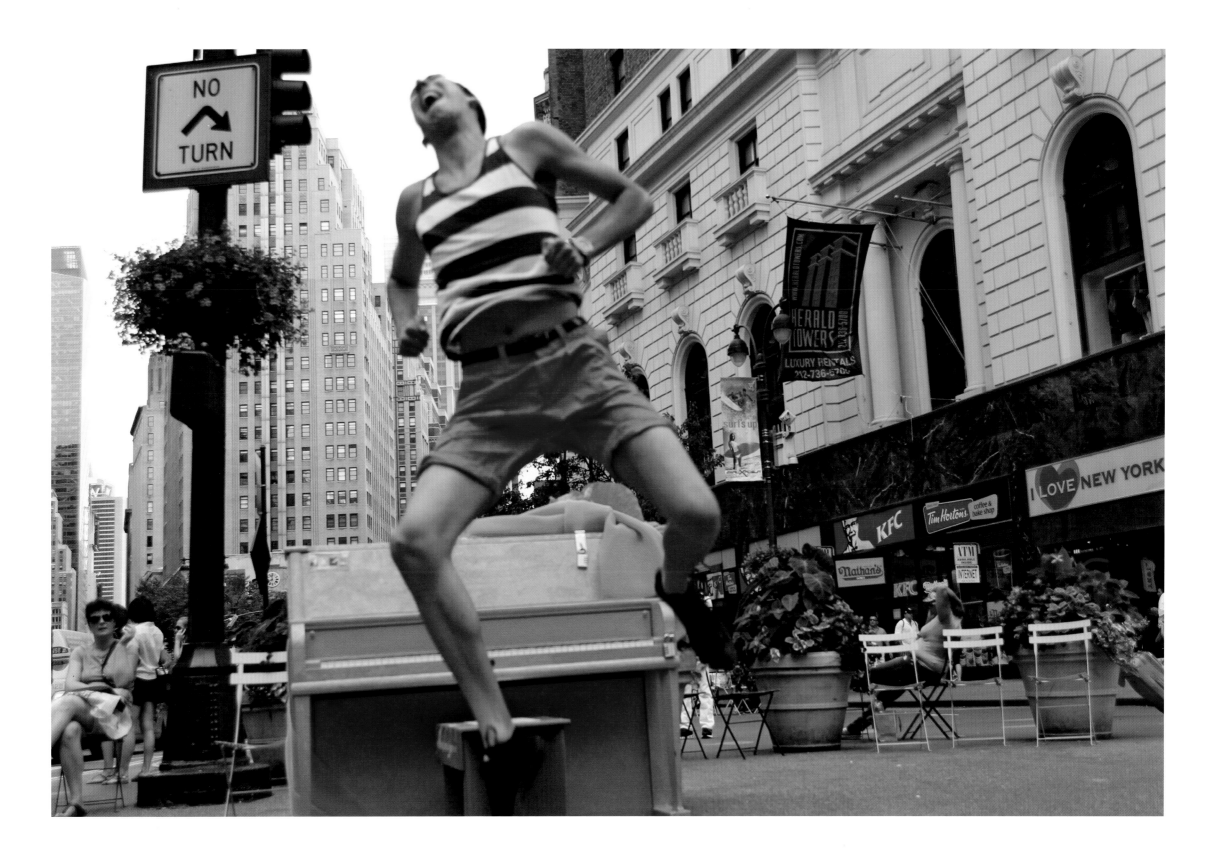

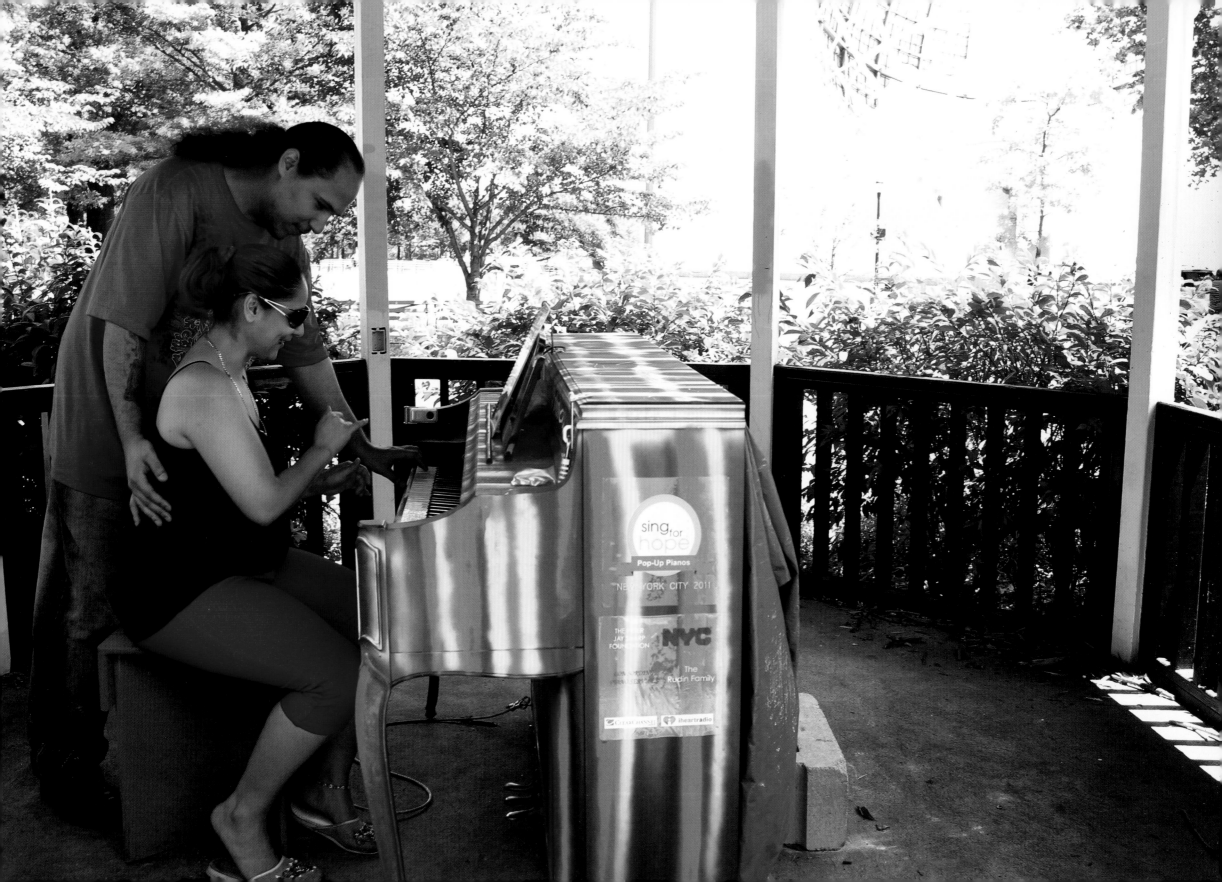

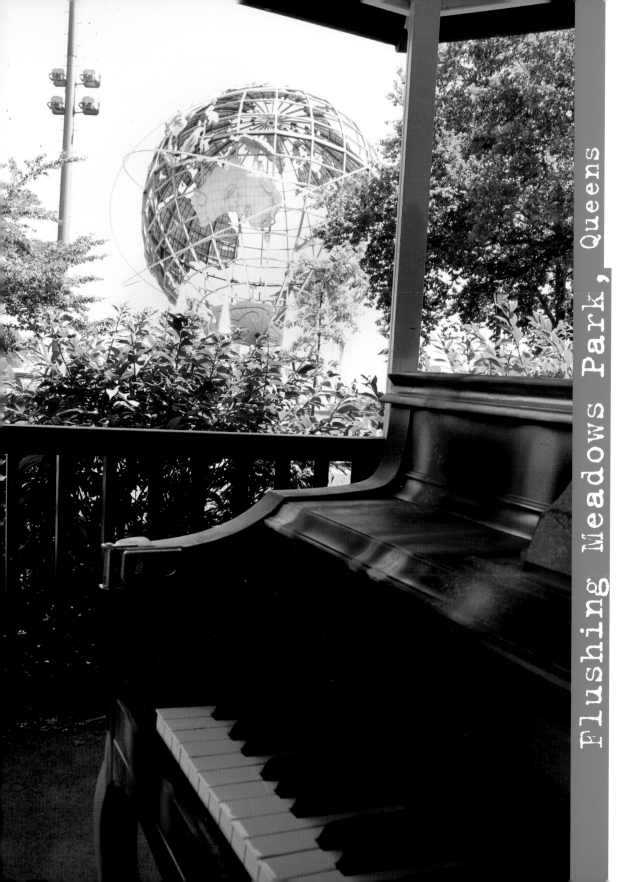

Flushing Meadows Park, Queens

My artist is:
Sing for Hope Teaching Artist Team

My keys were at:
In Flushing Meadows Park, by Unisphere

My name is:
All The World's A Stage

This is what my artist says about me:
Streaks of color, blazes of light.
Our piano is New York lights, it's a
fast-paced blur. It's the mad, beautiful
energy of our city in all its glory.

You can find my artist at:
www.singforhope.org

My community buddy is:
Queens Theatre

My new home is:
Queens Theatre

 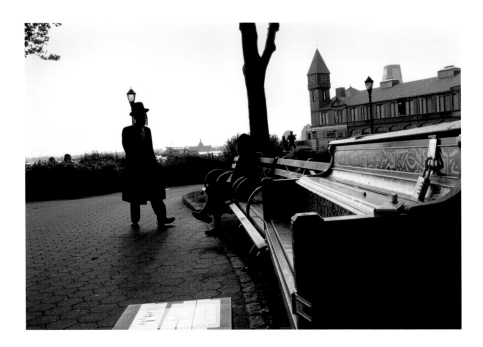

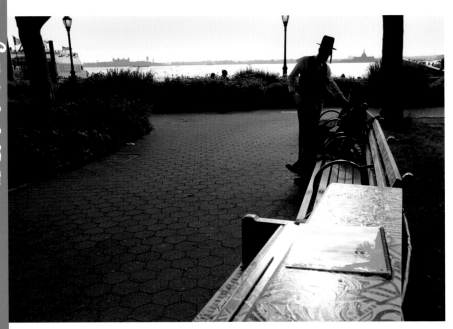 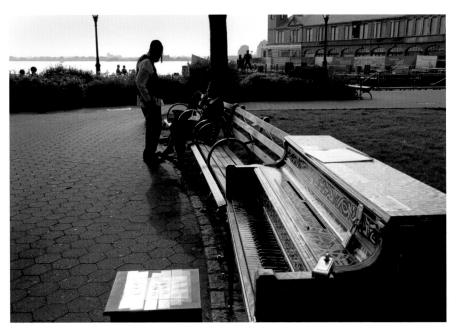

My artist is:
Zeke Decker

My keys were at:
Near Battery and West Street

My name is:
Tribute To Elsworth Ausby

This is what my
artist says about me:
I have painted my piano
in the memory of the great
artist/teacher Elsworth Ausby,
honoring him through the
reinterpretation of form,
color, line, and texture.

You can find my artist at:
www.zekebeginsnow.net

My community buddy is:
NYC Parks, The Battery
Conservancy

My new home is:
New York City Housing
Authority Youth Chorus

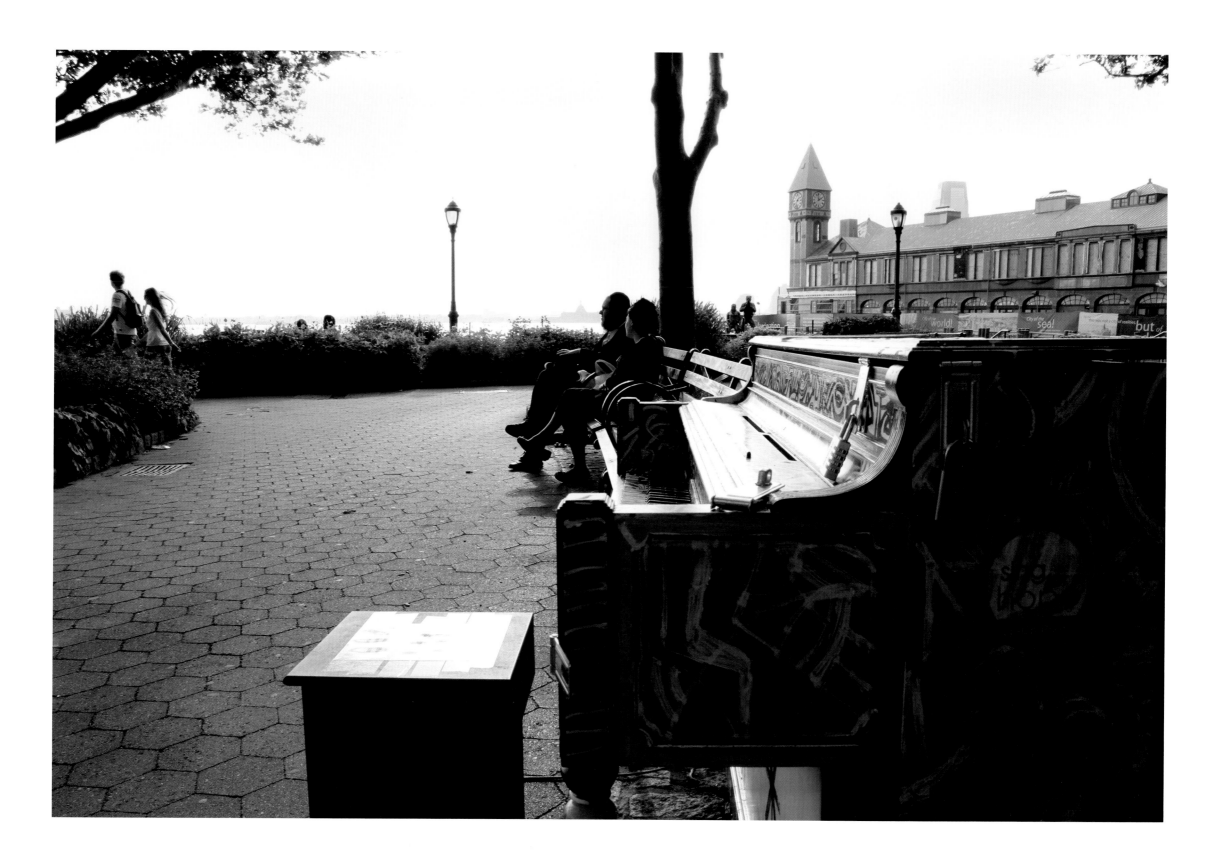

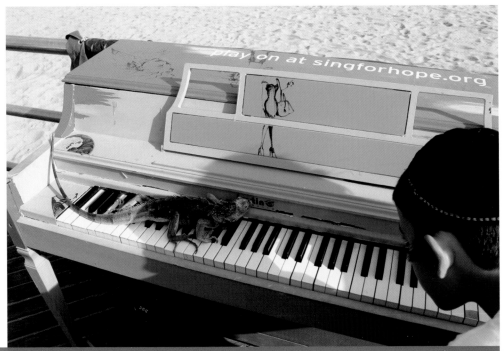

Coney Island Boardwalk, Brooklyn

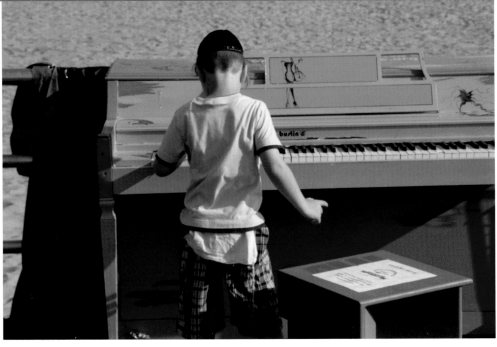

My artist is: Matt Allamon

My keys were at: Coney Island Boardwalk at West 15th Street

My name is: That Girl

This is what my artist says about me:
What song comes to mind when looking at these characters?
Which characters would you add? Friends, or just more
accessories? In what color Sharpie? Color me!

You can find my artist at: www.mattallamon.com

My community buddy is: NYC Parks

My new home is: P.S. 132

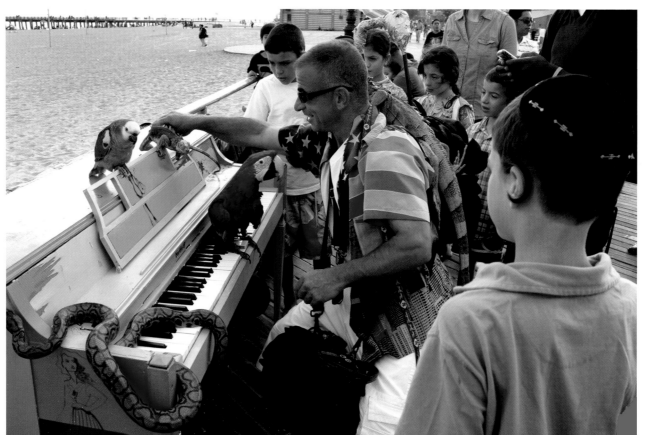

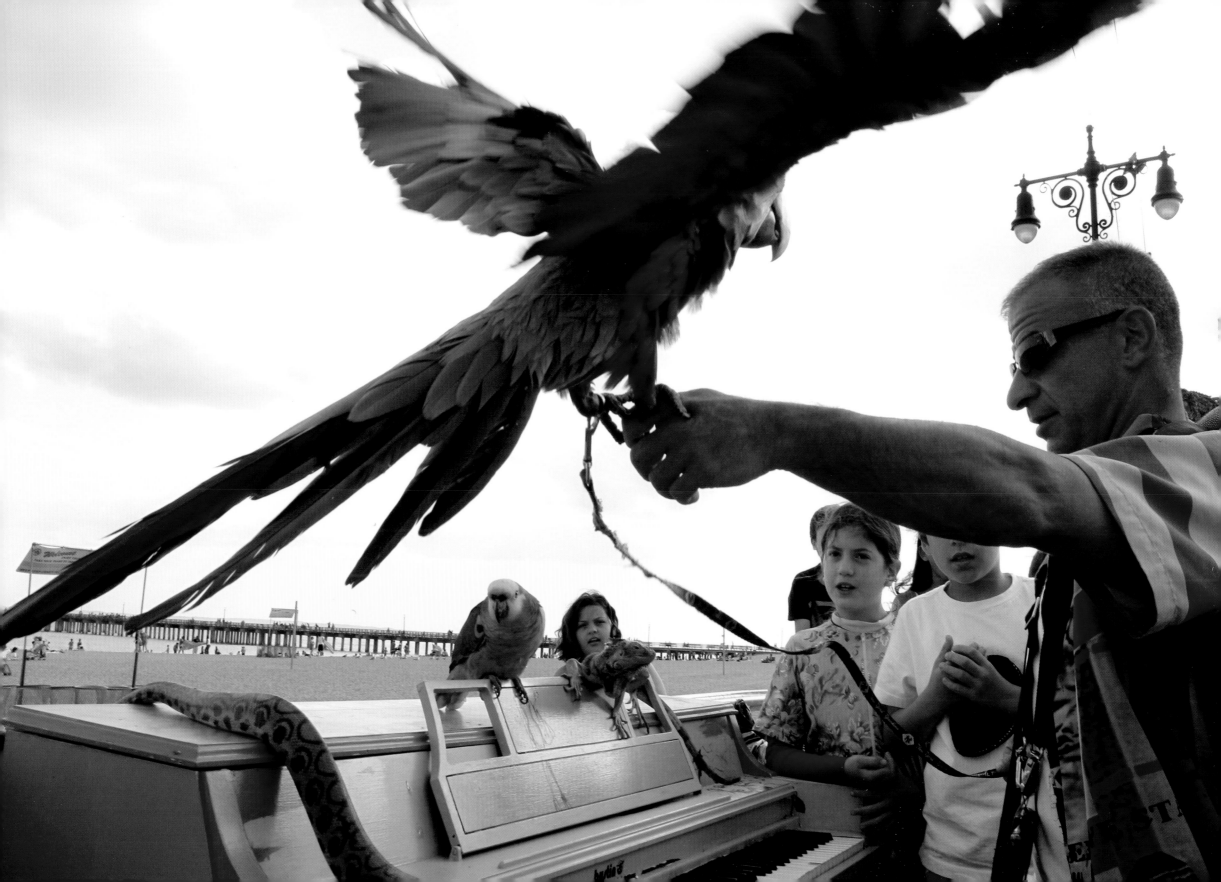

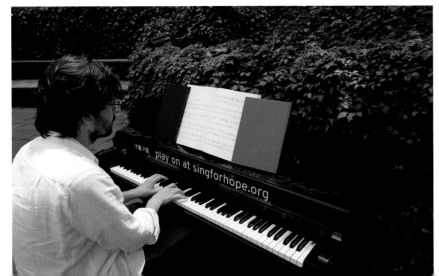

My artist is:
Sara Forney and Lex Liang

My keys were at:
Saint John the Divine,
West 111th Street and Amsterdam Avenue

My name is: Winged Victory

This is what my artist says about me:
Winged Victory is inspired by our fascination with
textures, particularly those occurring in nature
and sought after for their unique beauty. We approached
the piano with an attempt to capture the myriad facets
of the instrument itself: classicism, timelessness,
glamour, and a little bit of rock 'n' roll.

You can find my artist at:
www.lexliang.com

My community buddy is:
Cathedral Church of St. John the Divine

My new home is:
The Urban Assembly School of the Performing Arts

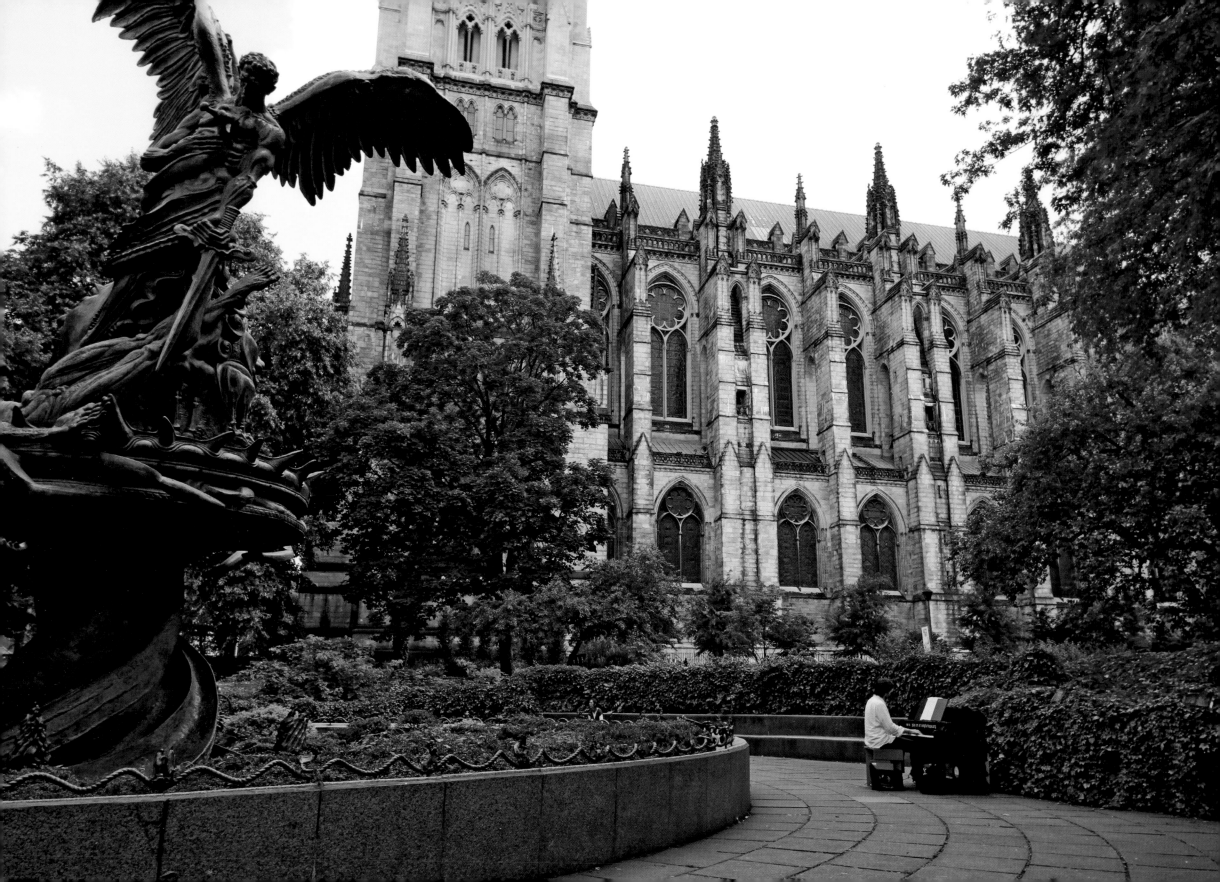

My artist is: Richard Fine

My keys were at: Grand Army Plaza

My name is: This Too Shall Pass

This is what my artist says about me:
This Pop-Up Piano is about the passing of time and its inevitability. The bits of paper collaged upon this piano show us that the problems of the past always become the possibilities of the future.

My community buddy is: NYC Parks

My new home is:
Brooklyn Academy of Science and the Environment

Prospect Park Grand Army Plaza, Brooklyn

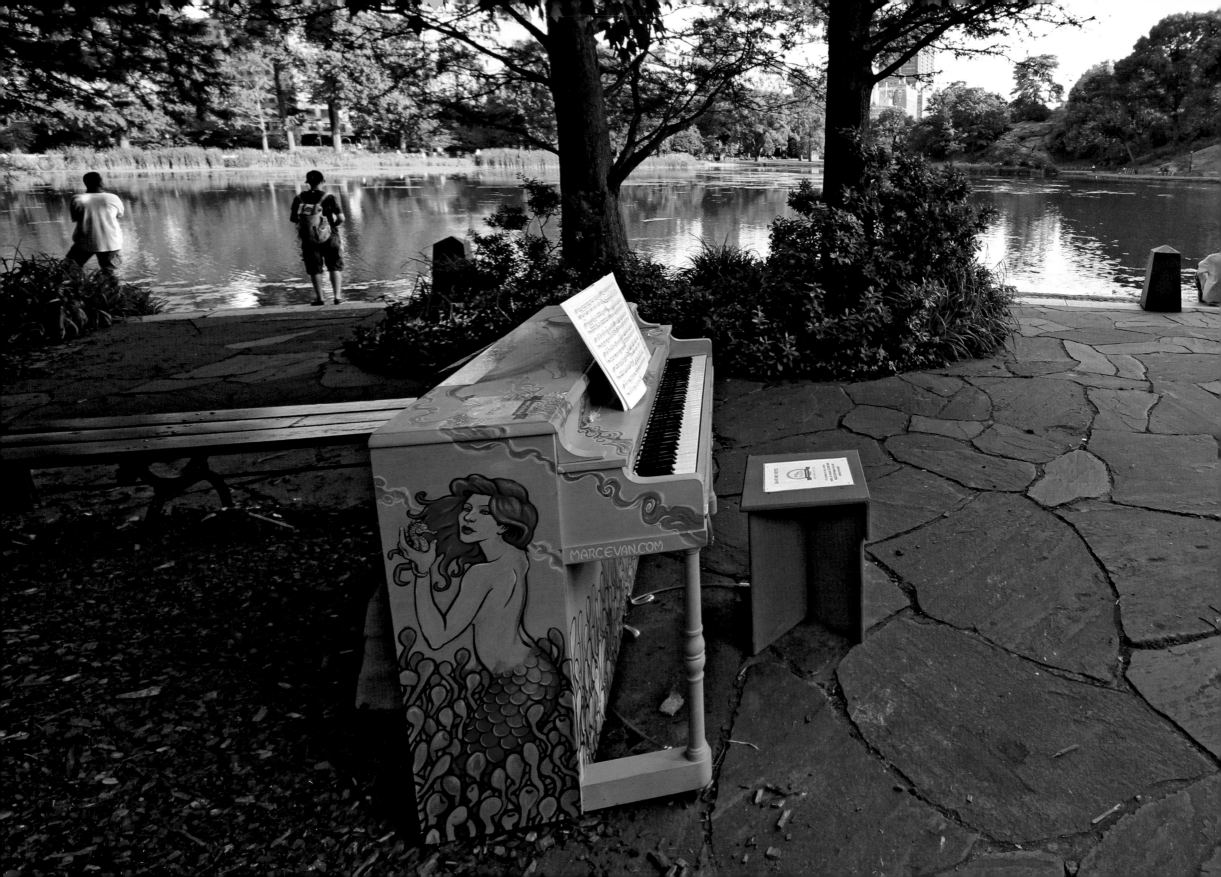

My artist is: Marc Evan

My keys were at: East 110th Street between
Malcolm X Boulevard and 5th Avenue

My name is: Whale Song

This is what my artist says about me:
The aquatic realm is rhythmic, beautiful,
and alien. Sounds of the ocean and its
inhabitants have inspired folklore,
myths, and ages of the arts.

You can find my artist at:
www.marcevan.com

My community buddy is:
NYC Parks

My new home is:
NYC Public School System

Central Park Dana Discovery Center, Manhattan

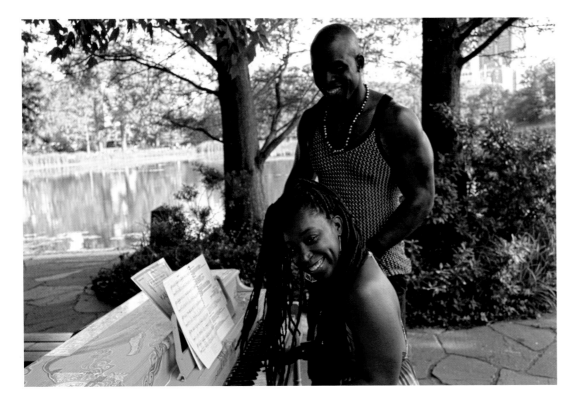

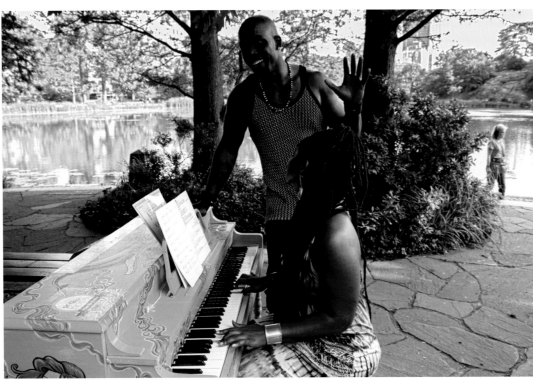

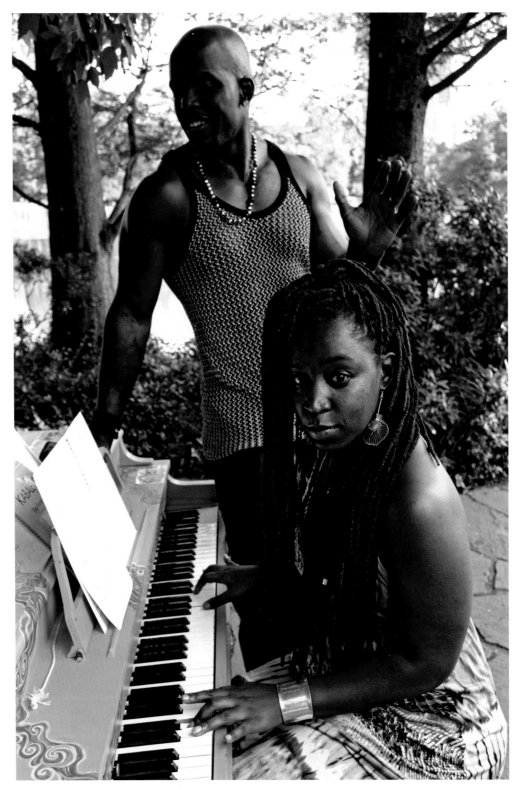

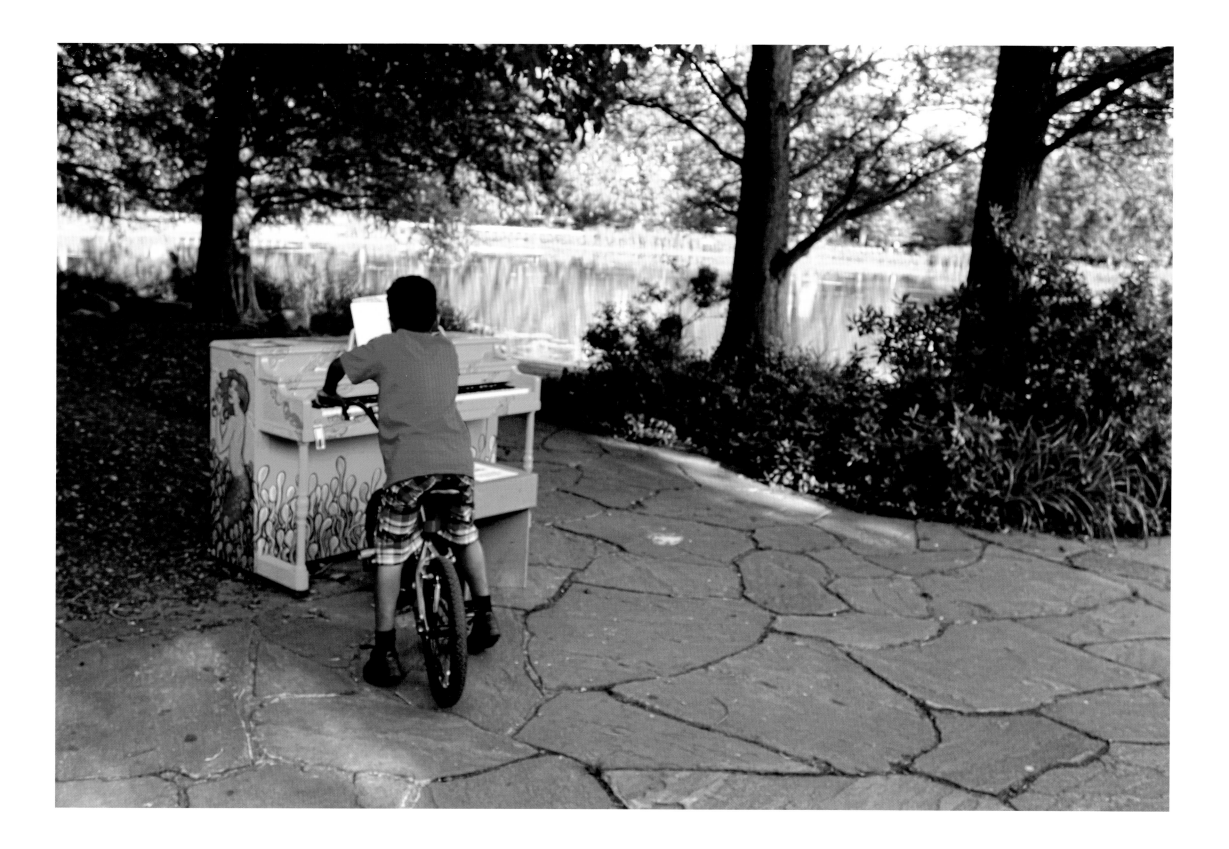

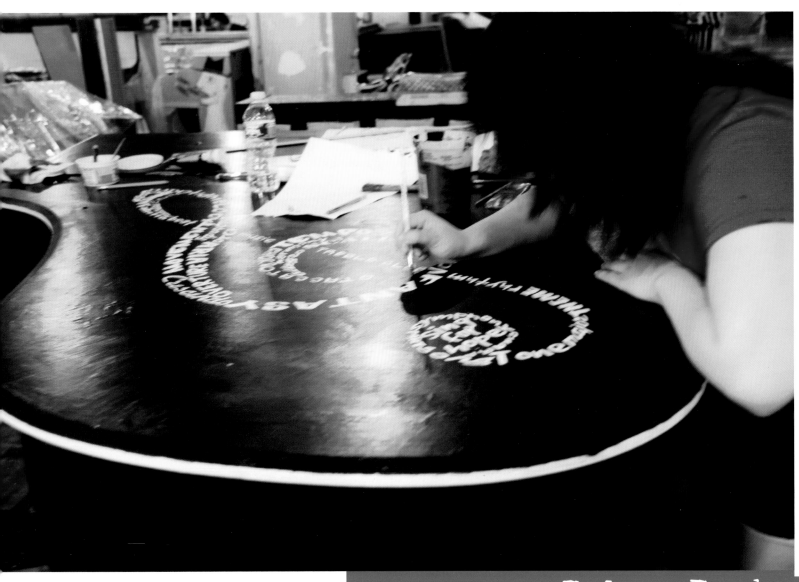

My artist is:
Ai Ling Loo

My keys were at:
Richmond Terrace and Sharpe Avenue

My name is:
Music, Text, Art

This is what my
artist says about me:
I shall paraphrase a quote
by Aaron Copland:
"Is there a meaning to music?
Yes. Can you state in so
many words what the
meaning is? No."

My community buddy is:
NYC Parks

My new home is:
Faber Park and Pool

Faber Park, Staten Island

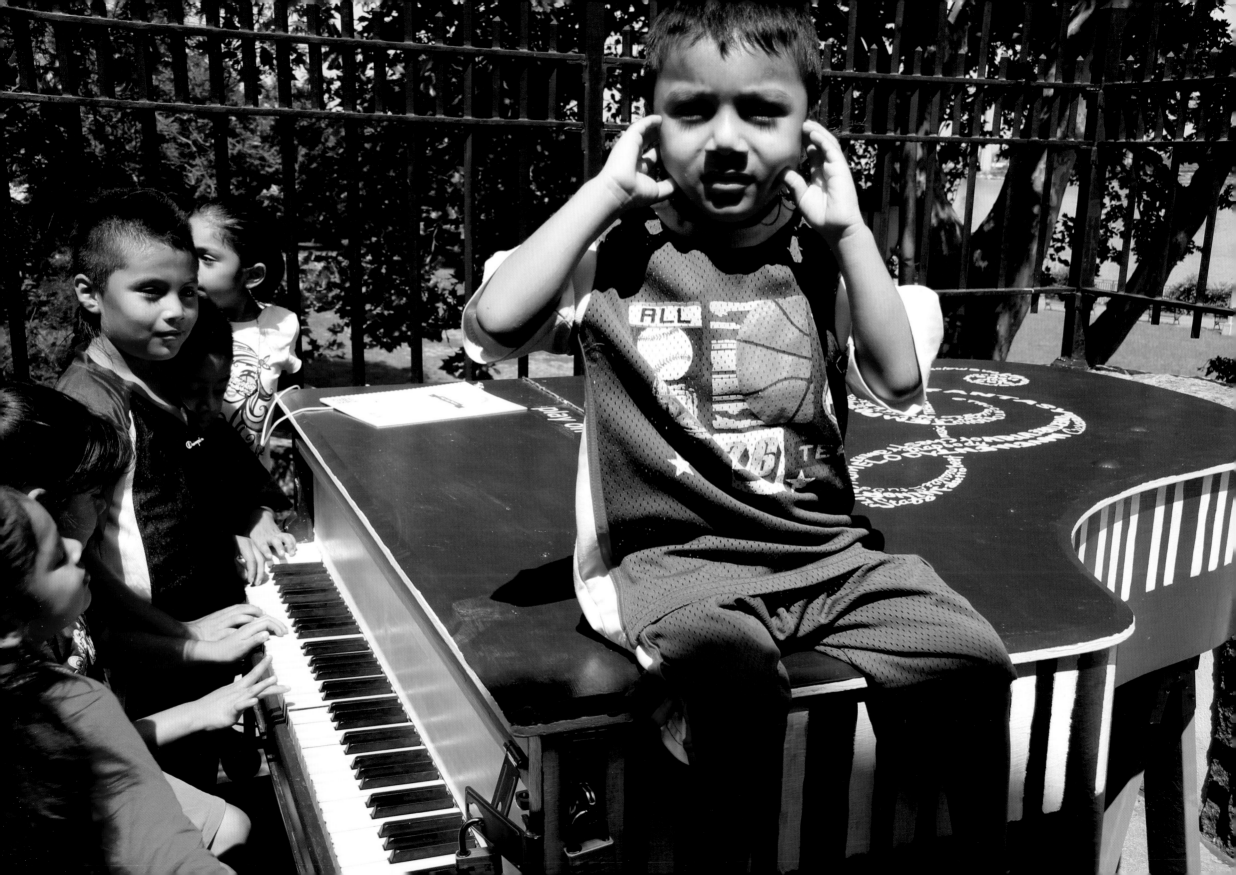

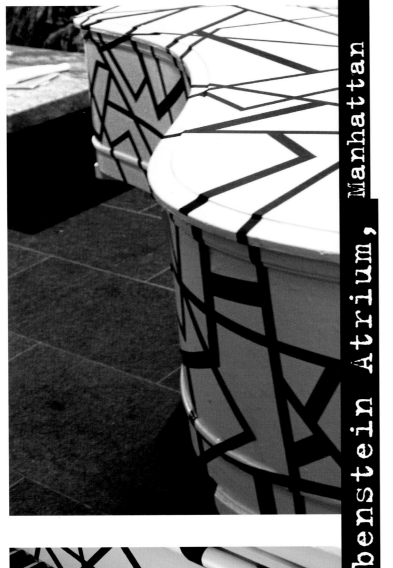

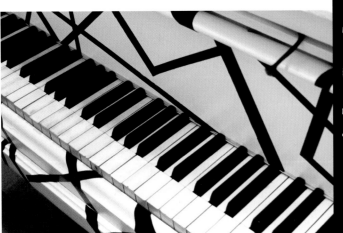

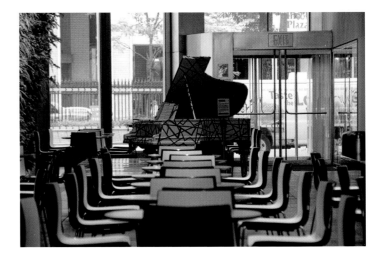

My artist is: Scott Taylor

My keys were at:
Lincoln Center, West 62nd Street and Broadway

My name is: Manhattan Rhapsody

This is what my artist says about me:
Inspired by the music of NYC's intersecting
ideas, streets, cultures and people.

You can find my artist at: www.scotttaylorart.com

My community buddy is: Lincoln Center

My new home is: This piano was auctioned
to fund Sing for Hope's Art U! program that
brings arts education to under-resourced
youth in New York City.

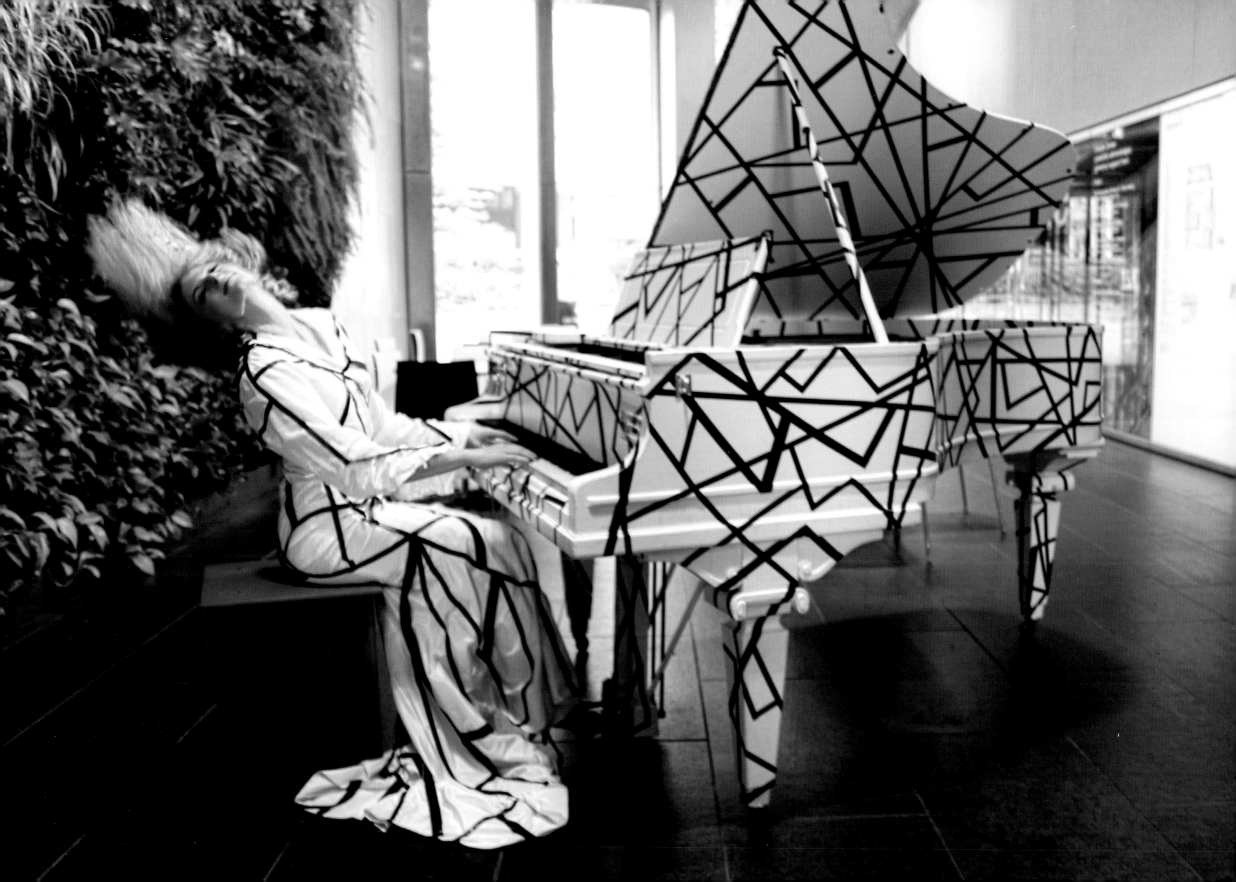

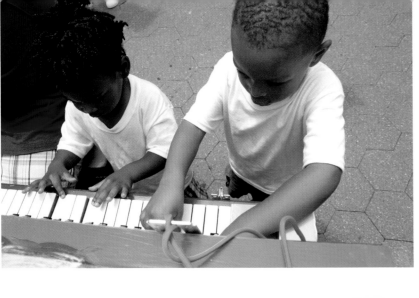

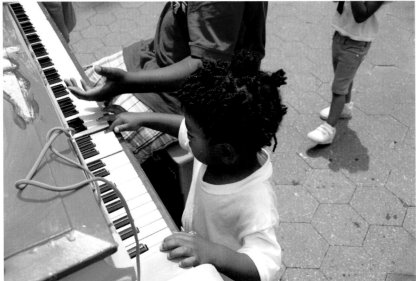

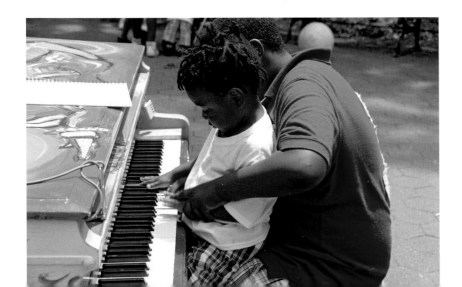

My artist is: NycArtsCypher: Geoff Rawling, Athena Zhe, Wolfman, Diana Sorkin, Gano Grills, and Charlie Balducci

My keys were at: Water Street and Beach Street

My name is: Entertain Your Imagination

This is what my artist says about me: The piano was our collaborative effort, reflecting a diverse mix of arts and entertainment elements, old and new!

You can find my artist at: www.nycartscypher.com

My community buddy is: NycArtsCypher, Friends of Tappen Park

My new home is: NycArtsCypher

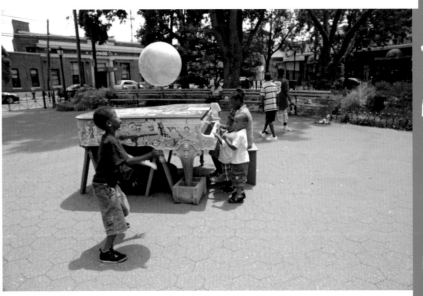

Tappen Park, Staten Island

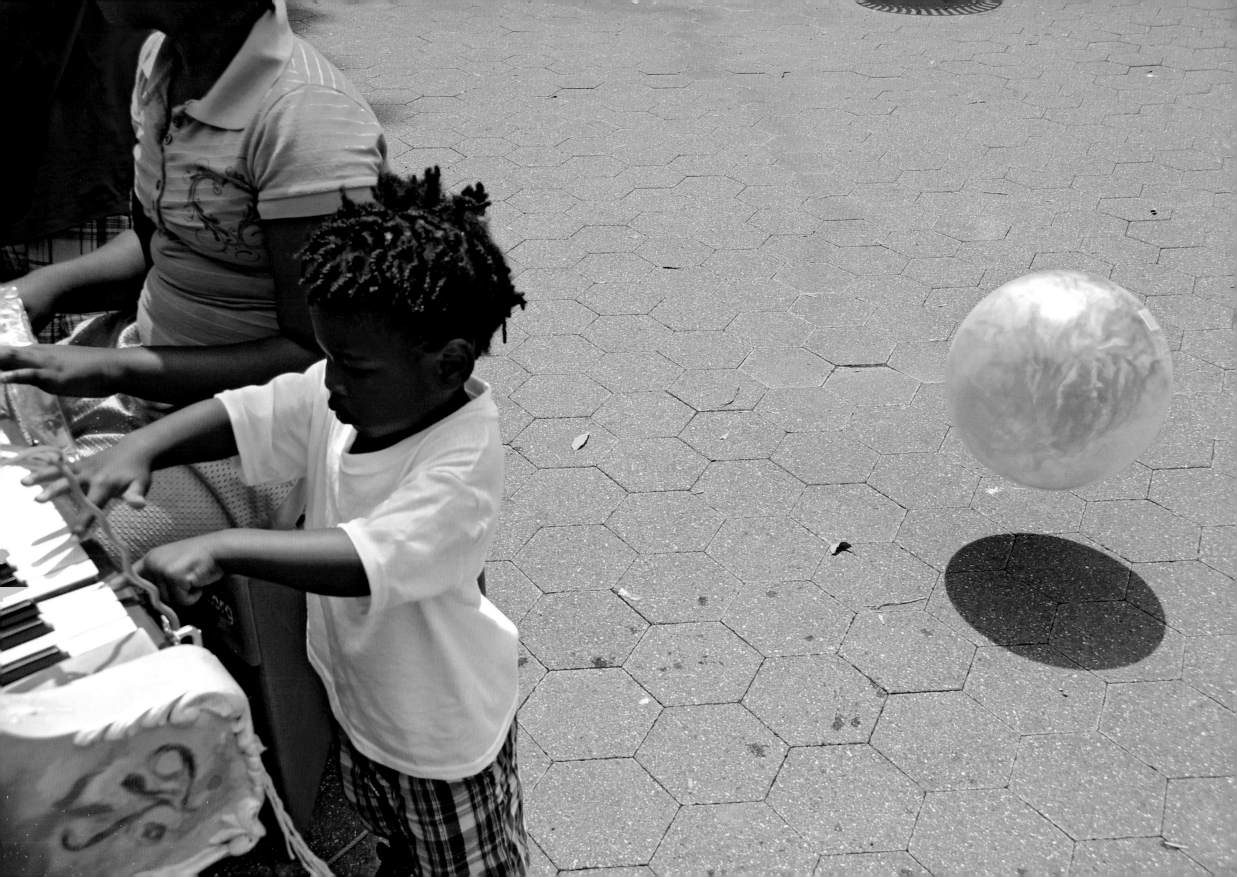

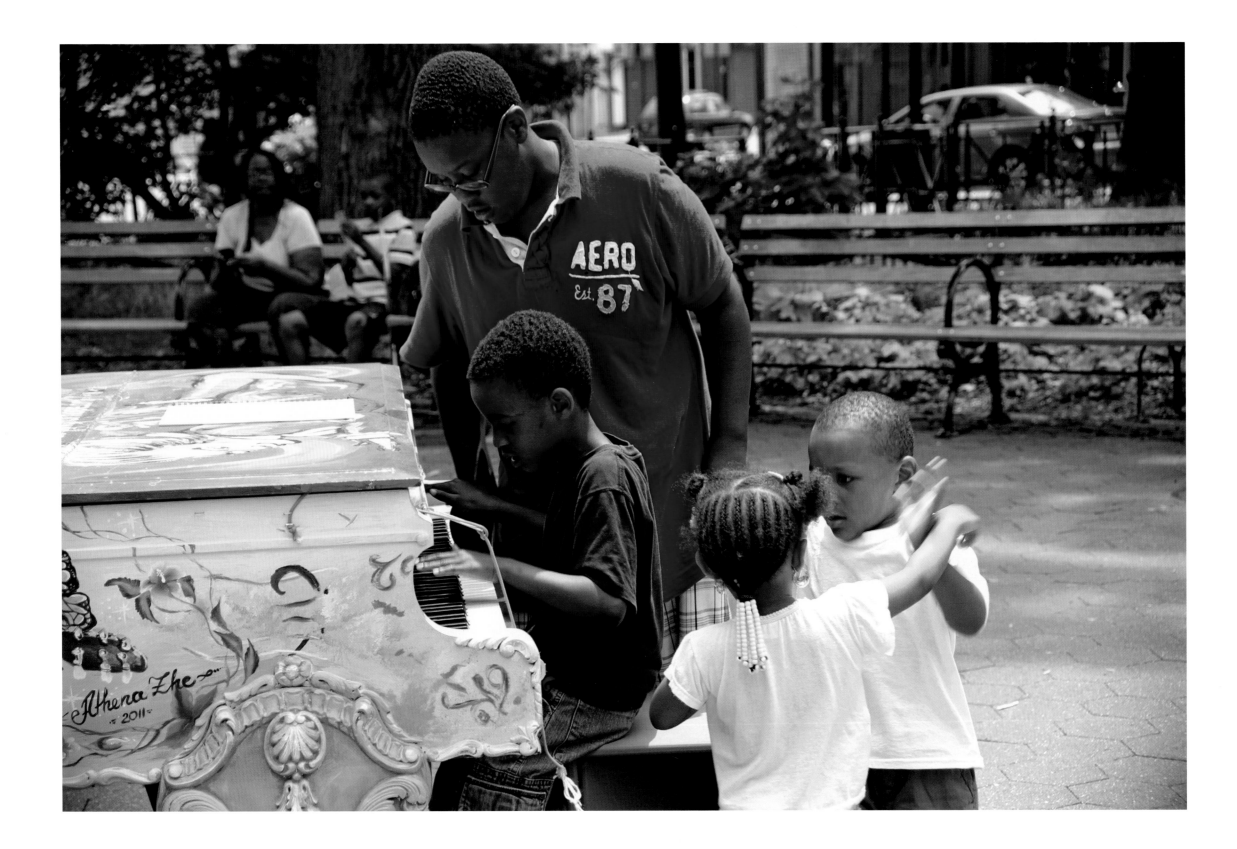

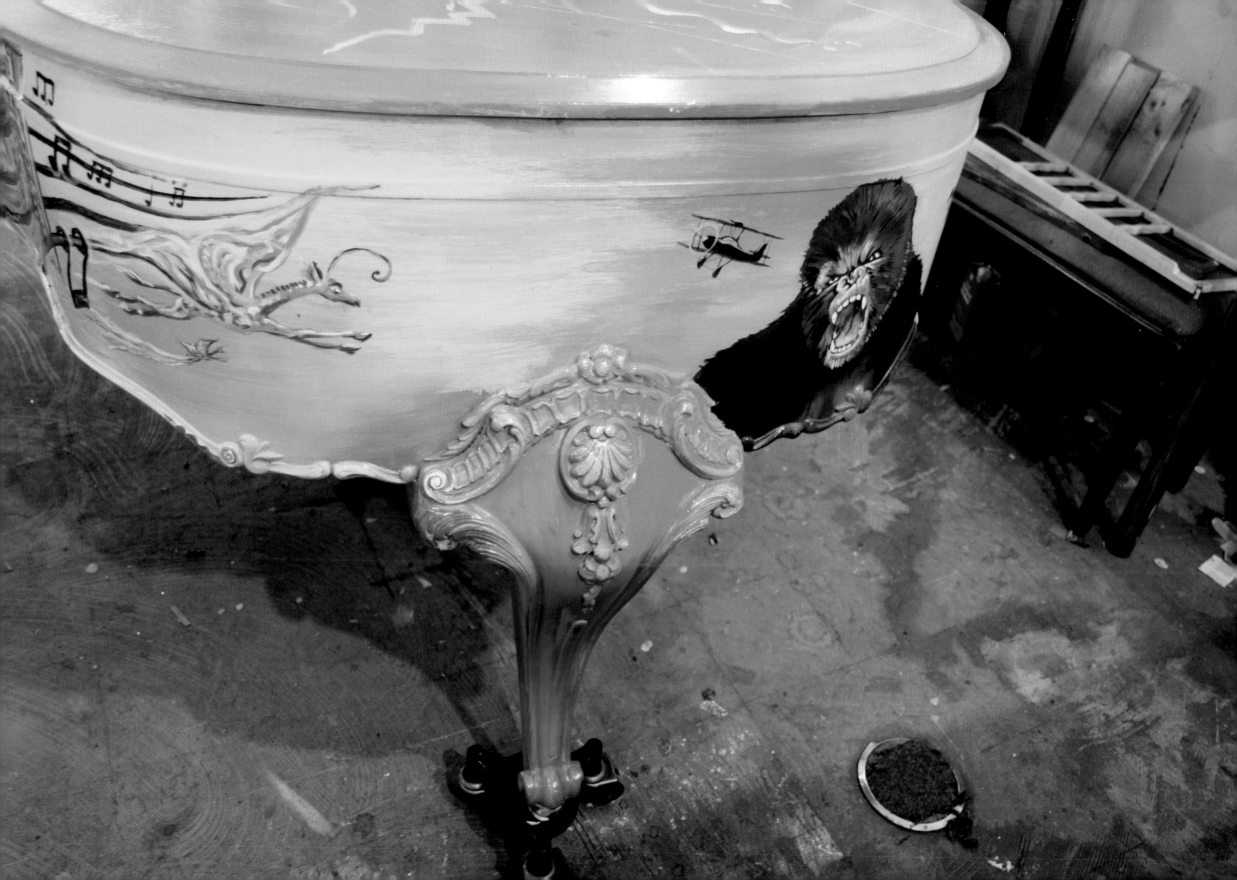

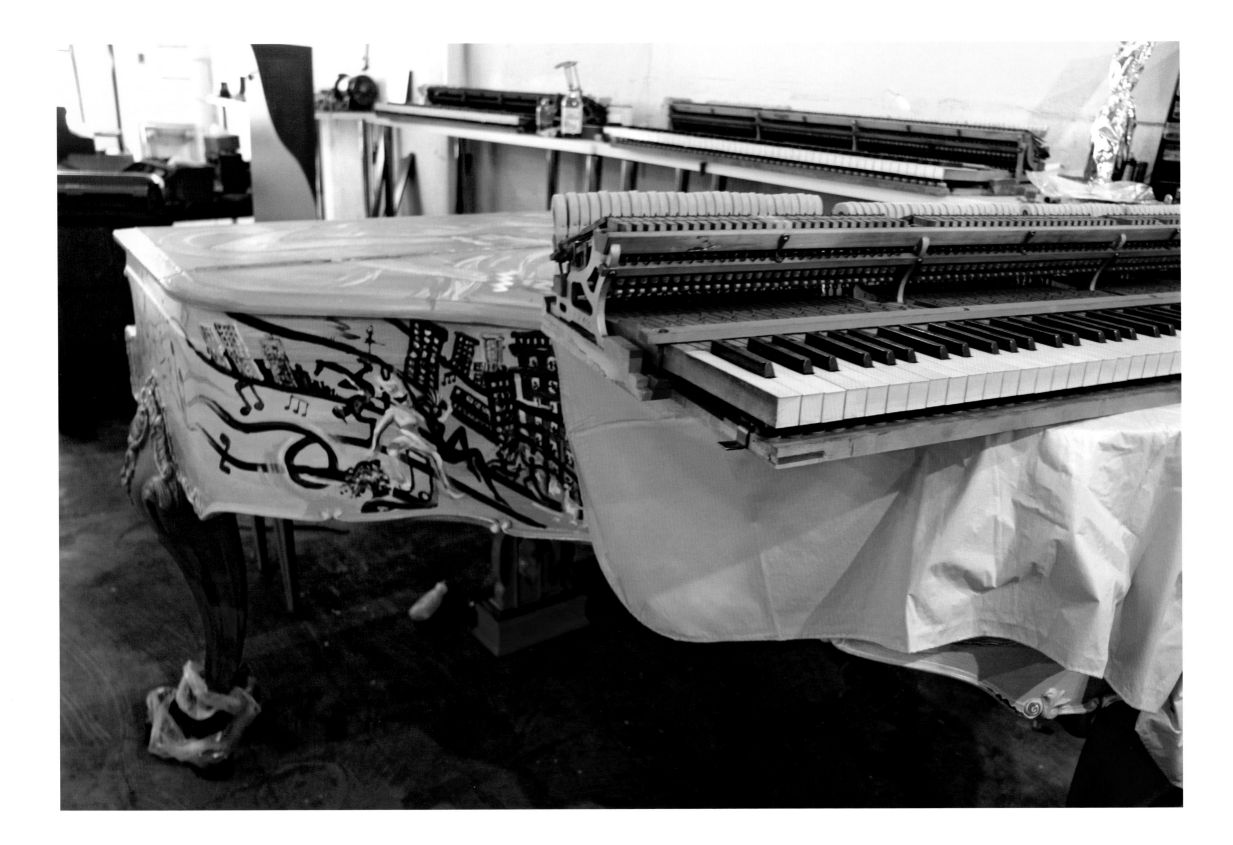

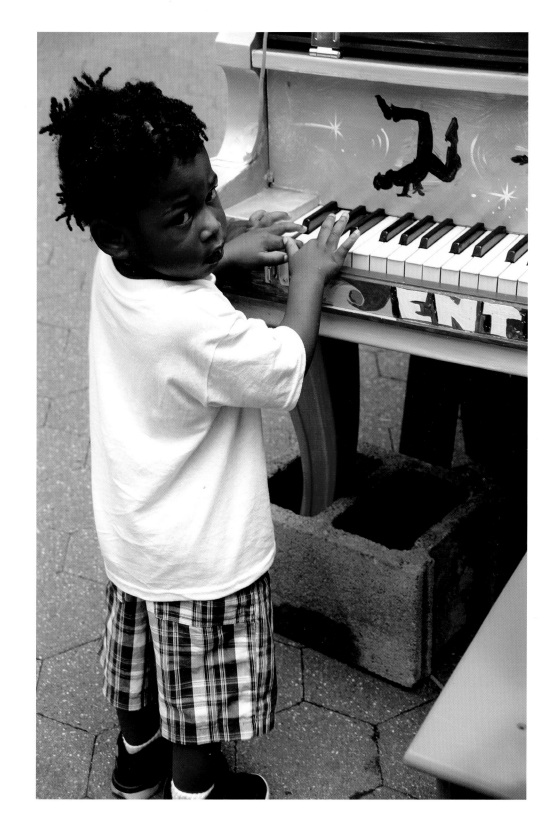
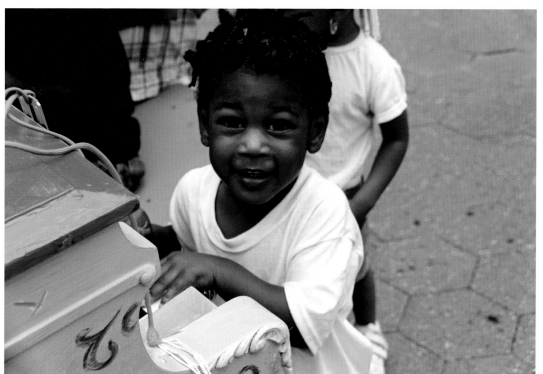
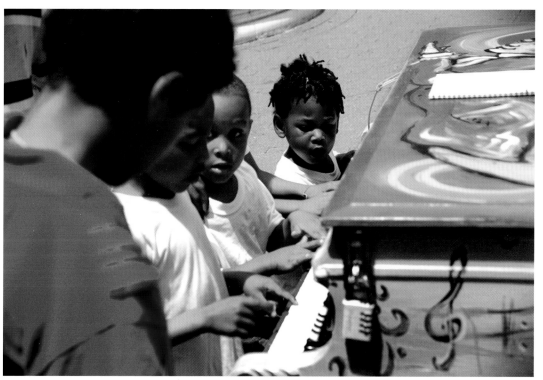

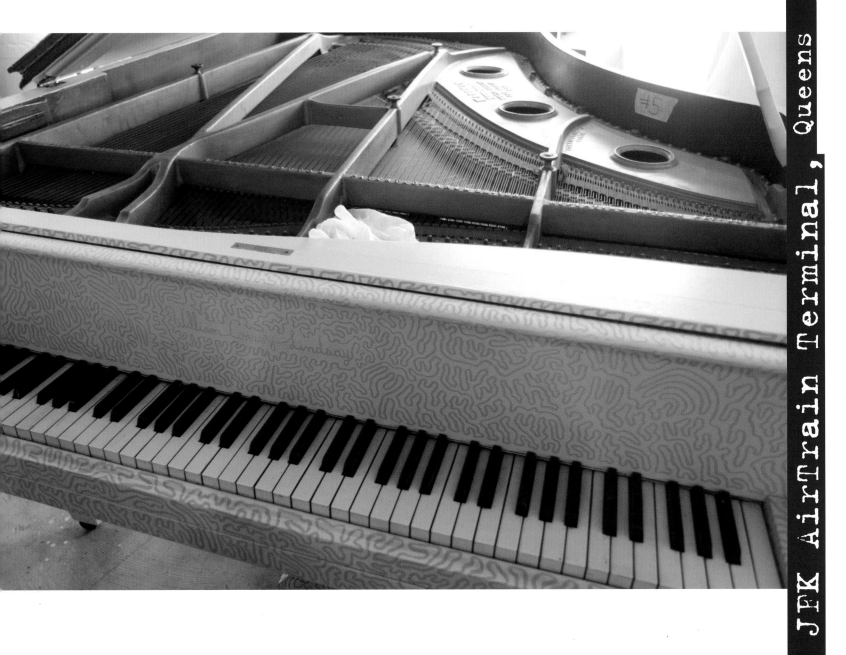

My artist is:
William Conroy Lindsay

My keys were at:
94th Avenue and Sutphin Boulevard

My name is:
Playing One Continuous Line

This is what my artist says about me:
I squiggled an entire grand piano—
one continuous line that starts on one
area and ends in another. What started
out as just an everyday notebook
doodle turns into a sense of freedom and
escape from reality. I hope all enjoy
and see what they want to see in this
bright pop-art squiggle design piece.

You can find my artist at:
www.willsquigdesign.com

My community buddy is:
The Port Authority of New York
and New Jersey

My new home is:
This piano was auctioned to
fund Sing for Hope's Art U!
program that brings arts
education to under-resourced
youth in New York City.

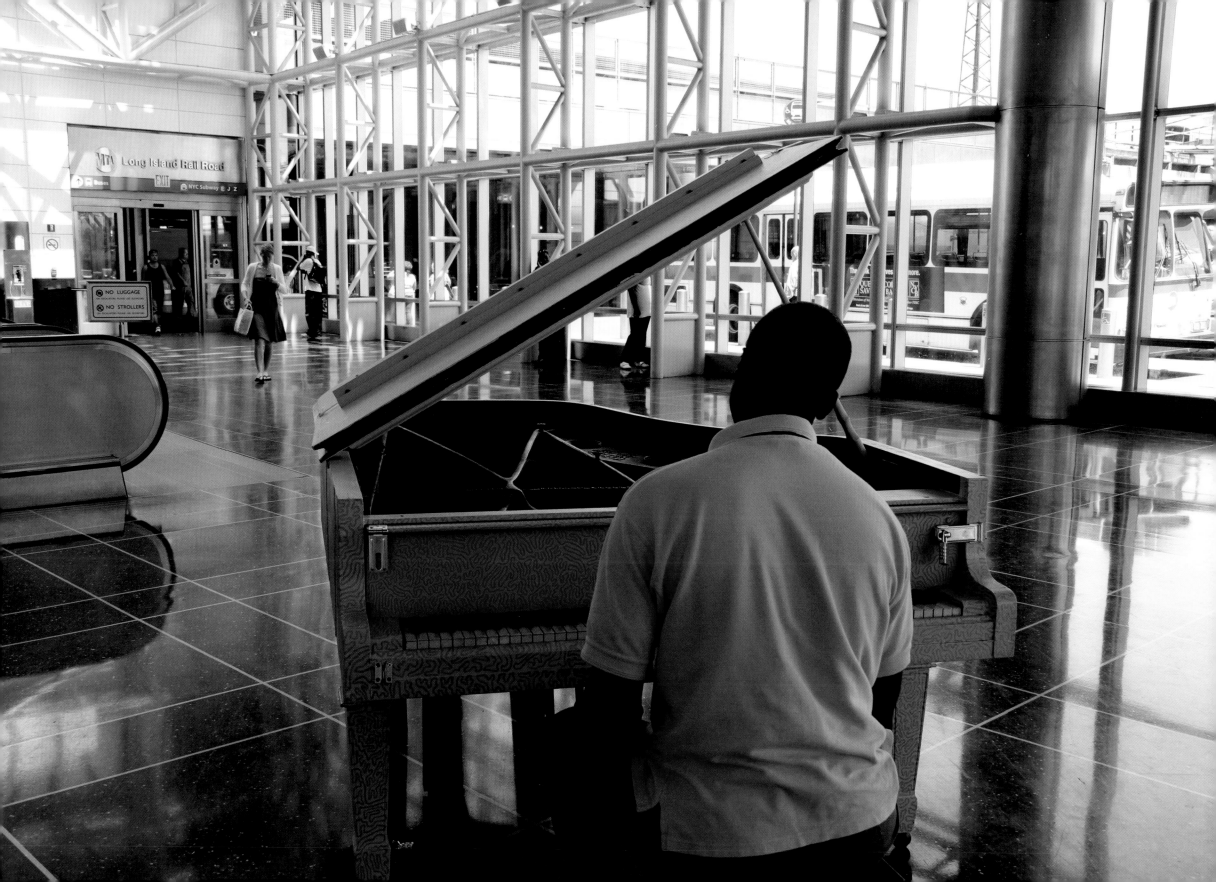

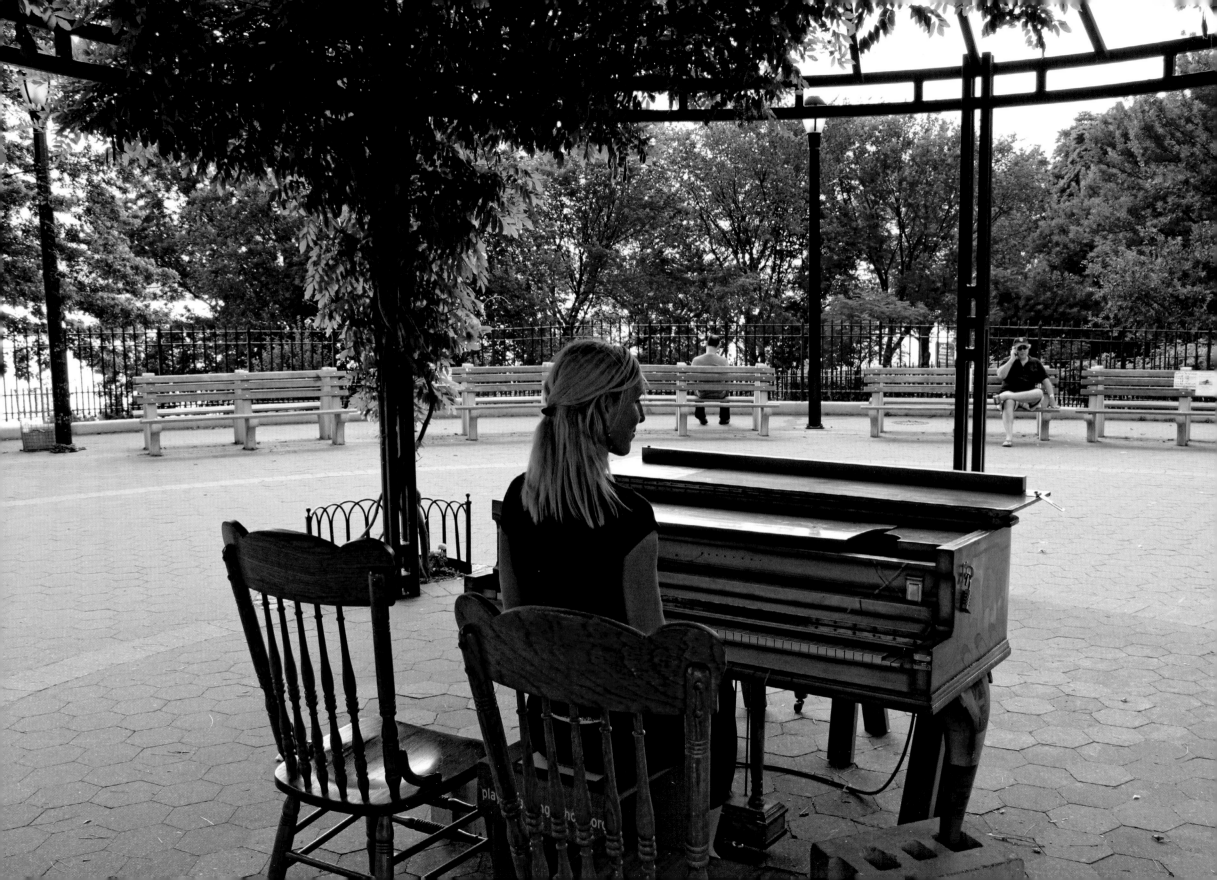

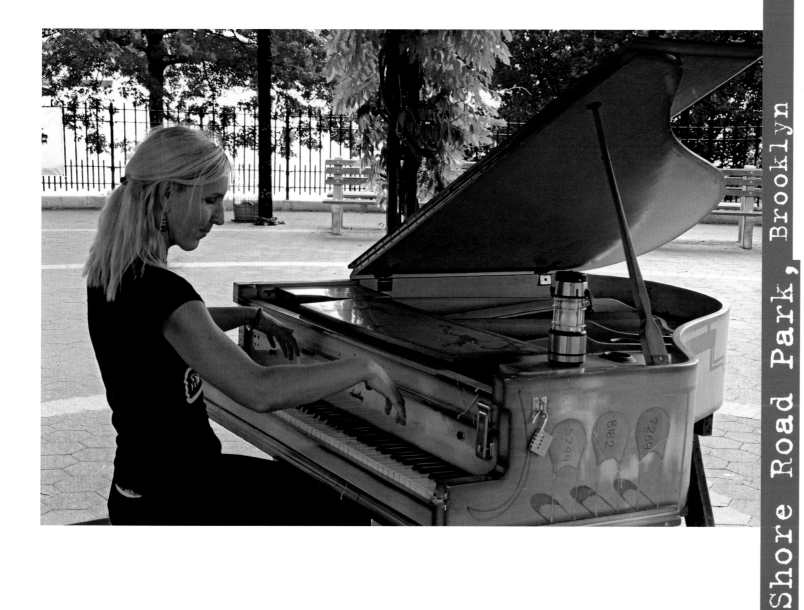

My artist is:
Sam Frons and Danielle Baskin

My keys were at:
Narrows Road and Shore Road

My name is:
Chords, Cords And Circuit Boards

This is what my artist says about me:
Inspired by the design of the circuit board, we transformed this 20th Century Grand to celebrate technology while preserving its original look.

You can find my artist at:
www.samfrons.com
www.bellehelmets.com

My community buddy is:
Shore Road Parks Conservancy

My new home is:
Shore Hill Senior Housing Center

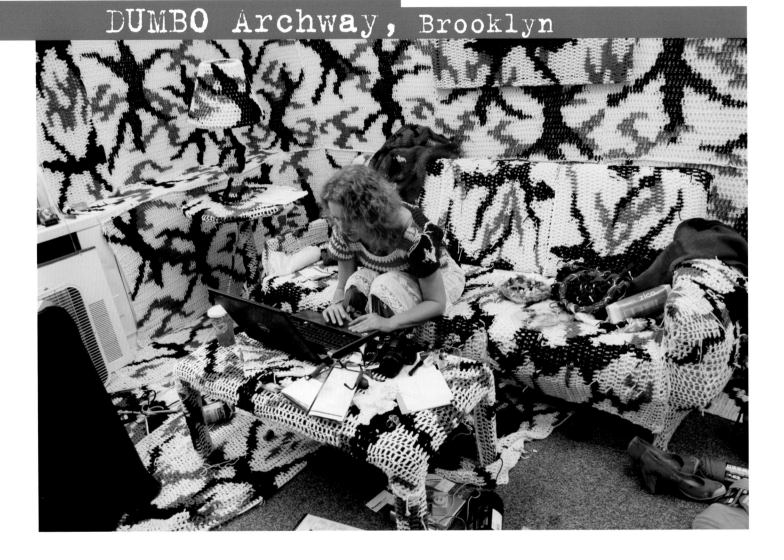

My artist is: Olek

My keys were at:
Adams Street and Water Street

My name is:
Imagine The Clouds Dripping

This is what my artist says about me:
I intend to take advantage of living
in NYC with various neighborhoods,
and create a feedback to reflect
the diverse economic and social realities
of our community. Made while in
residency with Workspace, LMCC, with
100% Red Heart Acrylic Yarn.

You can find my artist at:
www.agataolek.com

My community buddy is:
DUMBO BID

My new home is:
DUMBO Improvement District

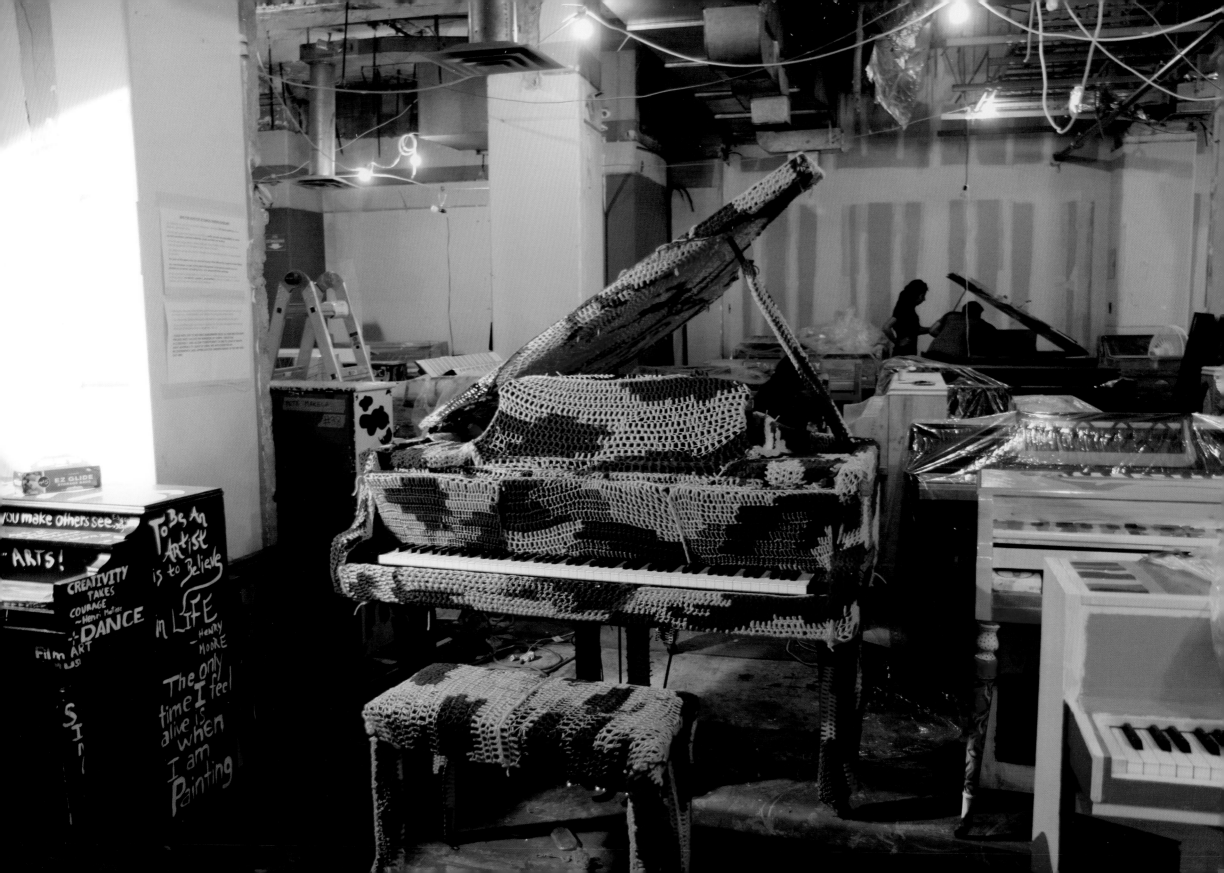

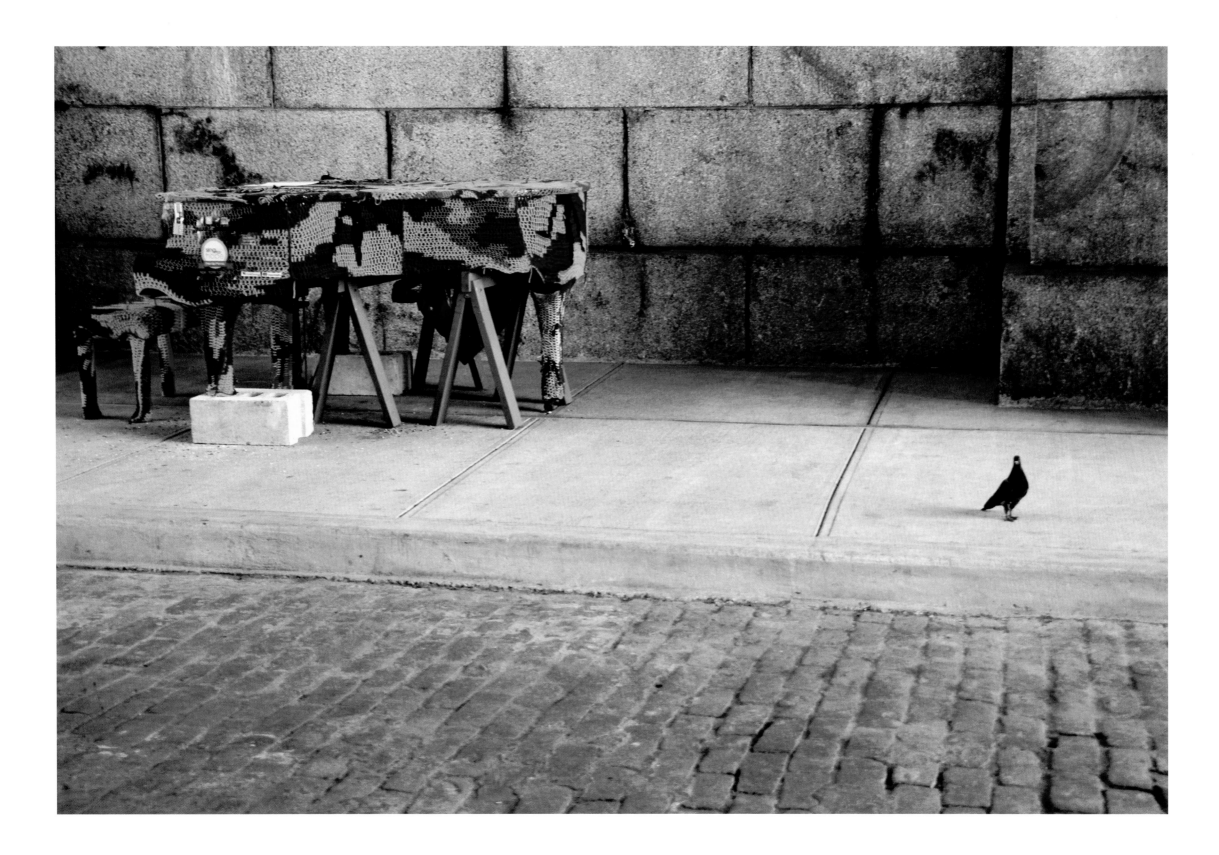

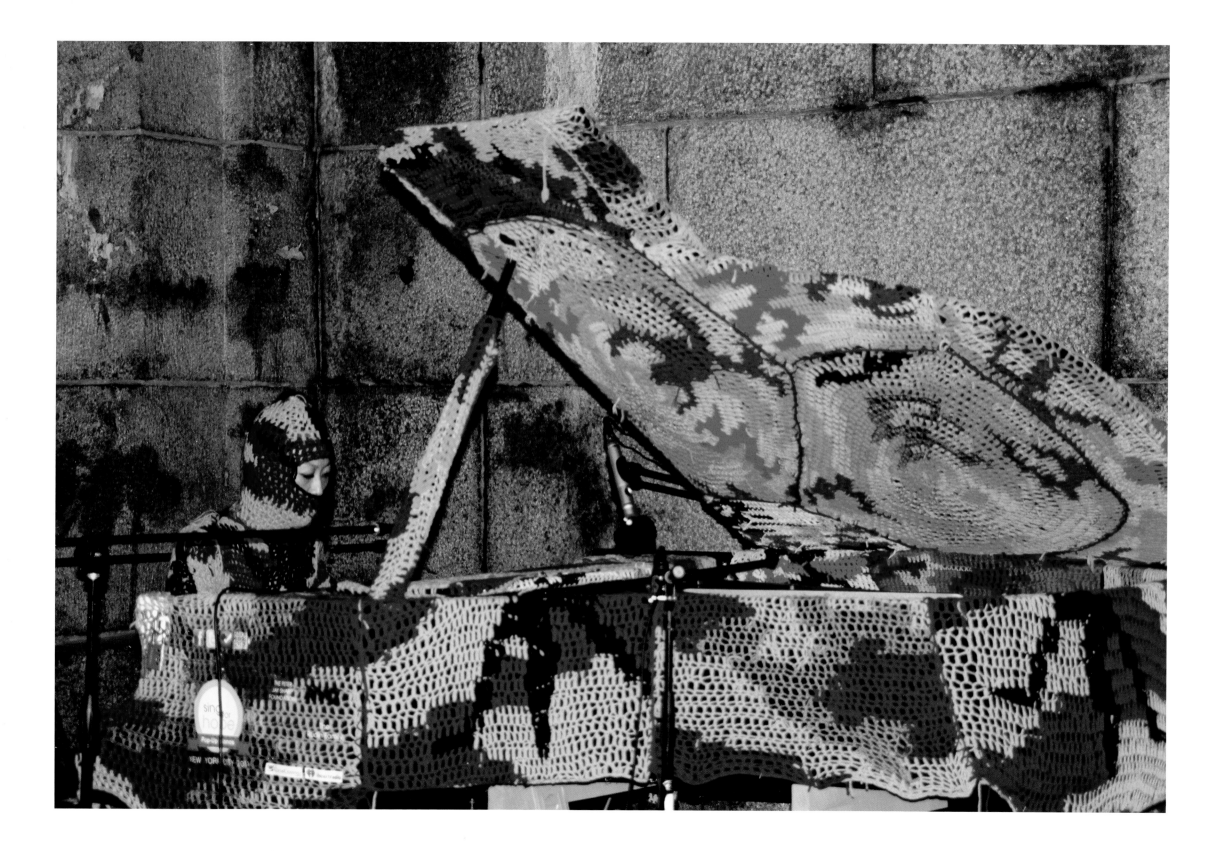

John Paul Jones Park, Brooklyn

My artist is:
Javier Infantes

My keys were at:
4th Avenue and Shore Road

My name is:
Neuronal Landscape

This is what my artist says about me:
Creativity is as a language of experimentation, a method of investigation and acquisition of knowledge. Through art, we travel towards our inner selves, towards what we are: thought, emotion, feeling, memory.

You can find my artist at:
www.javierinfantes.carbonmade.com

My community buddy is:
Shore Road Parks Conservancy

My new home is:
NYC Public School System

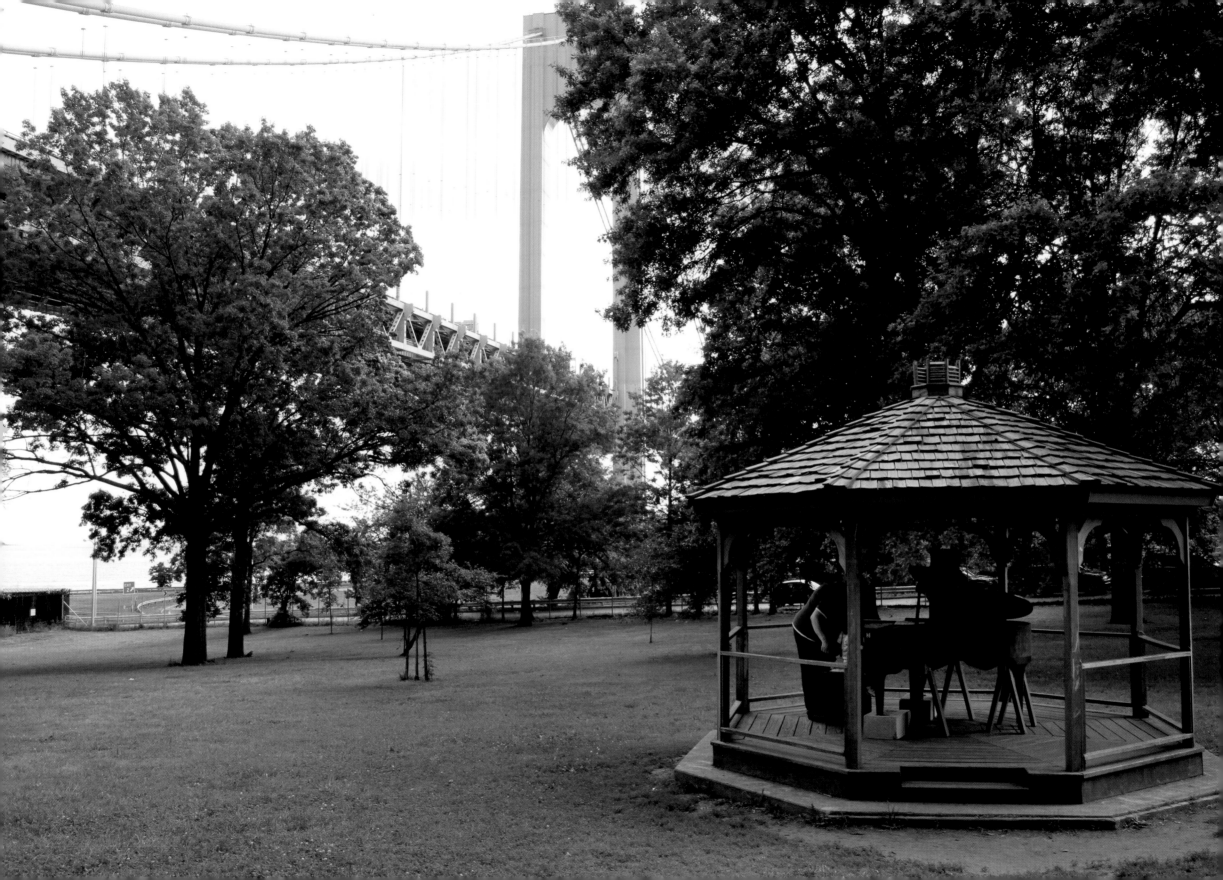

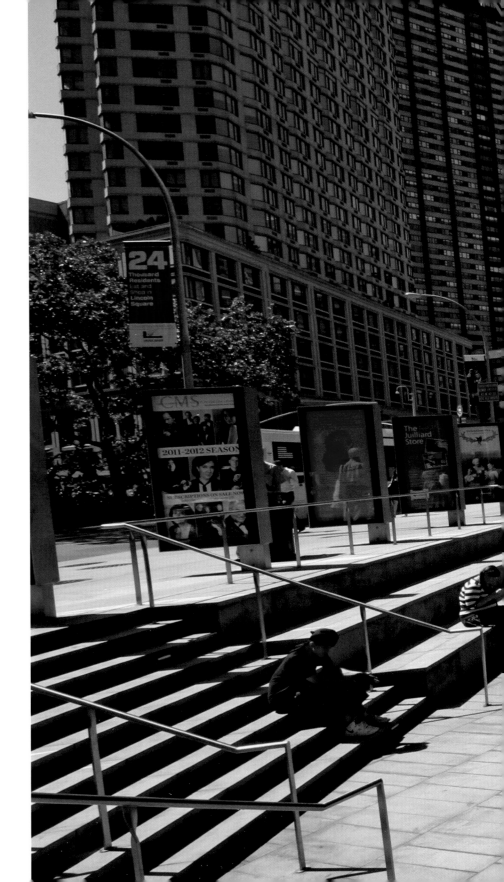

My artist is: Chris Soria

My keys were at:
Lincoln Center, Broadway and West 65th Street

My name is:
Polychromatic Scales

This is what my artist says about me:
When the keys play under dancing fingers,
they rouse grasshoppers and fly under and over
hammers, pouncing upon metal strings,
creating sounds that resonate in waves like
color through light, in a variety of schemes,
scales, chords and chroma.

You can find my artist at:
www.chrissoria.com

My community buddy is:
Lincoln Center

My new home is:
This piano was auctioned to fund
Sing for Hope's Art U! program
that brings arts education to
under-resourced youth in New York City.

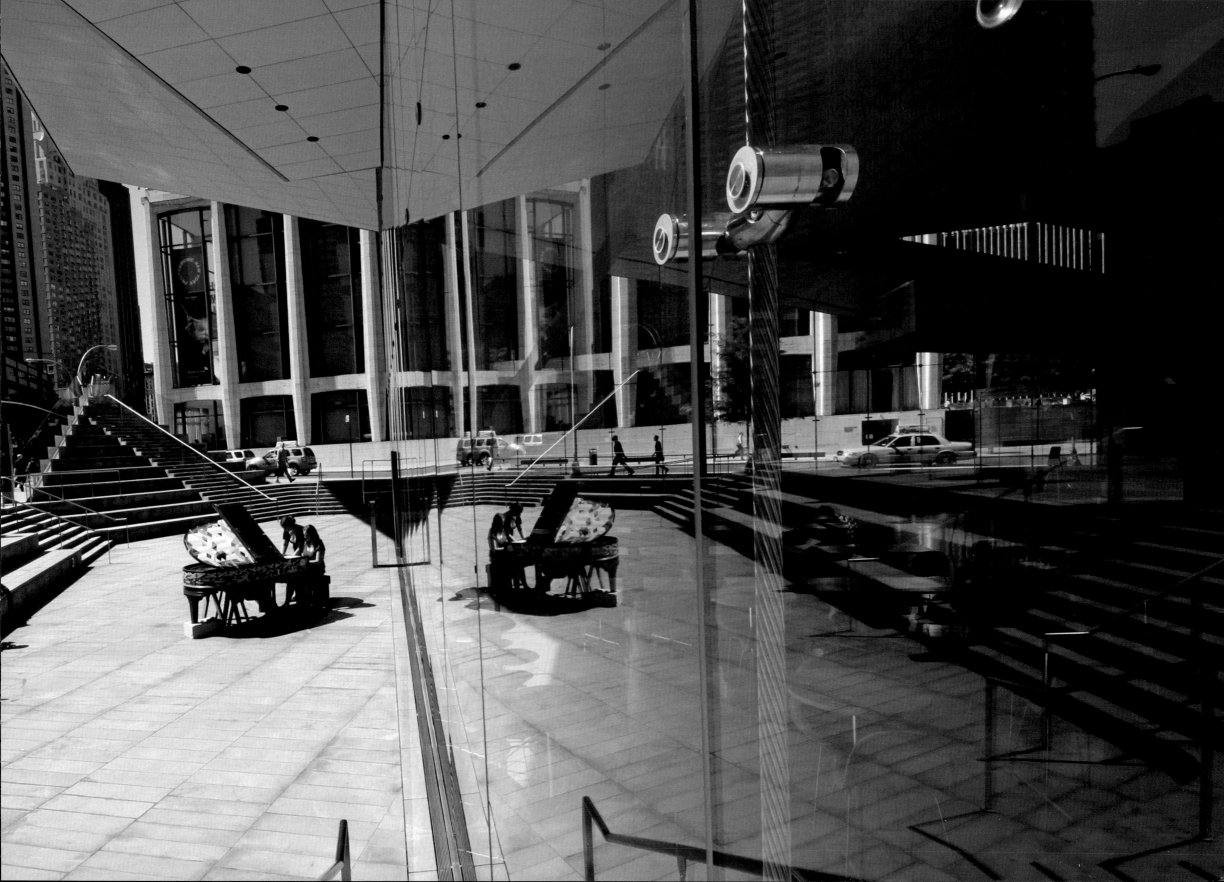

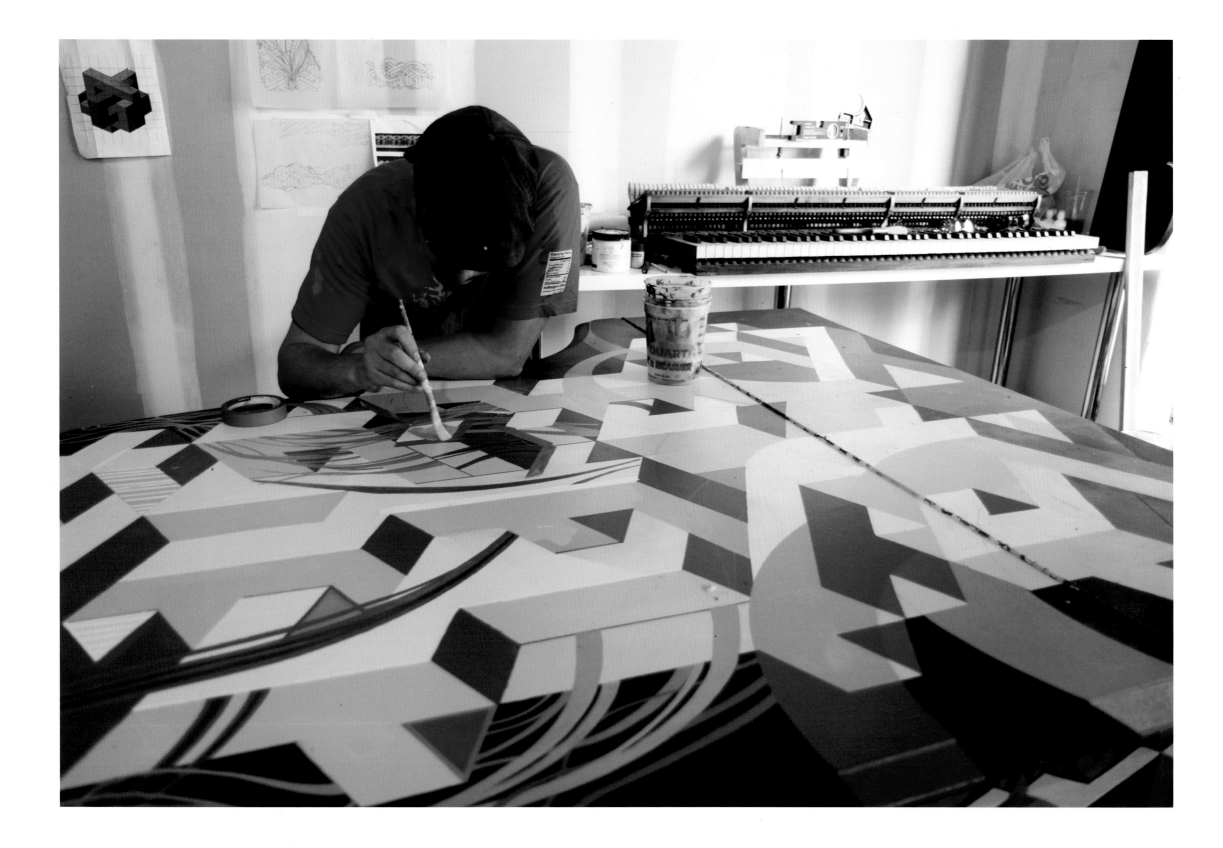

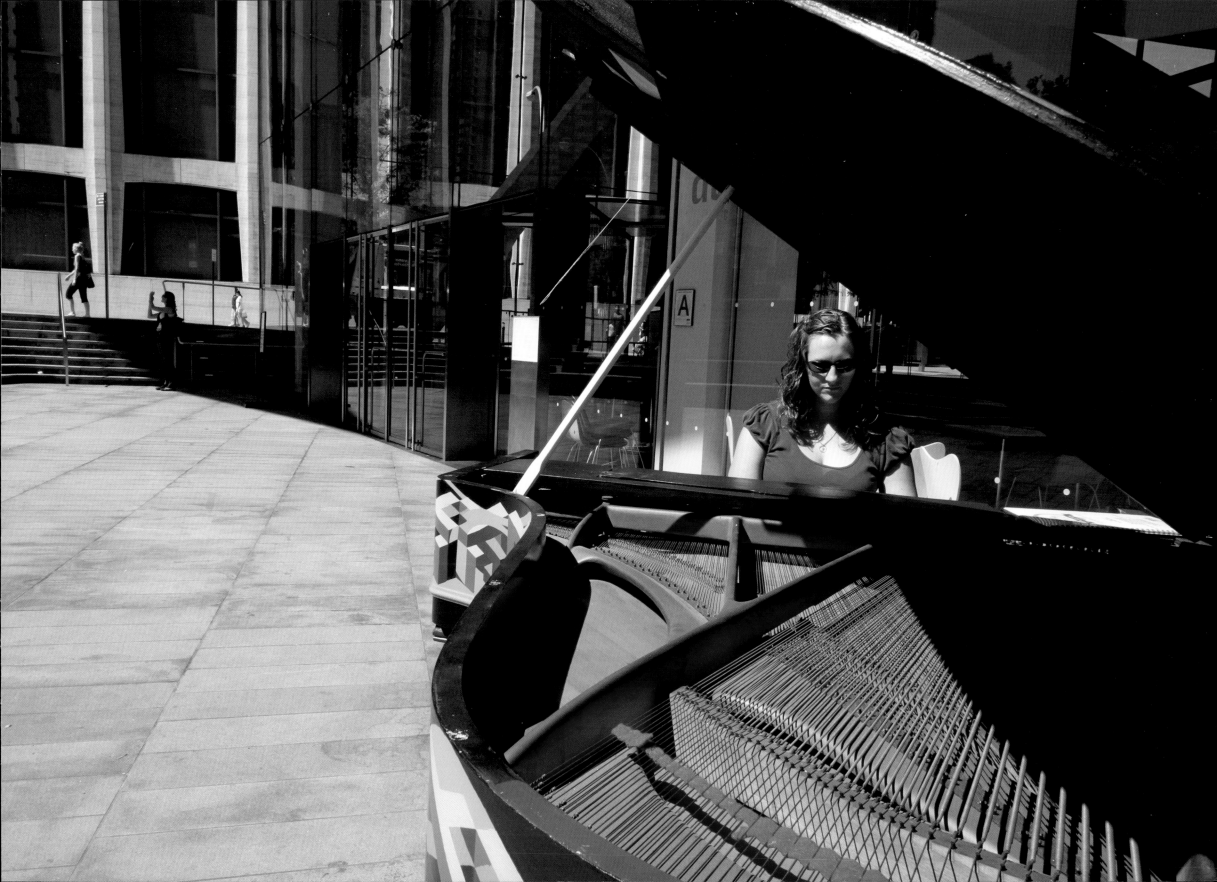

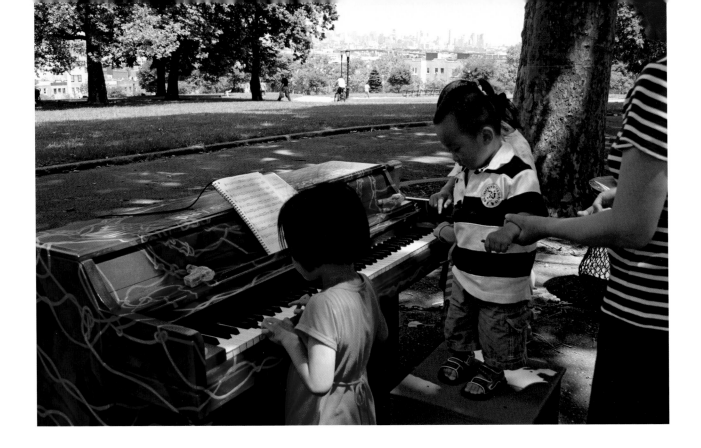

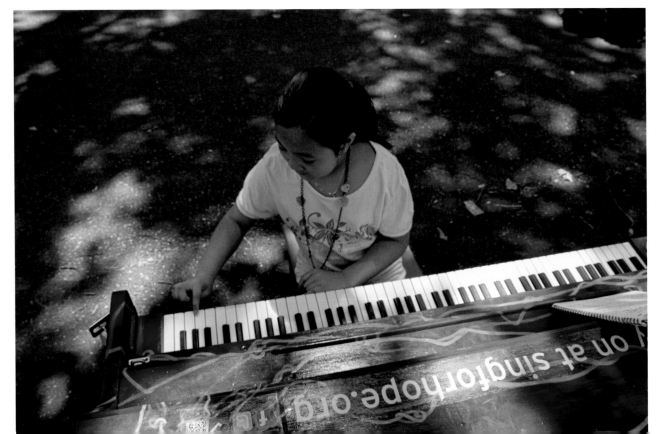

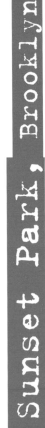

My artist is:
Masha Gitin

My keys were at:
Near 44th Street and 6th Avenue

My name is:
String Theory

**This is what my
artist says about me:**
I am so happy to be a part of
this great project. The strings
that envelop this piano are a
connection between the player,
the sound vibrations, our physical
selves, and our relationship with
nature that is always entangled
and one. Enjoy!

You can find my artist at:
www.mashagitin.com

My community buddy is:
Sunset Park BID, Gary Newton

My new home is:
Sunset Park Improvement District

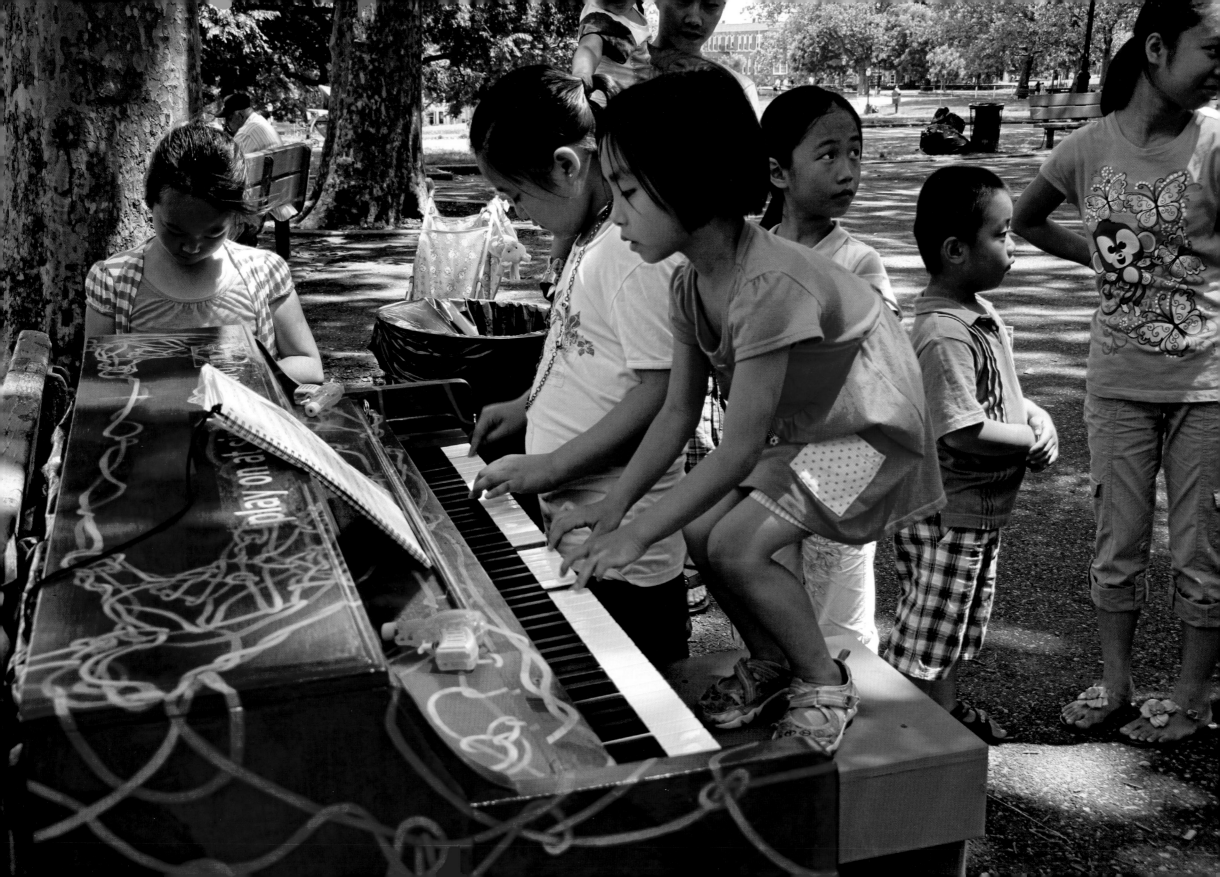

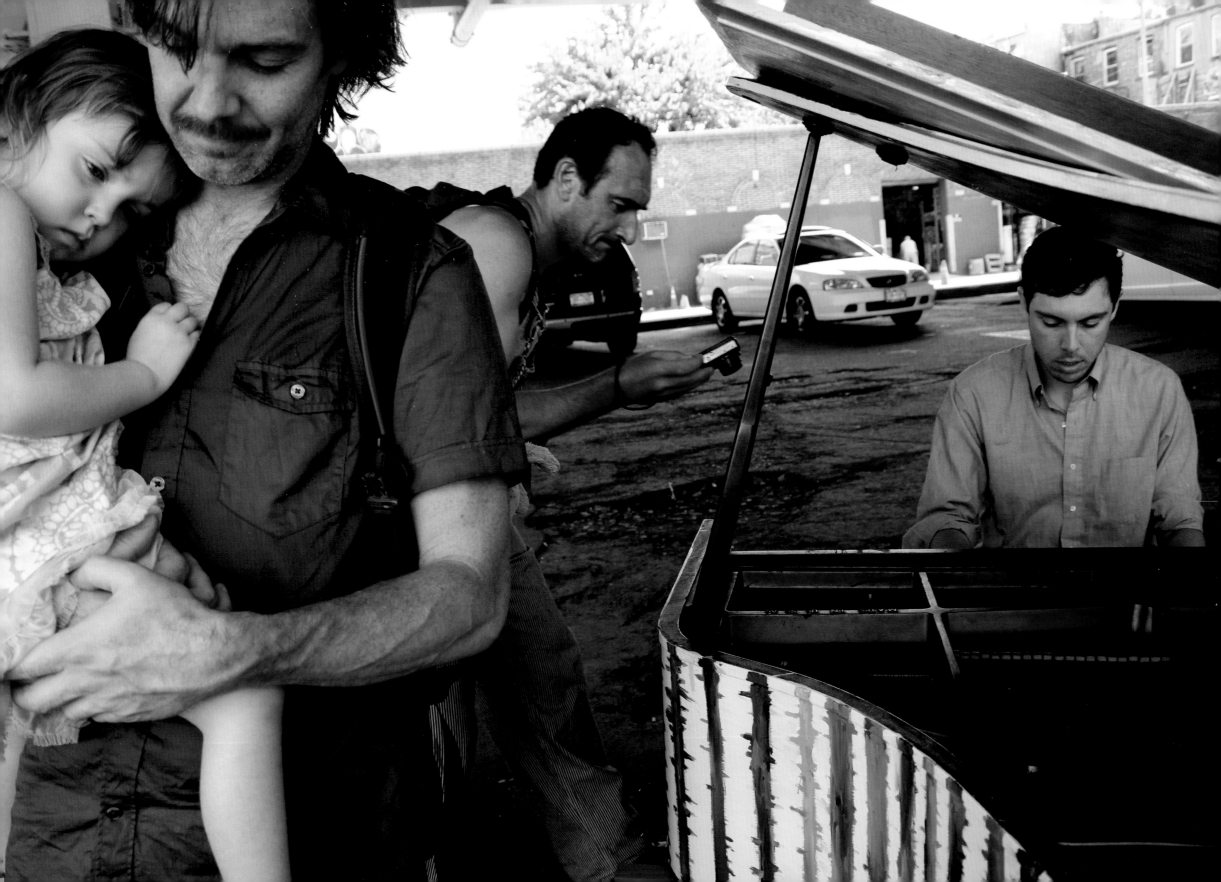

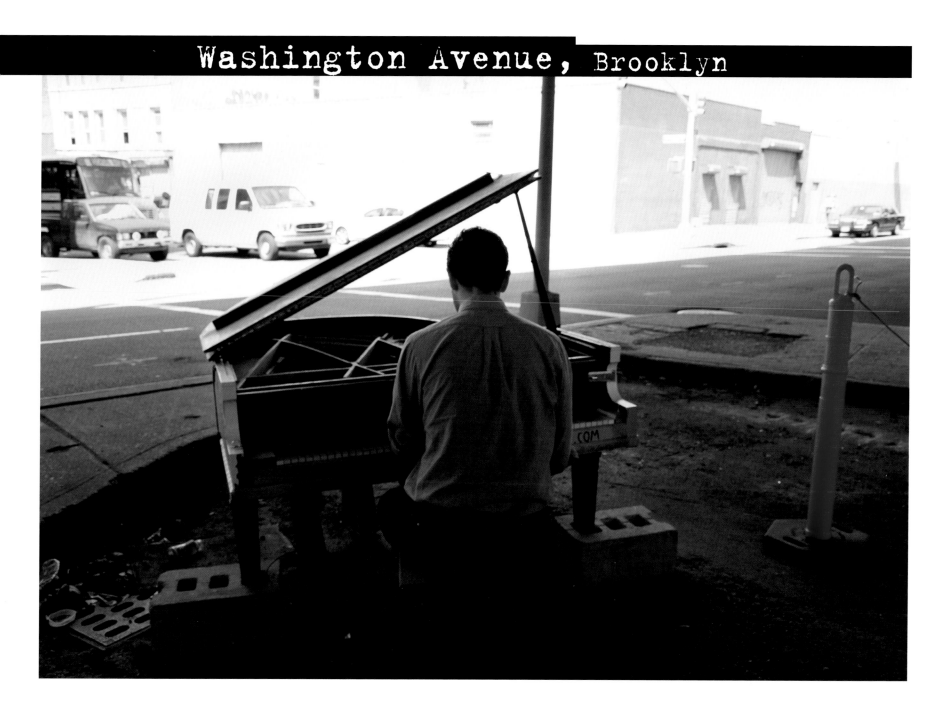

My artist is:
Benjamin Christopher Martins

My keys were at:
Washington Avenue and Park Avenue

My name is:
Sudden Oak Death

This is what my
artist says about me:
My piano, "Sudden Oak Death,"
represents an apocalyptic tree-scape
amidst our cement jungle.

You can find my artist at:
www.benjaminmartins.com

My community buddy is:
Fresh Fanatic, Myrtle Ave BID

My new home is:
High School for Public Service

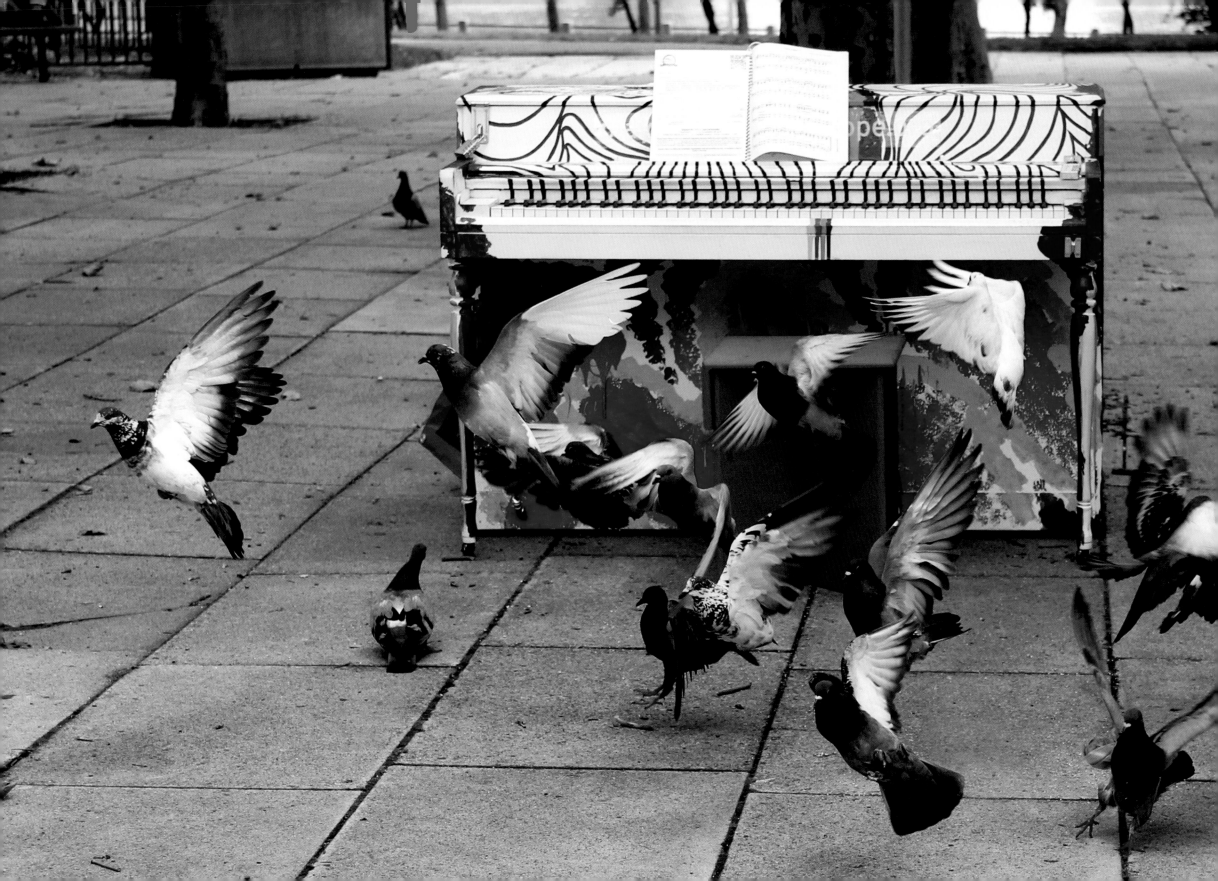

My artist is:
Rodrigo Quiroz

My keys were at:
East Road and Main Street

My name is:
Impro Paint

This is what my
artist says about me:
I made the lines go crazy
and then I jammed over
the piano with colors.

My community buddy is:
Roosevelt Island
Operating Corporation

My new home is:
Goldwater Hospital

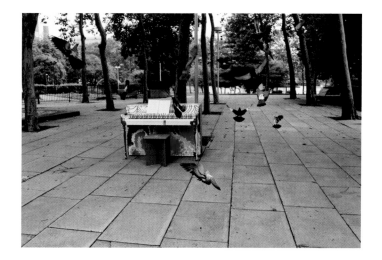

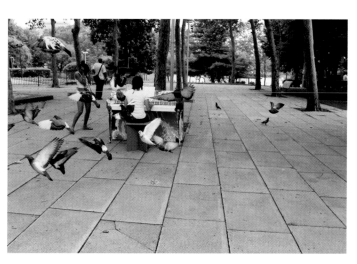

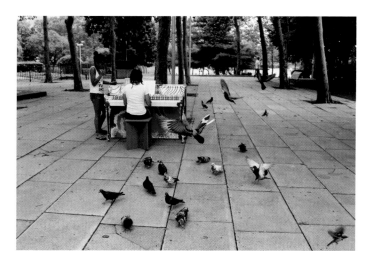

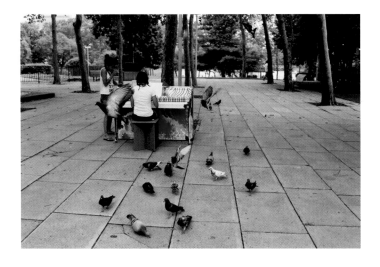 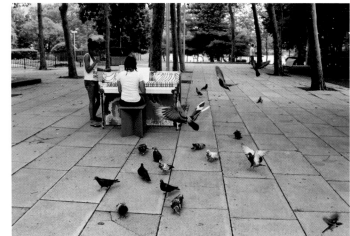 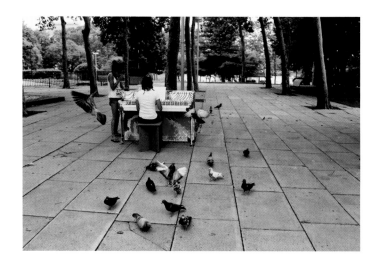
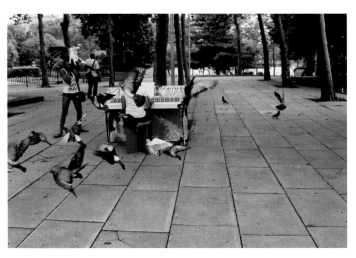 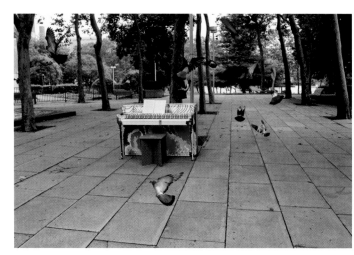 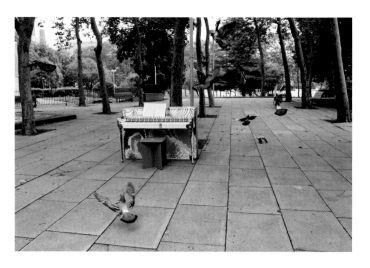
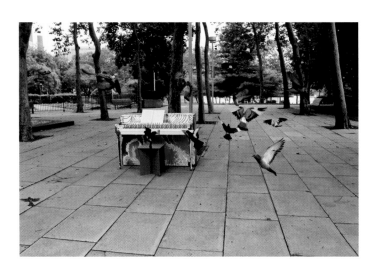 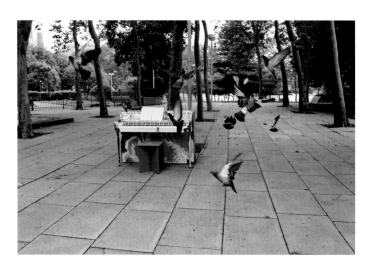 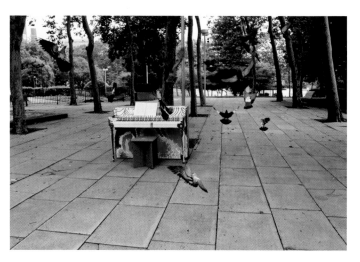

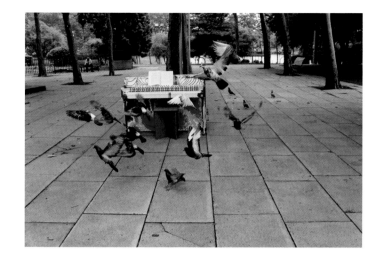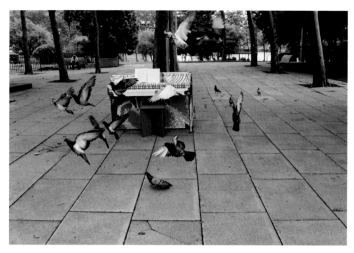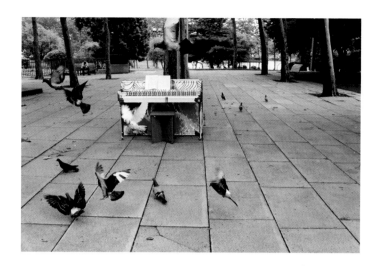
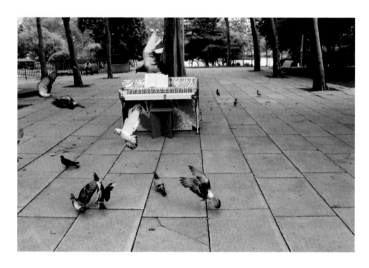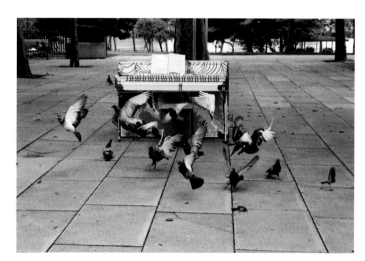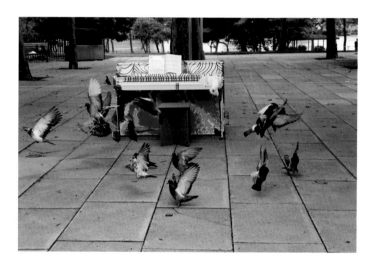
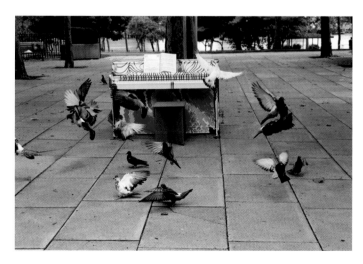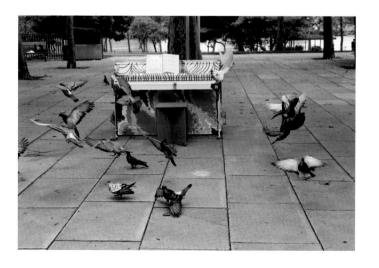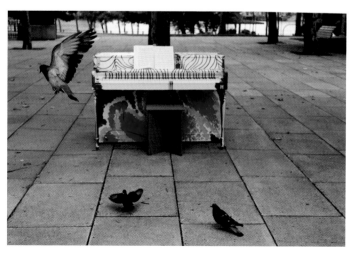

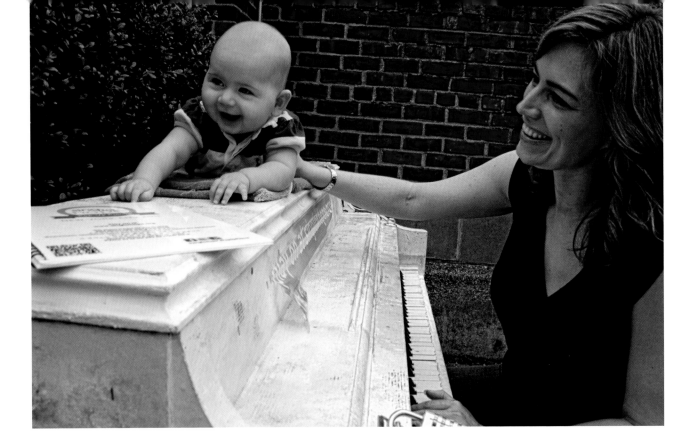

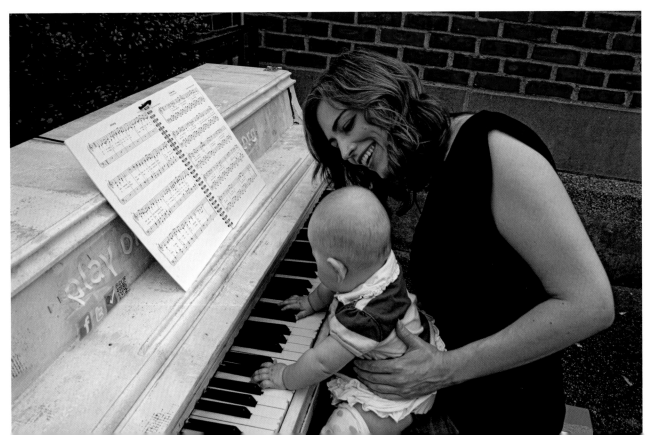

My artist is:
Jenna Samotin

My keys were at:
Jackson Heights Post Office,
37th Avenue and 78th Street

My name is:
Margherita

This is what my
artist says about me:
Inspired by fabric and the
abstract patterns of an urban
landscape, the colors and
rich texture allude to the subtle
beauty of, say, a wall of
peeling paint in NYC.

You can find my artist at:
www.jsamotin.com

My community buddy is:
Jackson Heights
Beautification Group

My new home is:
The Doe Fund—Help for the Homeless

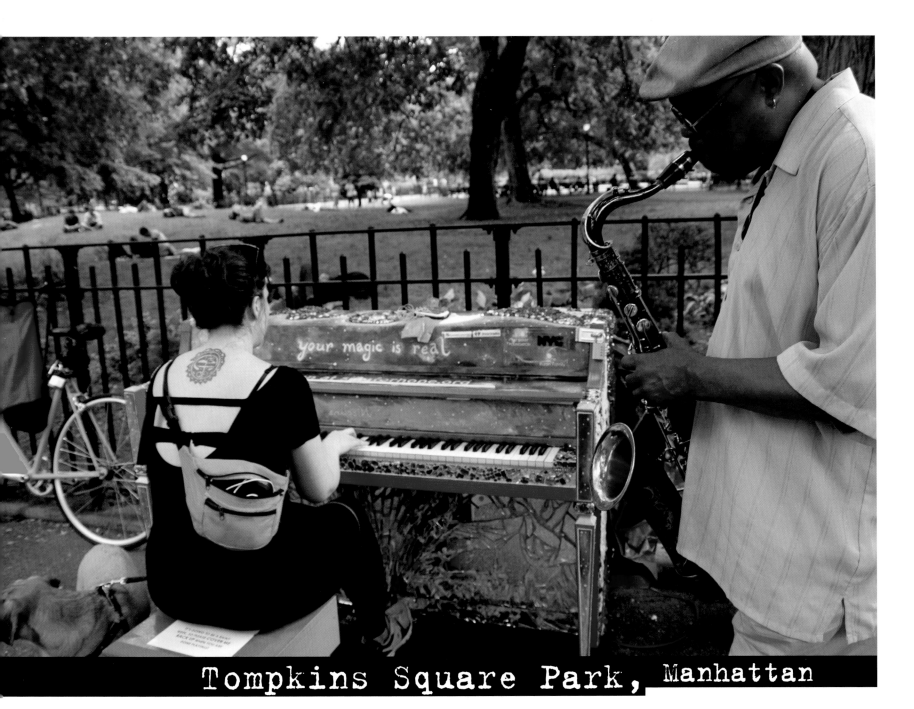

Tompkins Square Park, **Manhattan**

My artist is:
Nicolina

My keys were at:
Avenue A and East 9th Street

My name is:
Piano Of Magical Merriment

This is what my
artist says about me:
I painted the cosmic sound.

You can find my artist at:
www.NicolinaART.com

My community buddy is:
Free Art Society

My new home is:
The Lower Eastside Girls Club

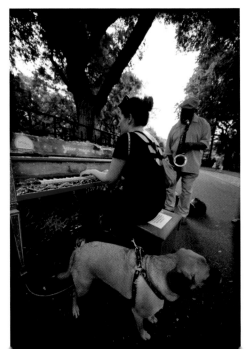

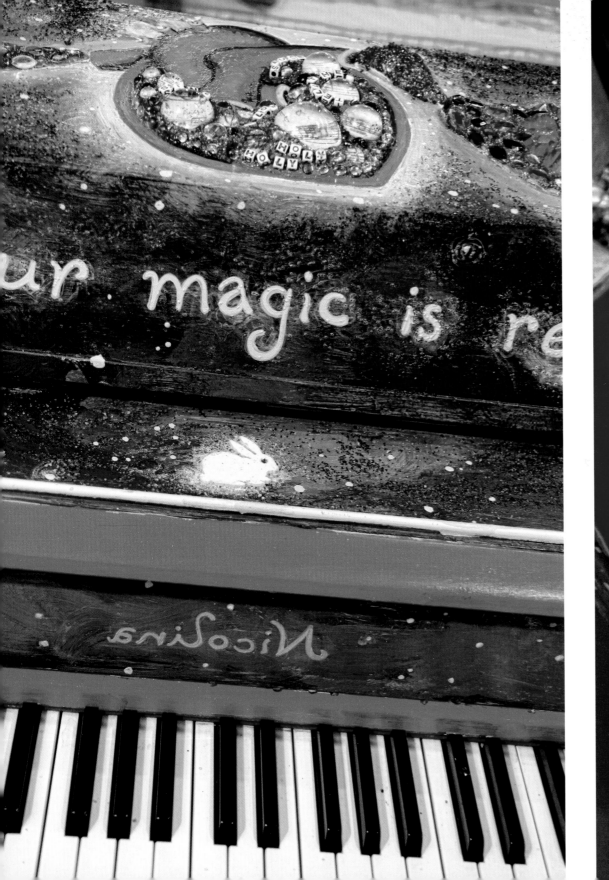
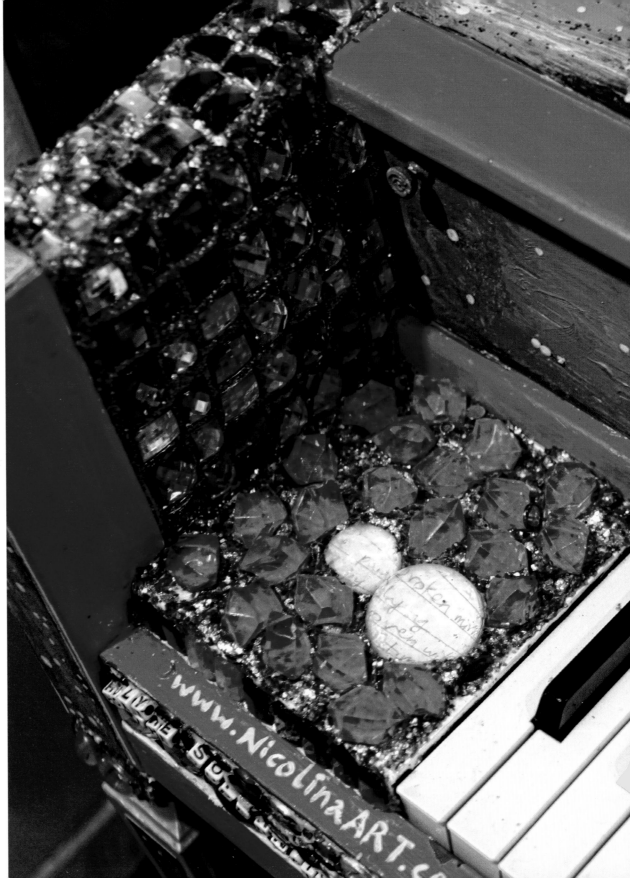

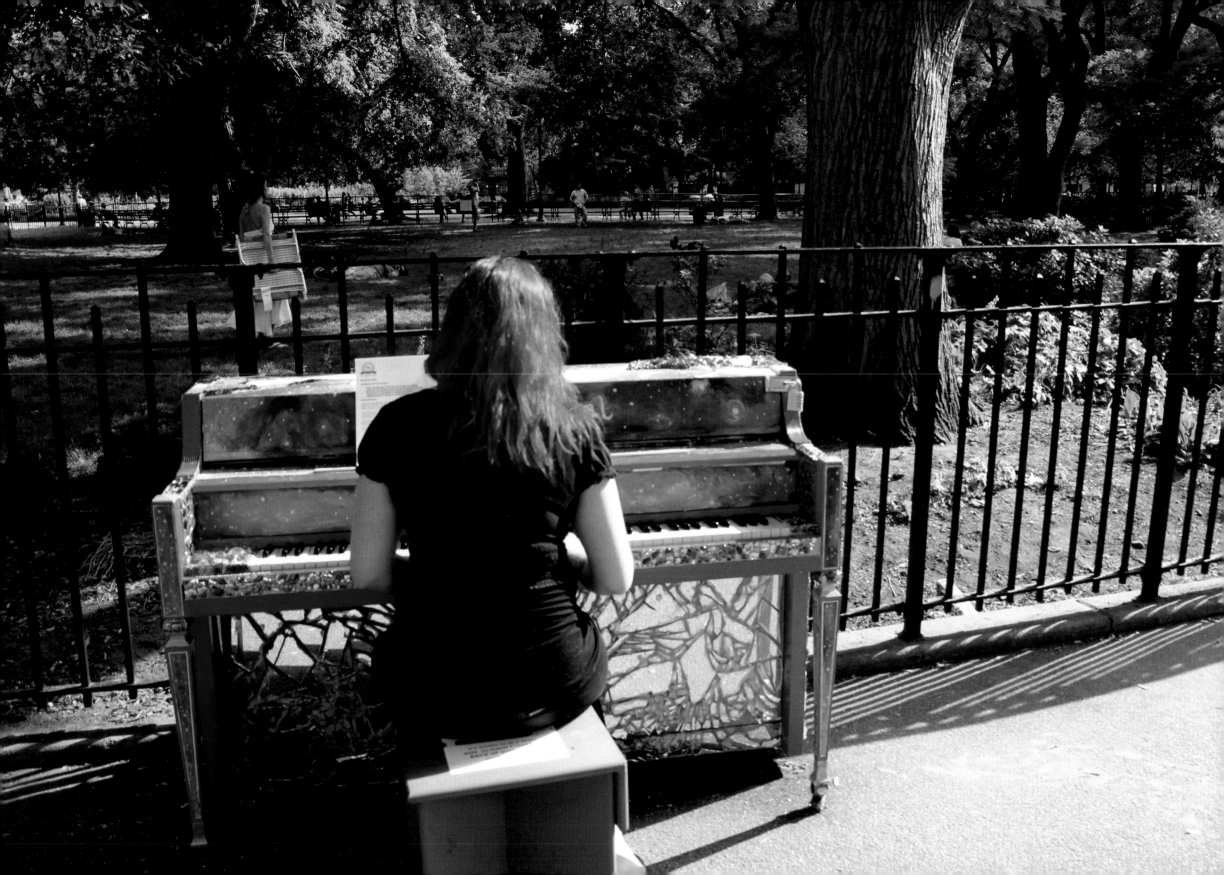

My artist is:
Sing for Hope Art U! students from P.S. 34

My keys were at:
Richmond Terrace and Bank Street

My name is:
Art U! Pop-Up Piano

This is what my artist says about me:
We painted what we thought was most important to us
in our community—color and fun and life!

You can find my artist at:
www.singforhope.org

My community buddy is:
Staten Island Yankees

My new home is:
P.S. 65

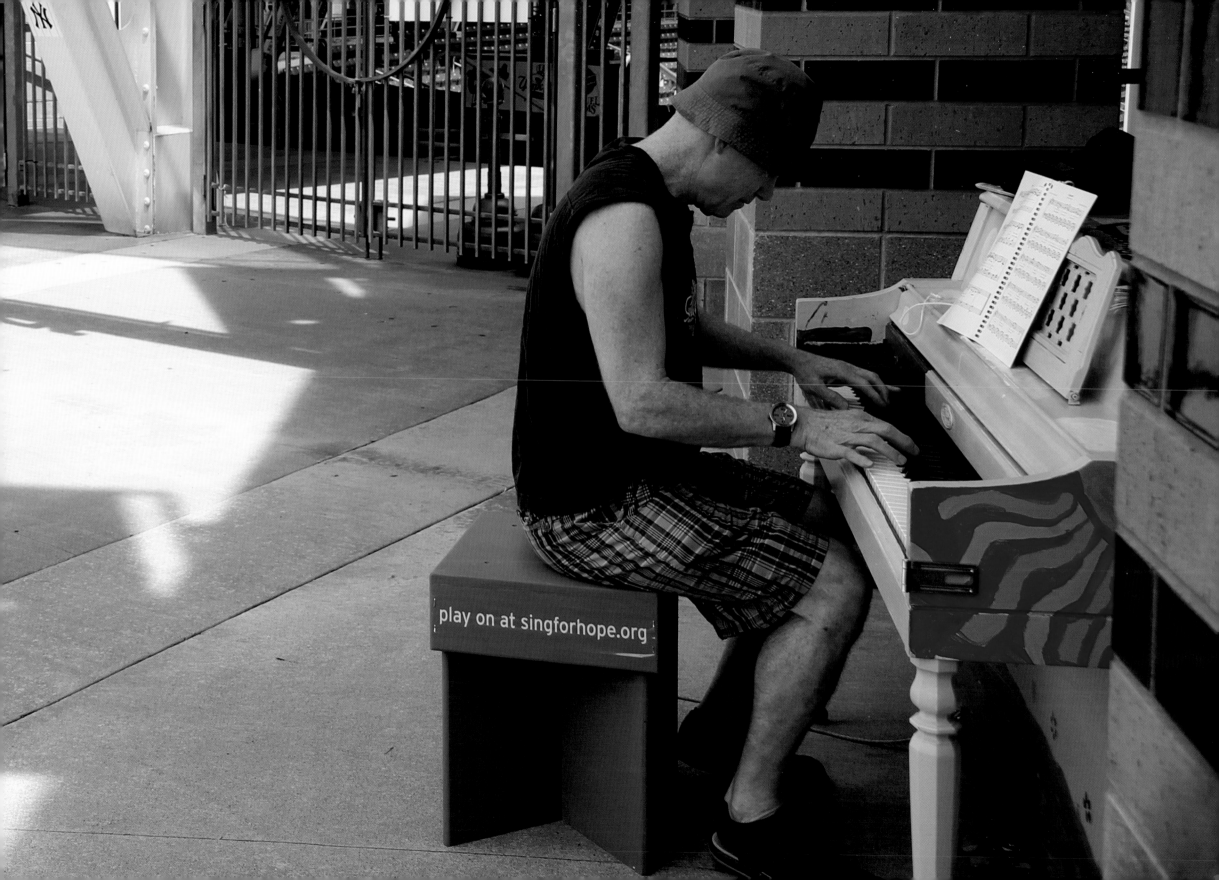

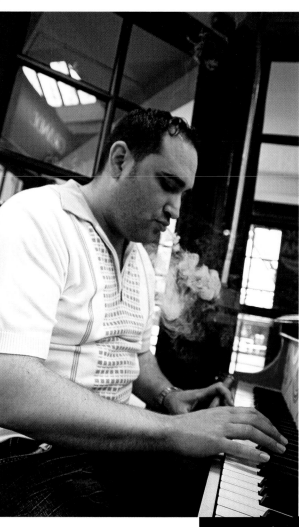
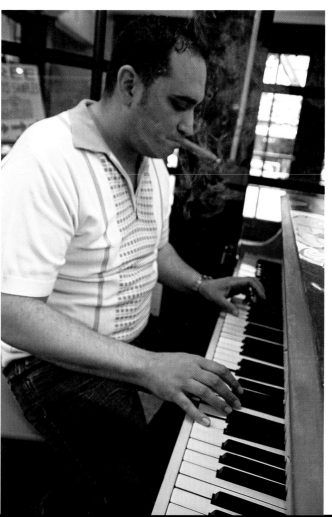

My artist is:
Armand Silvani

My keys are at:
Arthur Avenue

My name is: Allegro

**This is what my
artist says about me:**
My piano celebrates the
immigrant merchants of the
Bronx who were unified
under one roof, the Arthur Avenue
Retail Market, in 1940.

My community buddy is:
Arthur Avenue Retail Market

My new home is:
Arthur Avenue Retail Market

Arthur Avenue, Bronx

My artist is: Kate Spade

My keys were at:
Along waterfront at East 85th Street

My name is: Chopsticks, Anyone?

This is what my artist says about me:
A wicker-weave piano white-washed
and embellished with adhesive rose prints. To
find a piano that has that wicker-weave
that looks like baskets from our store with these
beautifully turned legs with brass on the
bottom—the shape was just perfect.

You can find my artist at: www.katespade.com

My community buddy is: Gibney Dance

My new home is:
This piano was auctioned to fund
Sing for Hope's Art U! program that
brings arts education to under-resourced
youth in New York City.

Carl Schurz Park, Manhattan

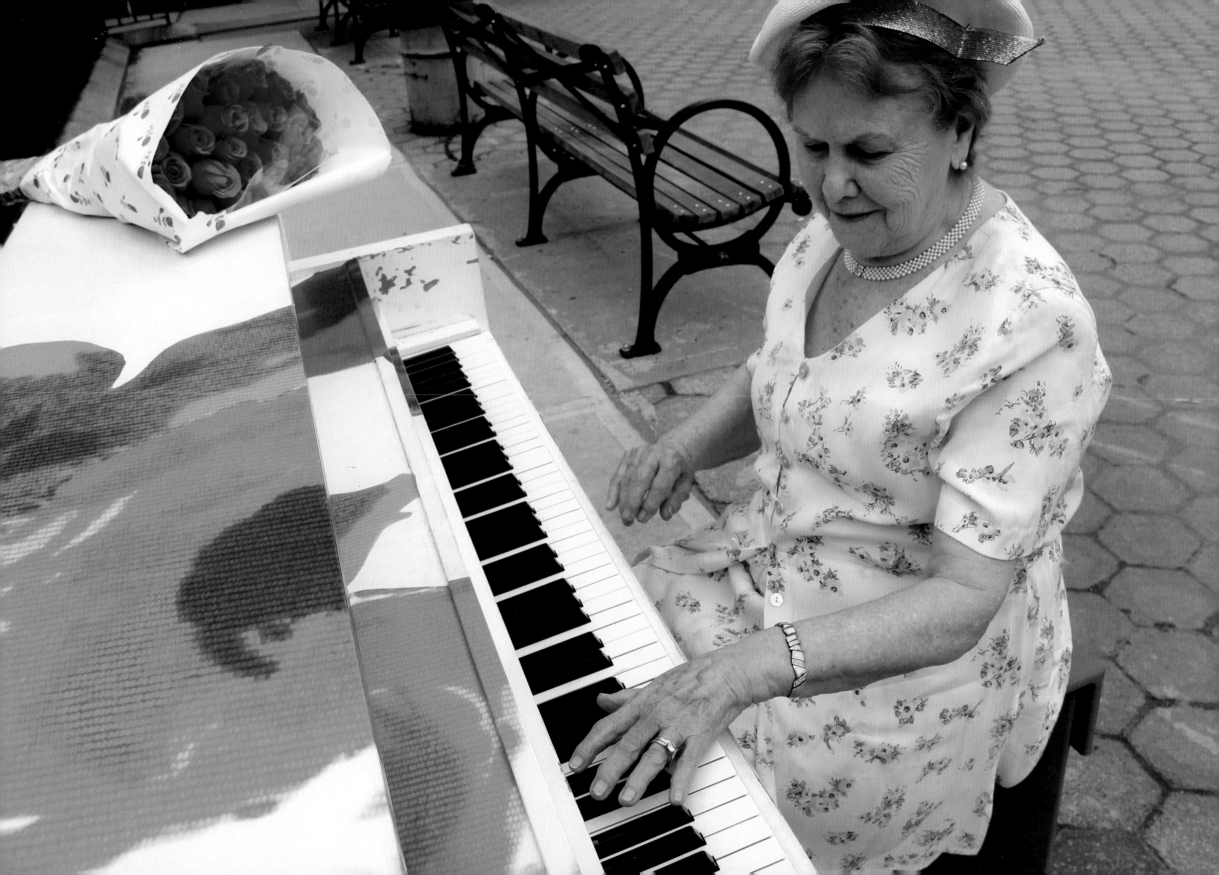

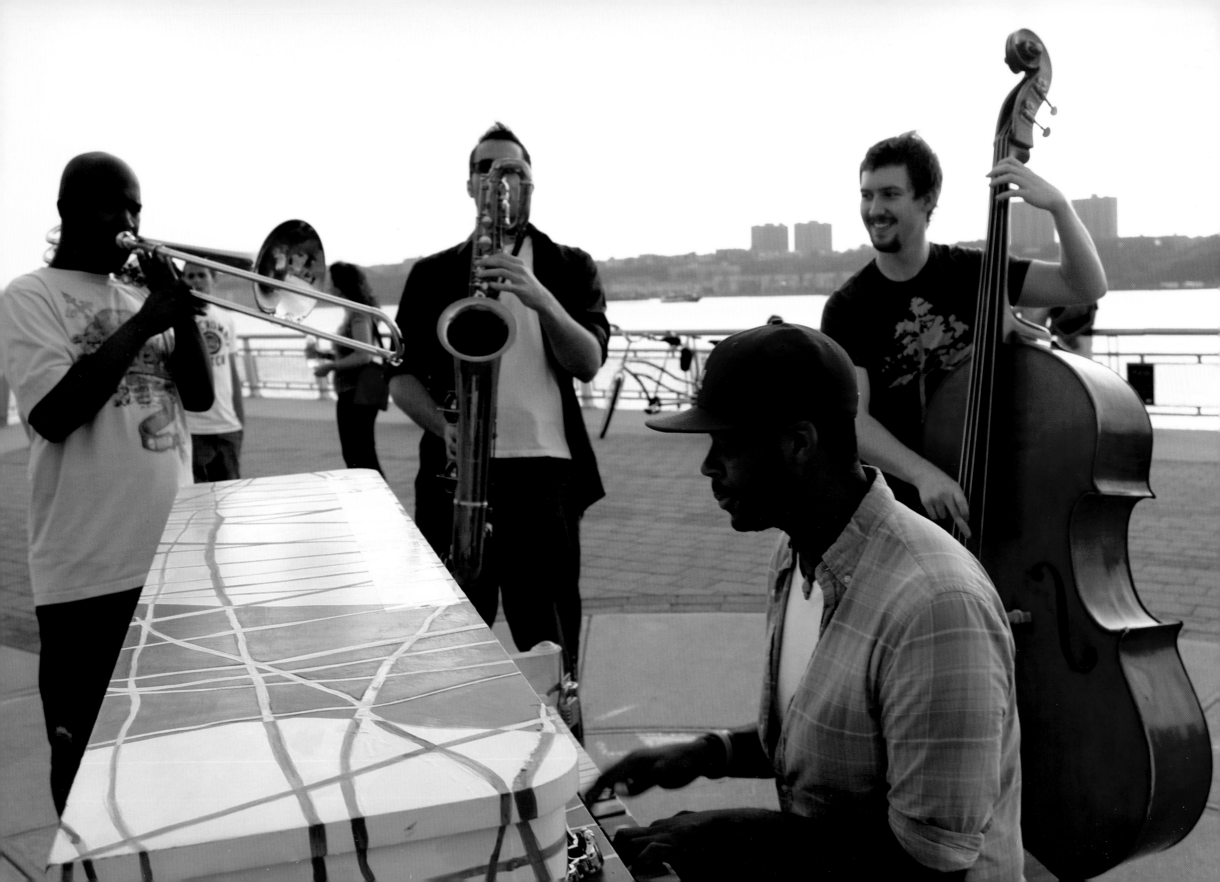

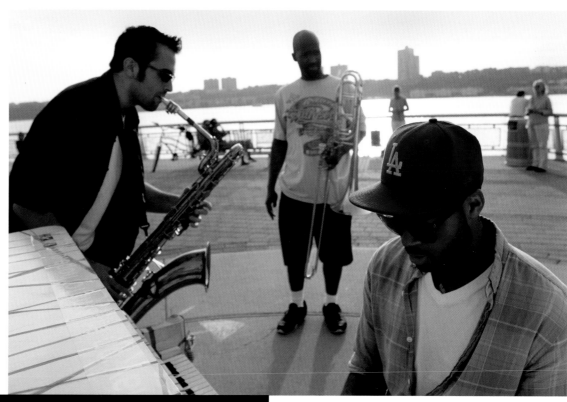

Riverside Park, Manhattan

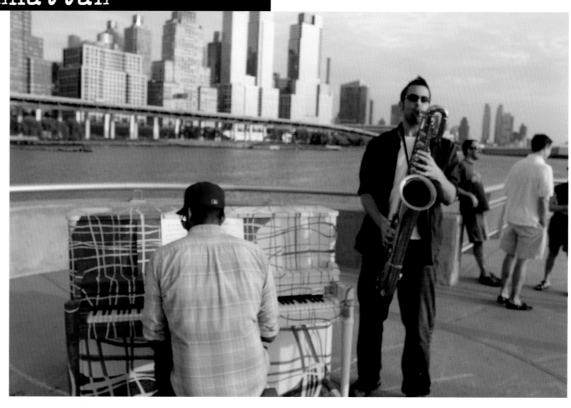

My artist is: Cara Bonewitz

My keys were at: Riverside Park, 70th Street Pier

My name is: Off The Grid

This is what my artist says about me:
Inspired by water, industrial forms, and the
glimpses of nature in NYC, this piano transforms
as daylight changes and glows after dark.

You can find my artist at: www.carabonewitz.com

My community buddy is: NYC Parks

My new home is: FEGS Support Services

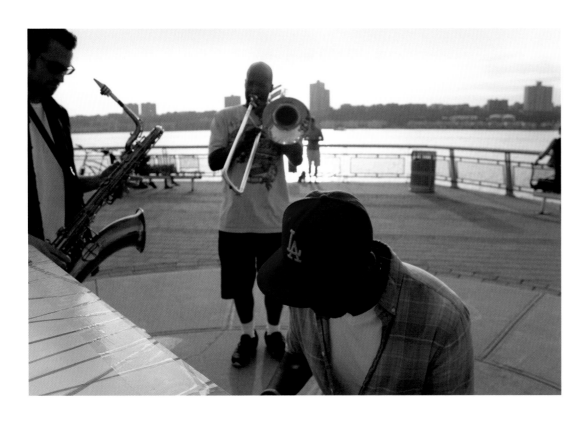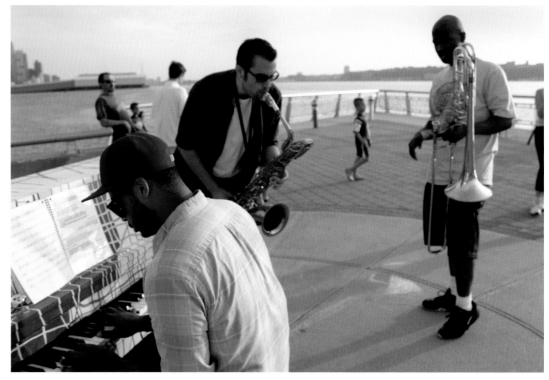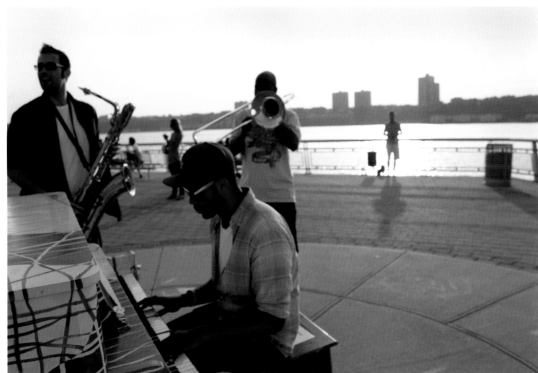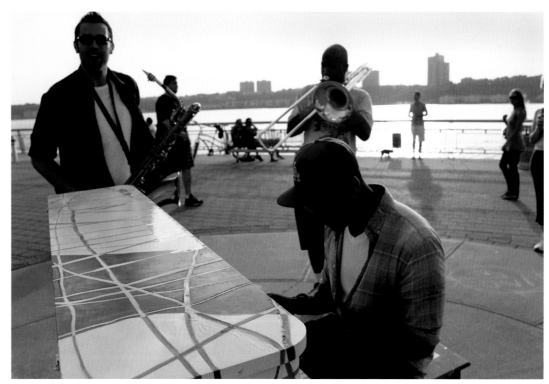

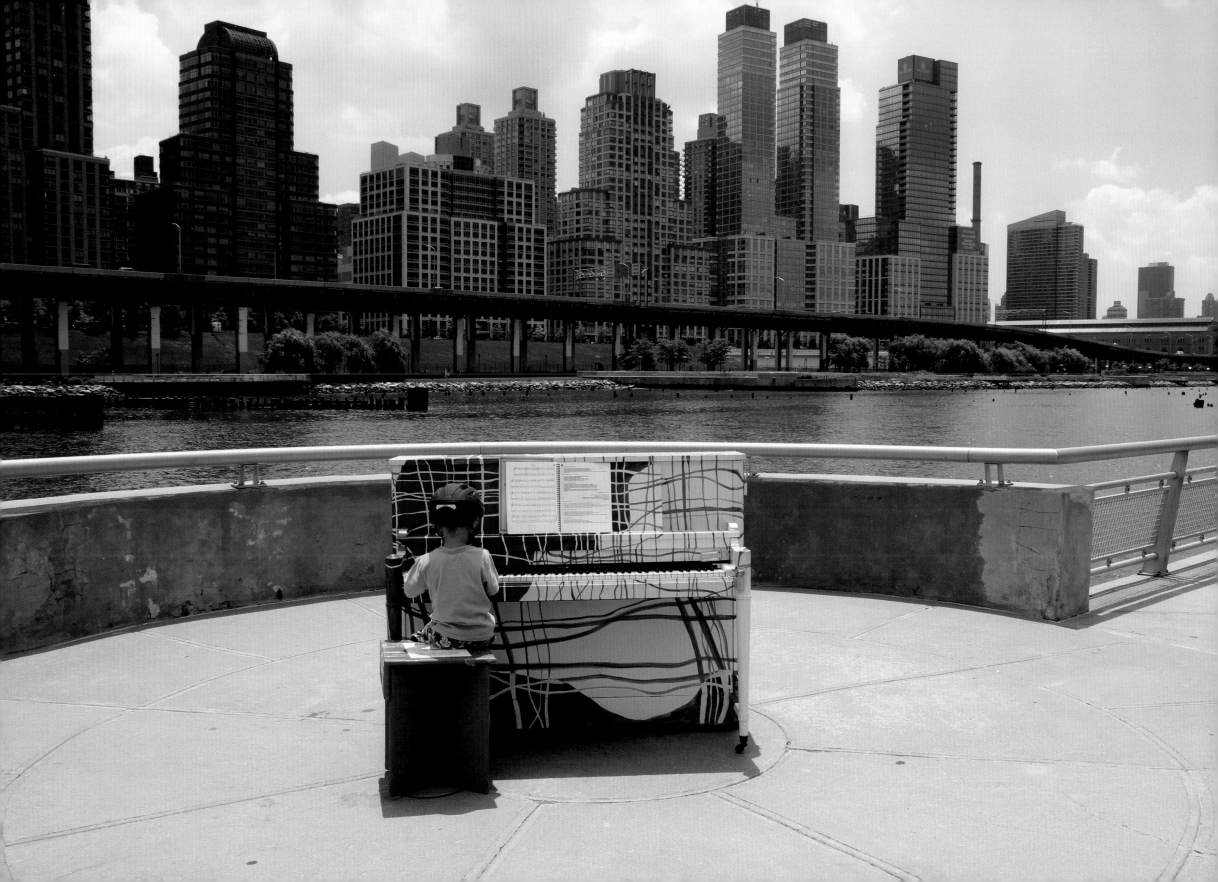

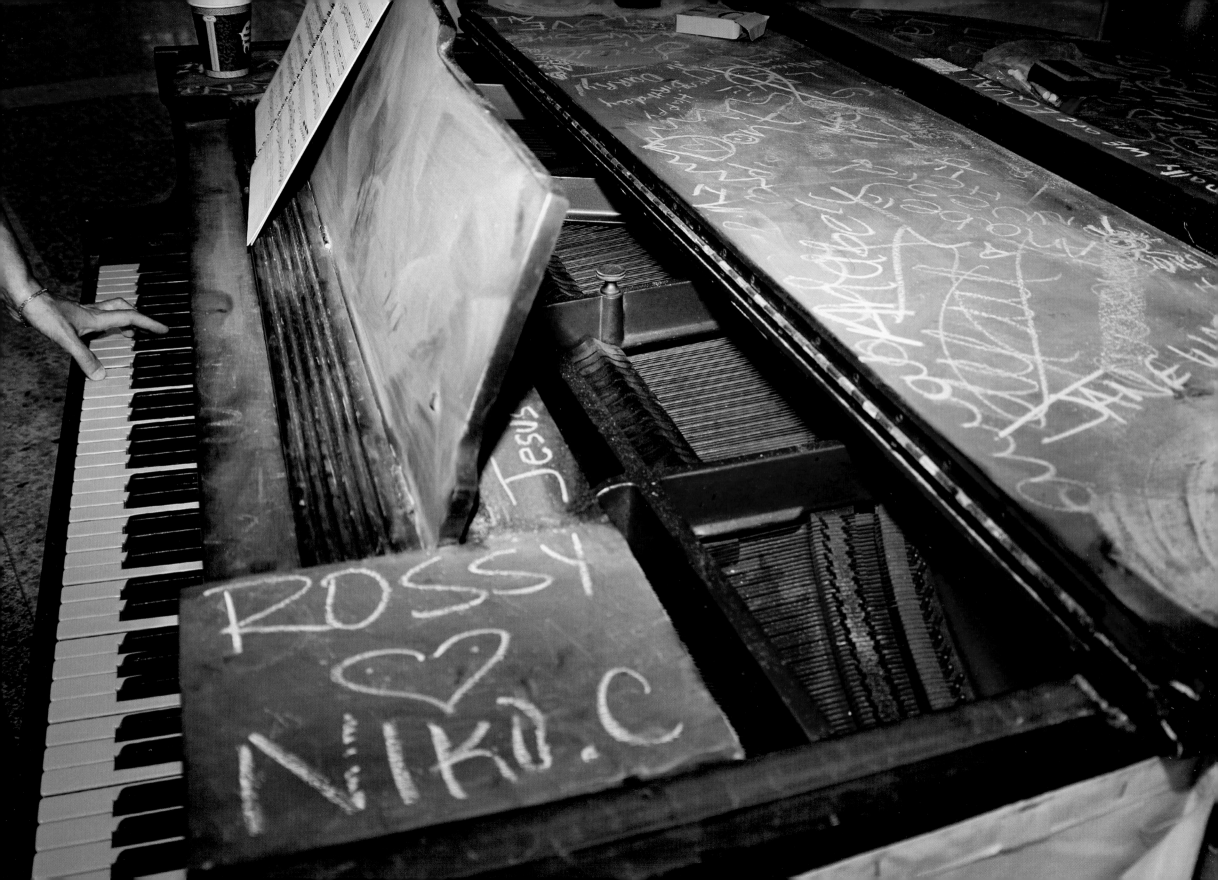

My artist is:
Zahir Babvani

My keys were at:
Broadway and West 178th Street

My name is: Chalk For Hope

This is what my
artist says about me:
Taking the interactive element of
this experience further, I'm painting
my piano with chalkboard paint so
that people can express themselves
visually as well as musically.

My community buddy is:
Port Authority of New York
and New Jersey, New York State
Psychiatric Institute

My new home is:
NY State Psychiatric Institute

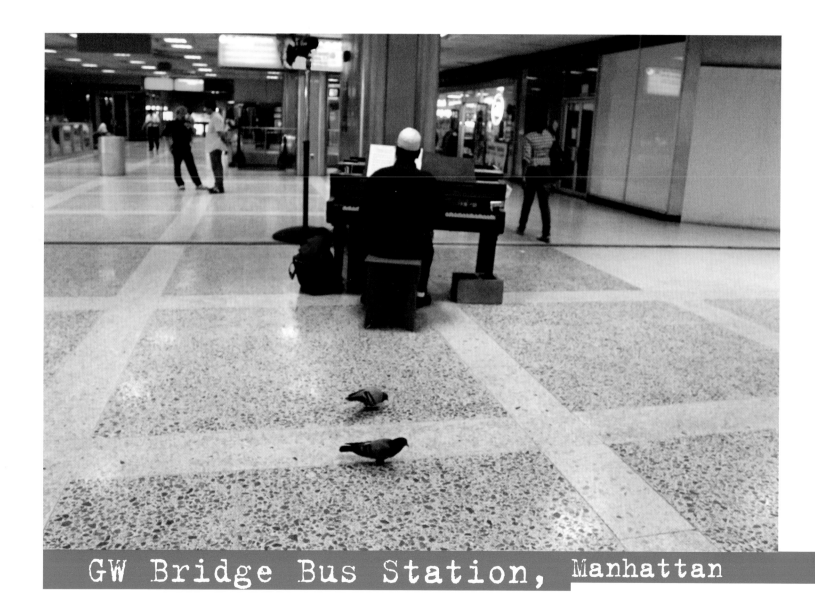

GW Bridge Bus Station, Manhattan

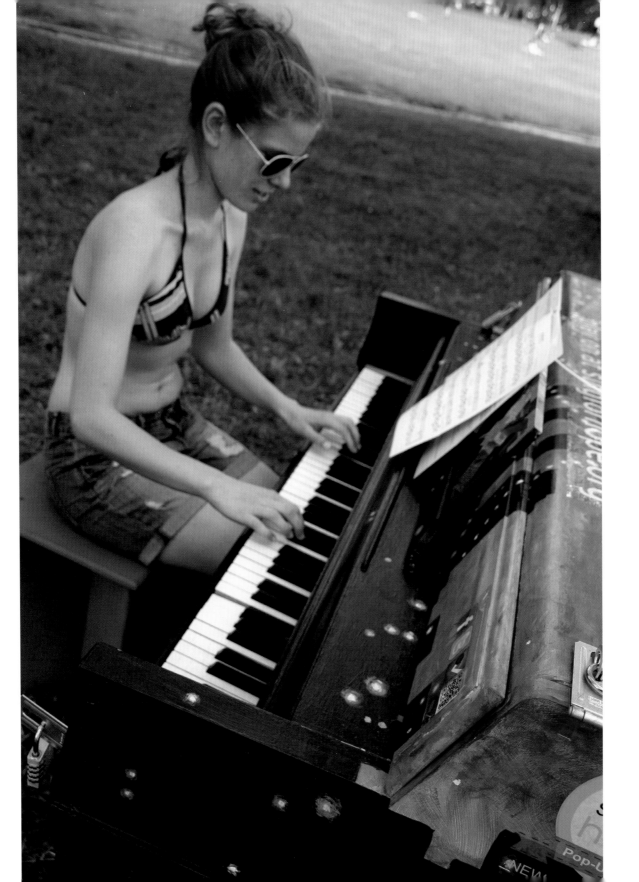

My artist is:
Robert Padovano

My keys were at:
Shore Boulevard and RFK Bridge

My name is:
New York Lights

This is what my
artist says about me:
My piano is an impressionistic
rendering of the New York skyline
at dusk. The concept was to
make the light from the setting sky
emerge out of the contrast of the
black piano color; making the bridge,
buildings, and piano into a
seamless silhouette behind the
glowing evening lights.

You can find my artist at:
www.padovanofineart.com

My community buddy is:
Astoria Park Alliance

My new home is:
Hyde Leadership Charter School

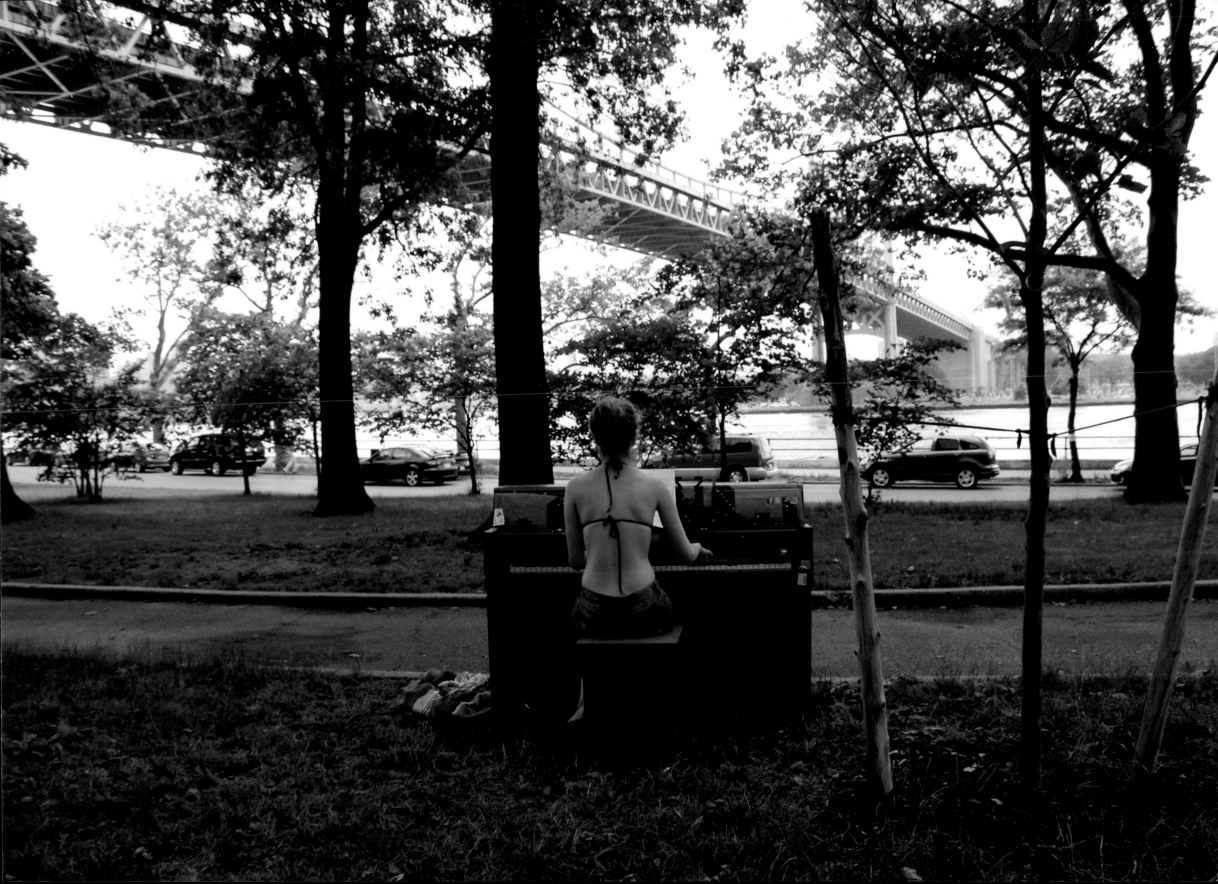

My artist is: Carlos DeMedeiros

My keys were at:
Father Capodanno Boulevard and Sand Lane

My name is:
Brazil's True Water Colors

This is what my artist says about me:
Can Art change the world? I truly believe
that in Art there is a redemption for the human
spirit. Without Art, we are empty shells with
no perspective of beauty, tolerance and love.
My piano speaks to this in colorful gesso!

You can find my artist at:
www.godskin9lives.blogspot.com

My community buddy is: South Fin Grill

My new home is: South Beach Psychiatric Center

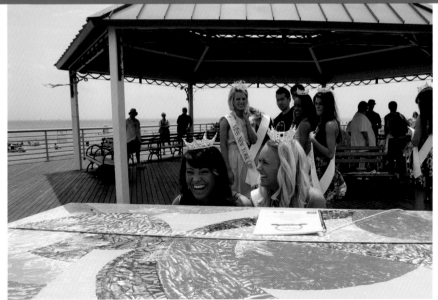

South Beach Boardwalk, Staten Island

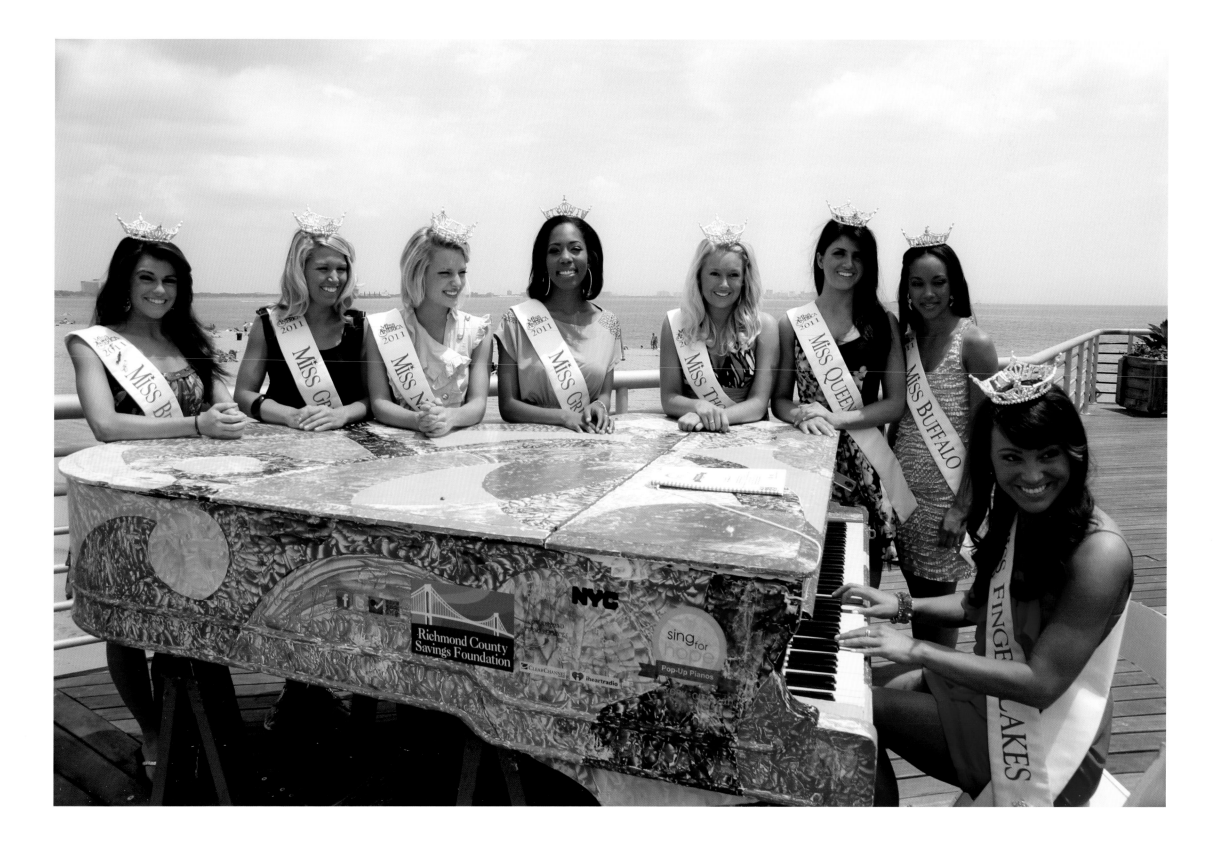

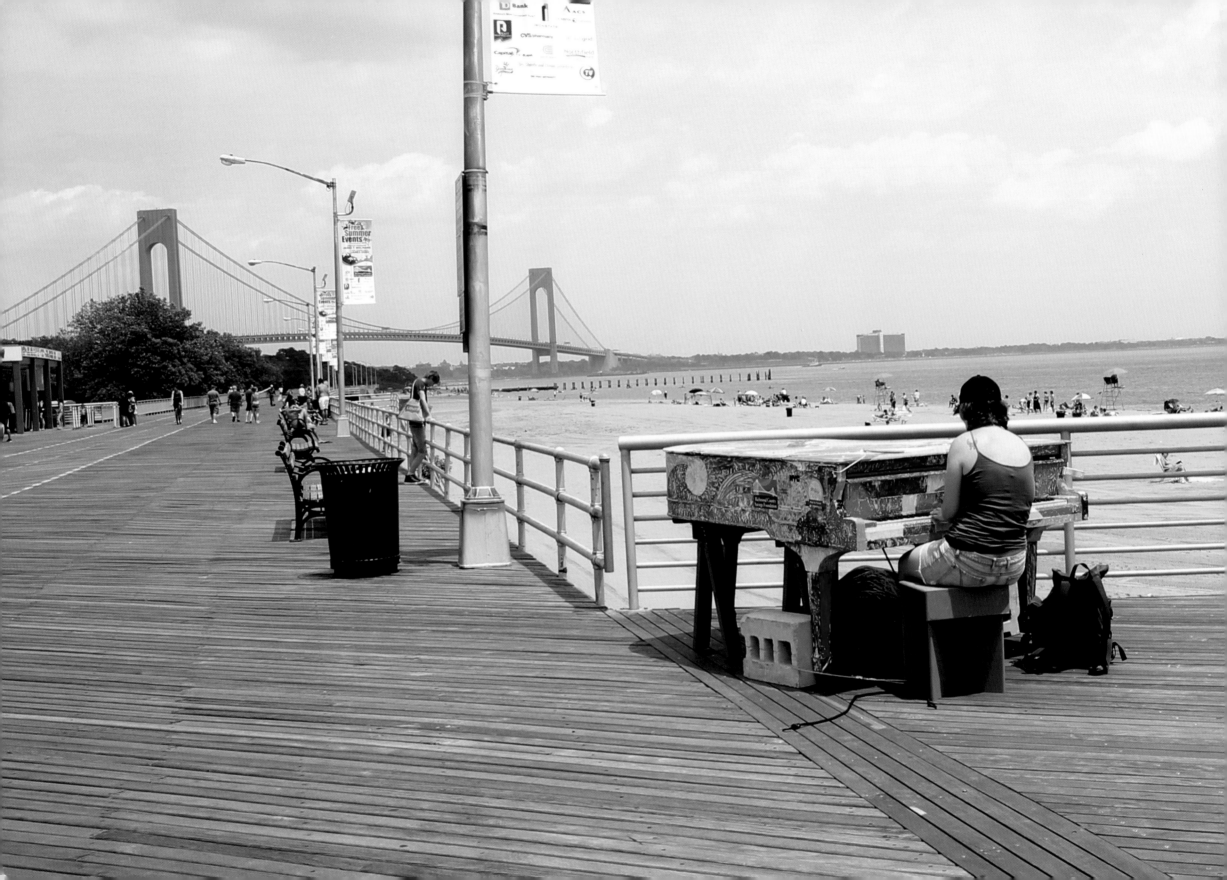

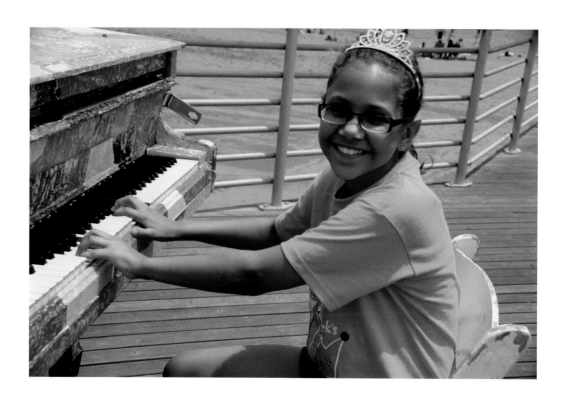

"People say, 'Oh, you put a piano in the South Bronx and people are going to destroy it.' That's not the case. I love the fact that this piano has challenged that stereotype, you know. We in the South Bronx are worthy of this piano. And at the end of the day, this piano will continue to live and be a part of this community. We have access, we can appreciate it, and we can take care of it." —Lisette, Betances Community Center, Bronx "I was never so moved by such a seemingly simple thing as a piano in a park. Especially in Harlem. I have to be honest, I live here, and blacks and whites don't mingle much. This piano is appreciated by all races. I witnessed blacks and whites playing, listening, and enjoying together." —Darryl, St. Nicholas Park, Manhattan "I was driving around my hometown of Winston-Salem, North Carolina, listening to NPR, and they were doing a story about the pianos. It captured me. I'm a teacher, and I couldn't afford to cancel lessons to go to New York. I told the parents of my students about my plans, and some of them offered donations toward gas money. I ended up with almost $200 in donations, and on July 3, my wife Jamie, my bandmate Chad and I jumped in the car and headed up to the Big Apple. This was our first time in New York City. At each piano we went to there were people who stopped and listened to the music and clapped. That felt so fun, just dropping into the deep end of the pool and staying afloat. I'd been nervous about the city because I had never been there, but it was absolutely beautiful. I wasn't prepared for how amazing it all was. The piano project felt like something much bigger than all of us. It felt like people were looking for an excuse to connect, and the pianos just gave us all an easy excuse." —Michael "I am the mother of a son visiting New York for a week. My son is 23 and we live in Michigan. He has been unemployed, laid off as a certified TIG welder, for at least a year. He is also learning disabled. But can he play the piano! He plays

by ear and plays his own music. When he left to visit New York and stay with friends (visiting New York has been one of his dreams since he was a young child) he said, 'Mom, I'm going to find a piano somewhere in the city to play.' We knew nothing about the piano project at the time. Tonight, he called me and told me there was a piano on the street, by the Brooklyn Bridge, and he couldn't believe his eyes! He sat down to play and said he drew a crowd. On the phone he sounded like he was on cloud nine, and happier than I have heard him be in years. " —Jon's mom "There's no language barrier that can't be crossed with music." —MaDDan, City Hall Park, Manhattan "Every day we look out and there's a family of at least four or five people playing, and you can tell that half of them have never played a piano before. As soon as someone sits down and plays, everyone stops and gathers around and you have this sort of immediate, temporary moment of community." —Anonymous, Brooklyn Queens Expressway at Clinton Hill, Brooklyn "The Pop-Up Pianos are an opportunity to kind of, I don't know, take the New York 'mask' off and let your guard down, even if it's just for a minute. To communicate with someone you might not otherwise have a vehicle to communicate with." —David, Fort Greene, Brooklyn "A lot of our young people have never really seen a piano up close. So it's amazing fun to sit down with them and really play, and see their energy and excitement." —Carolyn, George Walker Jr. Community Center in Brooklyn, a Pop-Up Piano permanent donation site "When I listen to music, it brings a different attitude to my body, to my soul. I love these guys here, and this musical instrument is a part of love from other people. People like us appreciate it, you know, 'cause it's music and it helps you grow." —George, Goddard Riverside Housing in Manhattan, a Pop-Up Piano donation site "I wish I would've learned piano when I was young. But I can still learn it if I put my mind to it." —Etta, Mid-Bronx Senior Citizens Center in the Bronx, a Pop-Up Piano permanent donation site

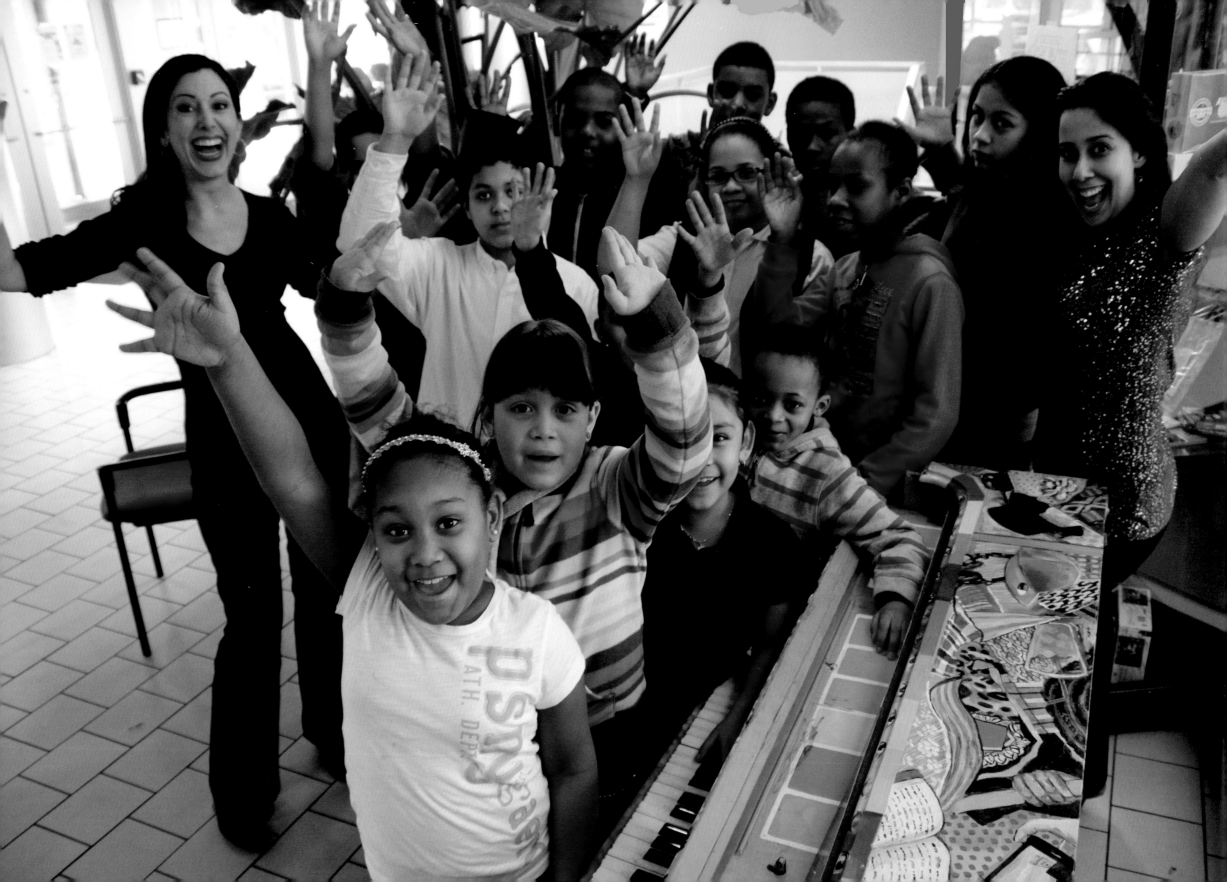

Where did the pianos go?

On July 2, the streets of New York seemed to be missing something. That morning, the Pop-Up Pianos had been loaded onto trucks and carted away. The air was still, because the music had stopped. Or had it?

The location of the pianos had definitely changed, but the music is far from over. From Betances Community Center in the Bronx to Brooklyn's P.S. 34 and in countless places in between, New York City's schools, hospitals, and community centers have welcomed colorful instruments into their new homes.

And so it is that artist Nicolina's piano has found its new home at the Lower Eastside Girls Club, where girls grades 4 - 12 now create their own musical stories in reflection of the words etched above the keyboard: "Your magic is real." At Bushwick High School, seniors come out of their shells in piano lessons with Sing for Hope Volunteer Artists on the school's first piano, its bright paint glowing as young fingers trace melodies, tentatively at first, then with growing confidence. And at the Brooklyn Children's Museum, a piano lid's butterflies, painted by Sing for Hope students, take flight, and a museum space is reinvigorated visually, musically, tonally.

The summertime Pop-Up Pianos are actually just part of a bigger story. It's about a year-round continuum of involvement in areas that are too often ignored, and about the ongoing transformation of our communities. It's about artists coming together and offering grassroots solutions, and about art's power to seed positive change in individuals, organizations, and our world. It's about the creative potential that lives inside each one of us, and our communal responsibility to unlock that potential, give it wings (or paintbrushes, or piano keys, or notepads) and let it soar. It's about how, in that soaring, we are all lifted up.

The music of Sing for Hope's Pop-Up Pianos is constant, ever-resonant, ever-varying, ever-developing.

Stop for a moment and listen closely. You can always hear it.

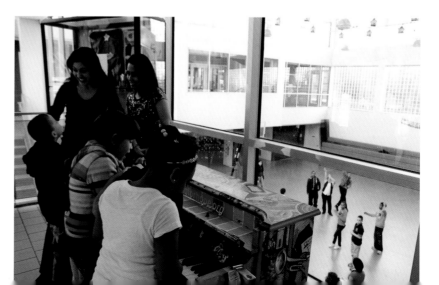

Sing for Hope Co-Founding Directors play Jillian Logue's Pop-Up Piano, *Subway Quilt*, with children at the Betances Community Center in the Bronx.

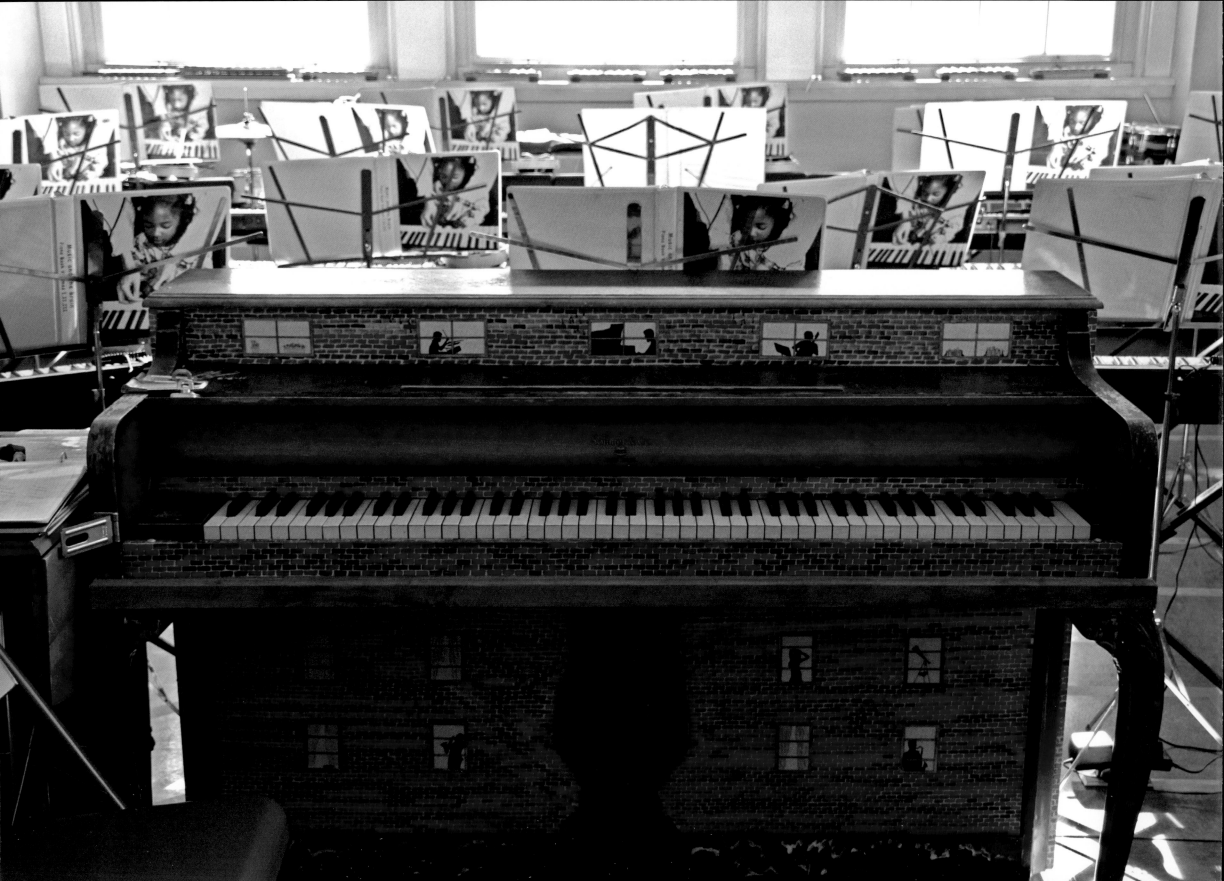

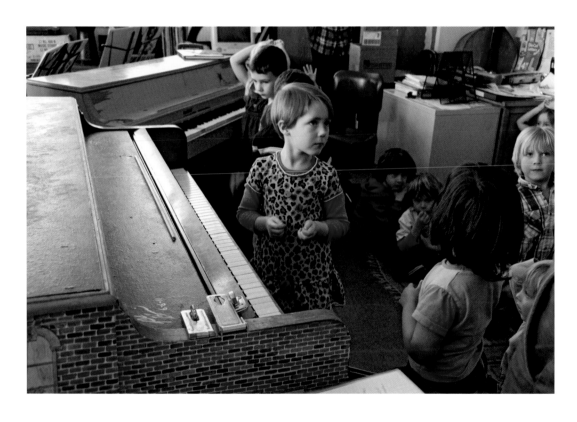

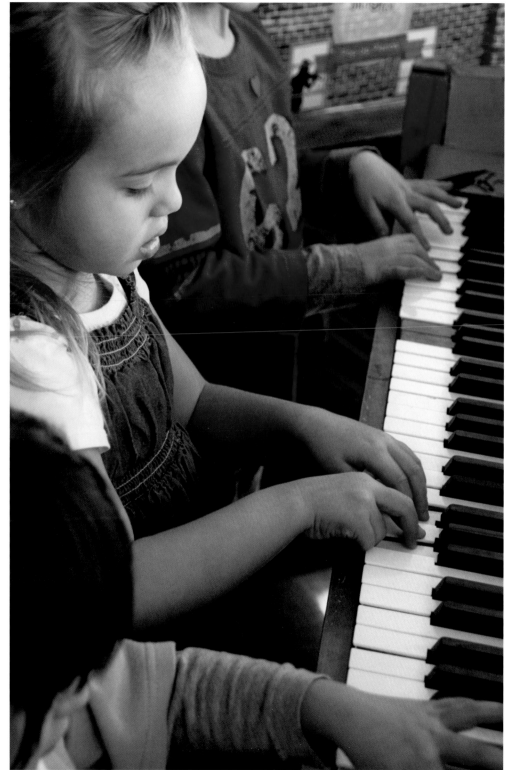

Robert Baird's Pop-Up Piano, *Windows*, now lives at P.S. 132 in Williamsburg, Brooklyn.

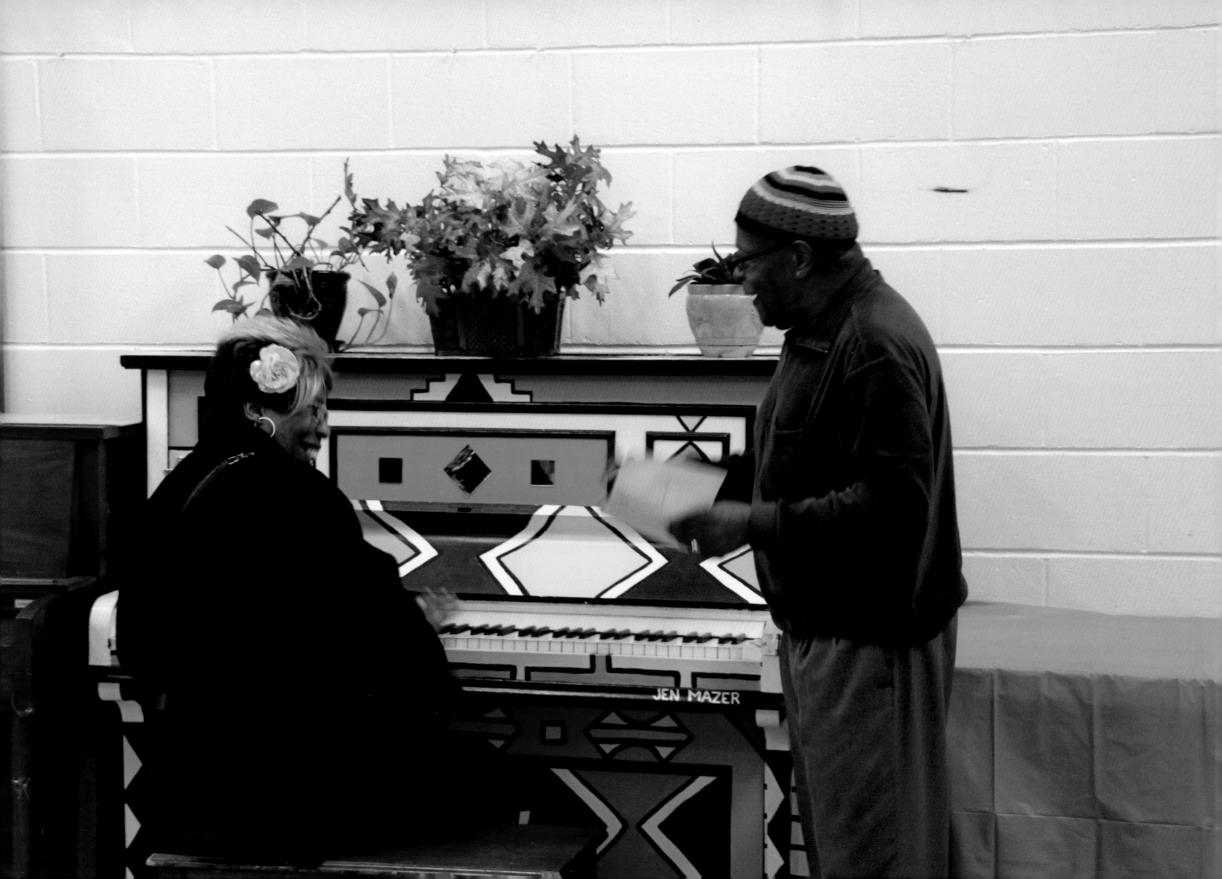

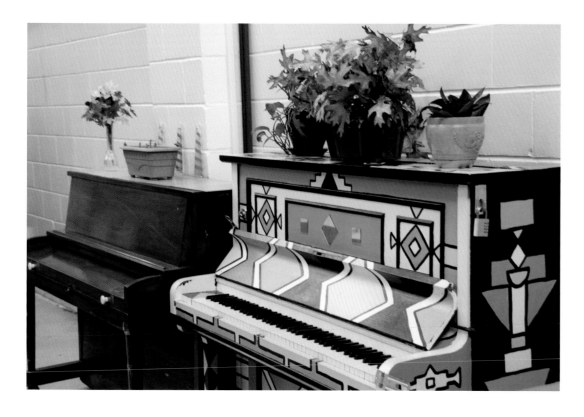

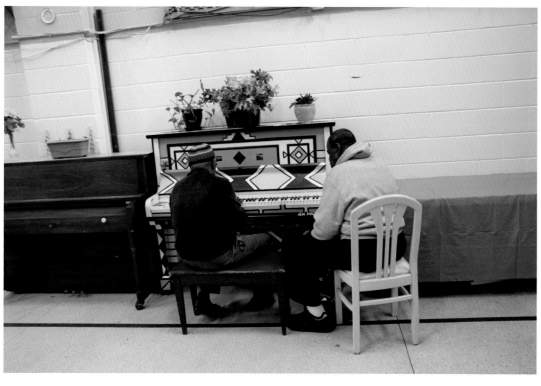

This page and opposite page: Jen Mazer's Pop-Up Piano, *Ndebele*, now lives at the Wilson Major Community Center and honors the Ndebele people from the Nguni tribe in South Africa, whose traditional pattern designs are believed to have healing powers.

The Artists

BRONX

Arthur Avenue Armand Silvani

Casita Maria Center for Arts and Education The Center for Arts Education Students

Crotona Park Sing for Hope Art U! Students

Fordham Plaza Elana Baziz

Joyce Kilmer Park The Center for Arts Education Students

The Owen Dolen Golden Age Center Andrea Williams

Roberto Clemente State Park Sing for Hope Teaching Artist Team

St. James Recreaction Center Elizabeth Misitano

St. Mary's Playground Debbie Gray

Van Cortland Park BD Wong

Williamsbridge Oval Pete Makela

BROOKLYN

Brooklyn Bridge Park Adam Suerte

Brower Park Bushwick High School for Social Justice Students

Columbus Park Sing for Hope Art U! Students

Coney Island Boardwalk Antony Zito, Matt Allamon

DUMBO Archway Olek

East River State Park Sing for Hope Art U! Students

Fort Greene Park Scott Ackerman

George Walker Junior Park Leola Bermanzohn

Herbert von King Park Emily Lynch-fries

John Paul Jones Park Javier Infantes

McCarren Park Robert Baird

Myrtle Avenue Scott Glaser

Newtown Creek Visitor Center Sing for Hope Art U! Students

Prospect Park Carousel Ellie Balk

Prospect Park Grand Army Plaza Richard Fine

Red Hook Park Recreation Center Guno Park

Salt Marsh Nature Center Jenn Wong

Shore Road Park Sam Frons and Danielle Baskin

Sunset Park Masha Gitin

Washington Avenue Benjamin Christopher Martins

Wilson Avenue Bushwick High School for Social Justice Students

MANHATTAN

Astor Place Jennie Booth

Battery Park Zeke Decker

Bryant Park Jillian Logue

Carl Schurz Park Kate Spade

Central Park Bandshell Samson Contompasis

Central Park Dana Discovery Center Marc Evan

Central Park Visitors' Center Moira Fain

The Chelsea Triangle Jenny Hung

City Hall Park Hannah Hogan

Columbus Park Linda Xu Zi

Fort Tryon Park Samantha Jones

George Washington Bridge Bus Station Zahir Babvani

Greeley Square Isaac Mizrahi

Harlem Art Park Lauryn Pepe

Highbridge Park Jennifer Mack

Inwood Hill Park Sing for Hope Art U! Students

Jackie Robinson Recreation Center Annamarie Trombetta

Alice Tully Hall at Lincoln Center for the Performing Arts Chris Soria

Hearst Plaza at Lincoln Center for the Performing Arts Diane von Furstenberg

David Rubenstein Atrium at Lincoln Center for the Performing Arts Scott Taylor

Little Red Square Little Red Schoolhouse Students and Families

Montefiore Park Travis Boatright

Riverbank State Park Sing for Hope Art U! Students

Riverside Park, 70th Street Pier Cara Bonewitz

Roosevelt Island Rodrigo Quiroz

St. Nicholas Park Jen Mazer

Stone Street Sing for Hope Teaching Artist Team

Times Square - Broadway and 42nd Street Michael Kale

Times Square - Broadway and 45th Street Walker Fee

Tompkins Square Park Nicolina

Tribeca Park Stefan Sierhej

Washington Market Park Alice Mizrachi

West 111th Street People's Garden Sara Forney and Lex Liang

QUEENS

Astoria Park Robert Padovano

Court Square Park Jeannine Jones

Flushing Meadows Park, Unisphere Sing for Hope Teaching Artist Team

Flushing Town Hall Sing for Hope Art U! Students

Fort Totten Park Christopher Crawford

Gantry Plaza State Park Edyta Halon, Sing for Hope Teaching Artist Team

Jackson Heights Post Office Jenna Samotin

JFK AirTrain Terminal William Conroy Lindsay

Louis Armstrong House Gray Edgerton and Manoela Madera

Rockaway Park Sing for Hope Teaching Artist Team

Rufus King Park Sing for Hope Art U! Students

STATEN ISLAND

Blue Heron Nature Center Maud Taber-Thomas

Clay Pit Ponds State Park Mitchell Martinez

Clove Lakes Park Mount Sinai Medical Center Doctors and Medical Students

Faber Park Ai Ling Loo

Greenbelt Nature Center Lisa Robin Benson

Historic Richmond Town Sing for Hope Teaching Artist Team

Snug Harbor Cultural Center Tim Farley

South Beach Boardwalk Carlos DeMedeiros

Staten Island Ferry Terminal Alexandra Leff

Richmond County Bank Ballpark Sing for Hope Art U! Students

Tappen Park NYCArtsCypher: Geoff Rawling, Athena Zhe, Wolfman, Diana Sorkin, Gano Grills, and Charlie Balducci

Wolfe's Pond Park Elizaveta Gaglio

About Sing for Hope

Sing for Hope was founded by two opera singers who shared a common belief in the power of arts volunteerism to transform underserved communities.

To honor the memory of a dear friend who spent his final days at Houston's Omega House Hospice, soprano Camille Zamora organized a benefit concert which is now one of the country's largest annual AIDS fundraisers. In the aftermath of Hurricane Katrina, soprano Monica Yunus, the daughter of Nobel Peace Prize Laureate Muhammad Yunus, brought together colleagues from The Metropolitan Opera in concert to benefit the hurricane's victims.

In 2006, recognizing their shared passions, Camille and Monica, who became close friends while in the Master's Degree program at The Juilliard School, established Sing for Hope as a resource for professional artists to use their art to give back to their communities.

Both sopranos continue active performing careers. Monica has performed at The Metropolitan Opera, Glimmerglass Opera and Washington National Opera, and in recital on three continents. Camille has performed principal roles with companies including Los Angeles Opera, Houston Grand Opera and Glimmerglass Opera, and has collaborated with musical artists ranging from Plácido Domingo to Sting.

Today, Sing for Hope is an artists' peace corps made up of professional artists of all kinds—opera singers, painters, jazz musicians, actors, ballet dancers—who volunteer in programs that bring the transformative power of the arts to underserved schools, healthcare facilities and community-based organizations. And we bring the Pop-Up Pianos to our parks and public spaces in an open festival that celebrates our vision of art for all.

At Sing for Hope, we believe that all people should have the opportunity to express the art that lives inside of them.

To learn more, visit us online at www.singforhope.org.

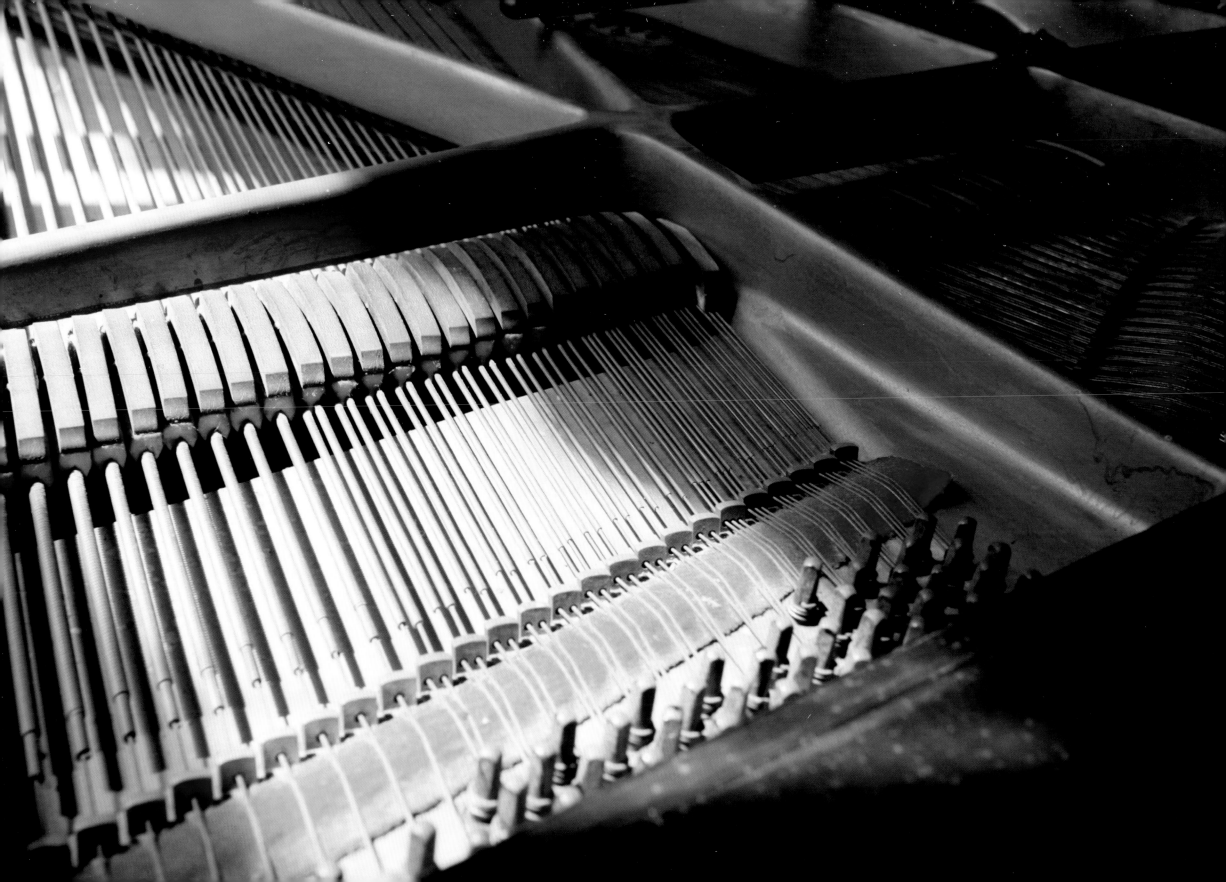

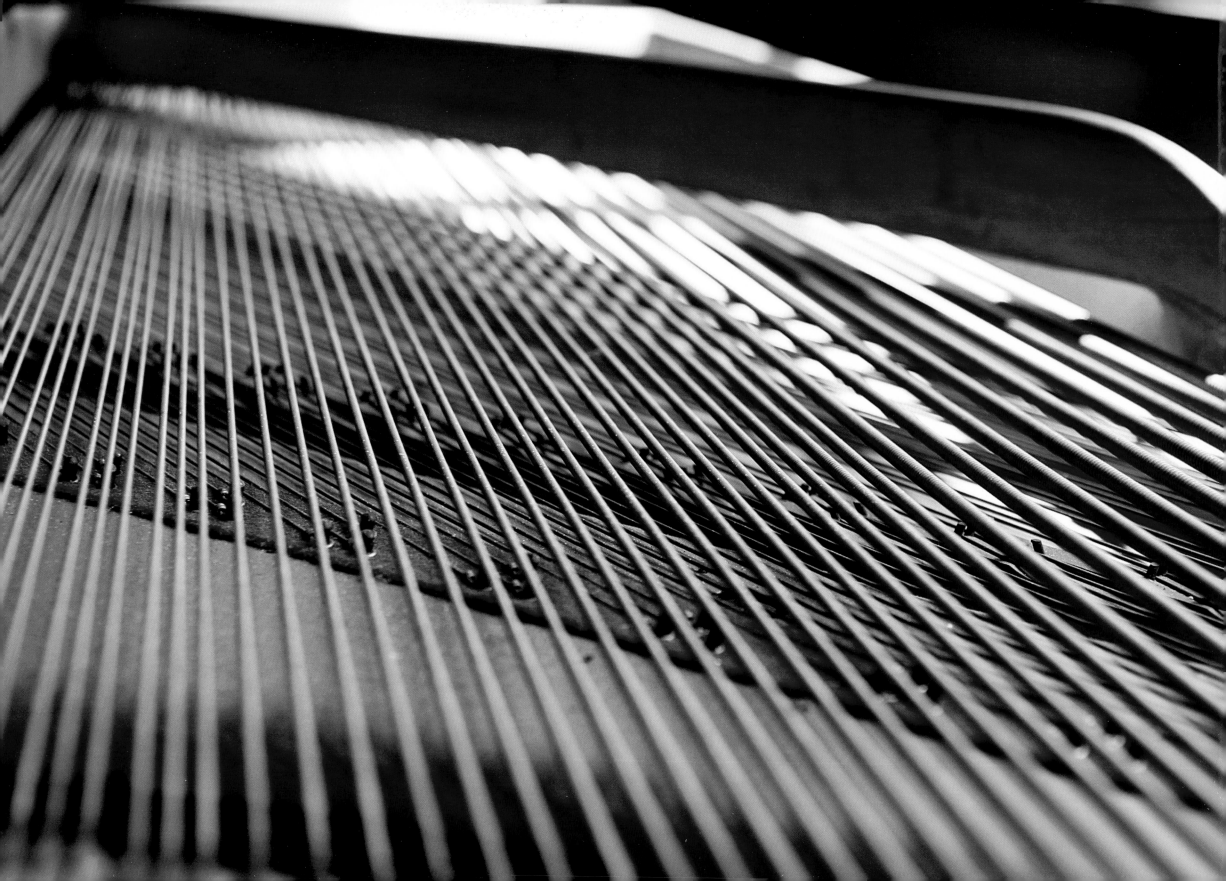

Photographer and documentary filmmaker Lekha Singh's work offers insight and understanding of people around the world. It is often said that her work opens "a window to the world." Her photos are featured in National Geographic's *The Other Side of War: Women's Stories of Survival and Hope*, *The Making of an Activist*, *Call to Love: In the Rose Garden with Rumi*, and *Bhutan*.

Beyond Right and Wrong, Stories of Forgiveness and Justice, a documentary film directed by Ms. Singh, will soon be released. Focused on Rwanda, Northern Ireland, Israel and Palestine, the film examines individuals seeking forgiveness for acts perpetrated in war and genocide from the victims of their actions. The struggle to forgive with justice is poignantly explored. The personal courage and intimate conflicts of those asked to forgive are examined.

Lekha Singh, photographer

ACKNOWLEDGMENTS

There is no way to adequately thank Sing for Hope mentor, cheerleader
and donor Joseph H. Flom, in memoriam 2011, and his passionately musical wife
Judi Flom for their vision and philanthropy.

Special appreciation to Ed Duffy and The Peter Jay Sharp Foundation
for their support of the Pop-Up Pianos and this book.

Deep appreciation to the City of New York, NYC Department of Cultural Affairs,
NYC Department of Parks and Recreation, and Mayor Michael Bloomberg.

Thanks to the Rudin family for their invaluable donation of the
Pop-Up Piano staging space in Tribeca, where 88 pianos were brought to vivid, colorful life.

Great thanks to Fred Patella of Con Sordino Piano Services for his expert
care of the 88 rehabbed instruments, and for his boundless passion for the project.

Gratitude to Ryan LaMountain for his organizational skills in support of the photographer,
and to Hannah Daly, who quietly kept things humming.

Thank you to the Sing for Hope Board, for their continuing support, Sara Bergson, Valerie Demont,
Plácido Domingo, Renée Fleming, Annabelle Garrett, Eva Haller, Linda E. Johnson, David Miller,
Luis Moreno, Michael Pitman, Kara Unterberg, Billy Weisman, James Woolery,
Monica Yunus, Muhammad Yunus, Camille Zamora.

Impossible to adequately thank Yolanda Cuomo, Kristi Norgaard, and Bonnie Briant
for their creativity and skill. They truly made this book sing.

Finally, heartfelt thanks to the countless community partners who work together to bring
harmony to our streets. Without them, there would be no Pop-Up Pianos.

Pop-Up Pianos

Lekha Singh

[DAMIANI]

Damiani

via Zanardi, 376

40131 Bologna, Italy

t. +39 051 63 56 811

f. +39 051 63 47 188

info@damianieditore.com

www.damianieditore.com

Associate Book Designer: Bonnie Briant
Production Supervisor: Kristi Norgaard
Printed in May 2012 by Grafiche Damiani, Bologna, Italy.

ISBN 978-88-6208-233-4

BOOK DESIGN: YOLANDA CUOMO DESIGN, NYC

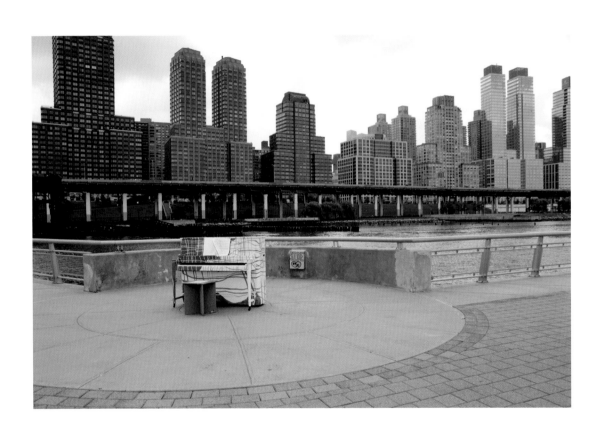